W9-DGV-142

WITHDRAWN

TEXTURED LIVES

TEXTURED LIVES

Women, Art, and Representation in Modern Mexico

Claudia Schaefer

THE UNIVERSITY OF ARIZONA PRESS

Tucson & London

The University of Arizona Press
Copyright © 1992 by Claudia Schaefer

97 96 95 94 93 92 6 5 4 3 2 1

Library of Congress Cataloging-in-Publication Data
Schaefer, Claudia, 1949–
 Textured lives : women, art, and representation in modern
Mexico / Claudia Schaefer.
 p. cm.
 Includes bibliographical references (p.) and index.
 ISBN 0-8165-1250-7 (cloth : acid-free paper)
 1. Mexican literature—Women authors—History and
criticism. 2. Mexican literature—20th century—History and
criticism. I. Title.
PQ7133.S33 1992
860.9'9287'09720904—dc 20 91-30584
 CIP

British Cataloguing-in-Publication Data
A catalogue record for this book is available from the British Library.

CONTENTS

Acknowledgments vii

Introduction ix

1. Frida Kahlo's Cult of the Body:
 Self-Portrait, Magical Realism, and the Cosmic Race 3

2. Rosario Castellanos and the Confessions of
 Literary Journalism 37

3. Updating the Epistolary Canon:
 Bodies and Letters, Bodies of Letters in Elena
 Poniatowska's *Querido Diego, te abraza Quiela*
 and *Gaby Brimmer* 61

4. Popular Music as the Nexus of History,
 Memory, and Desire in Angeles Mastretta's
 Arráncame la vida 88

 Epilogue 111

 Notes 115

 Bibliography 143

 Index 155

ACKNOWLEDGMENTS

This book is the product of a number of years of research and writing carried out in both the United States and Mexico. Its contents and theoretical perceptions are, of course, my own, although I owe an inestimable debt to colleagues and acquaintances both here and abroad whose formal and informal discussions were of great benefit to the development of my ideas. One particular comment stands out as I look back. During the preliminary stages of my research, in the days before Frida Kahlo was a household word internationally, I was asked by a young woman who teaches sociology in a Mexican university, "Why Frida Kahlo and why in the U.S.?" I tried to keep this question in mind as I worked my way through the project, its inference being, to me at least, that a "voyage of discovery" was not what I proposed to disembark from at the end.

The project began in the summer of 1984 when I received a generous Faculty Research Grant from the University of Rochester. This funding allowed me a lengthy and rewarding stay in Mexico, including the chance to interview writers, obtain a great deal of primary material, and make several visits to Frida Kahlo's Casa Azul and library in Coyoacán. As luck would have it, the "Frida Kahlo and Tina Modotti" exhibit from the Whitechapel Gallery in England had arrived at the Museo Nacional de Arte in Mexico City by that time, and I was able to view it during my visit as well. I am grateful to the university for its continued support of my work, particularly in the form of a Mellon Faculty Fellowship during the spring semester of 1987.

Special mention must be made of the research material and working

space made available to me at the Colgate Rochester Theological Seminary and at the Olin Library of Cornell University. I appreciate these tranquil environments, so conducive to writing. I would also like to thank Raúl Rodríguez for providing a "haven in a heartless world." Without them all, the manuscript might still be a collection of loose threads.

I presented a short preliminary version of some of the material from chapter 4 at the Feministas Unidas session of the Midwest Modern Language Association annual convention in Minneapolis in 1989. The final version and all other chapters are published here for the first time.

I would like to thank Greg McNamee for his support and encouragement throughout the initial review and subsequent revisions of the manuscript; his editorial suggestions always proved to be helpful and practical. Thanks are also due Joanne O'Hare for taking on this project in midstream and to Alan Schroder for a superb job of editing the manuscript.

Finally, it would be inaccurate and misleading of me to lay claim to purely intellectual roots for this book; it represents a personal investment as well. I must acknowledge my gratitude to and admiration for the women of Mexico with whom I have spoken and corresponded, especially those of Cooperativismo who, directly or more obliquely, have contributed to this project. Their historical consciousness will help them face the future. It almost seems as if Frida Kahlo were thinking of them too when she repeated as her motto the popular song lyric "árbol de la esperanza mantente firme" [tree of hope remain strong] when faced with difficult obstacles or challenges. That strength will come in handy as Mexico enters the 1990s, not just as "A Work of Art" (as an advertisement in the *New York Times* boldly baptized it in the Arts and Leisure section on December 16, 1990) but as a society on the brink of enormous change.

INTRODUCTION

The last decade or so has signaled an encouraging trend in the study of Latin American women. In the late 1970s, both June E. Hahner and Asunción Lavrin opened their anthologies on issues concerning women in Latin America with similar statements regarding their responses to a perceived as well as objectively real absence of such information as that provided by the documents and analyses in their collections of essays. In 1976 and 1978, respectively, they wrote:

> Although women comprise an indispensable element in the evolution of Latin America, their activities have received scant scholarly attention. . . . With the rise of social and economic history and with increasing concern for groups out of power, [however,] women have begun receiving more attention.[1]

> This book is the result of the search for a social group that has up to now eluded historical examination: the women of Latin America. The absence of women in most of the historical sources . . . challenged the contributors to this book to undertake the task of reconstructing a part of the past universe in which women of Latin America lived.[2]

Even though Hahner later recognized the increase in scholarly research and publications on Latin American women in the four years between the first and subsequent revised editions of her book, she continued to point out a discrepancy between the number of studies dedicated to women from the 'Old World' or the English-speaking countries of North America and women of the other parts of the 'New World.' In 1980 she acknowledged the fact that "[t]he field of women's history has expanded greatly since this volume was originally published, . . . [but] the gap

remains large between the amount of research on women in the United States as compared with that on women in many other parts of the world."[3] The same can be said for the emphasis given certain areas or groups in Latin America to the exclusion of others in terms of both geography and social class. For all the salutary achievements in this area, then, work remains to be done, some of it archival or historical but much of it pertaining to very contemporary matters of society, gender, class, and varieties of aesthetic representation.

In spite of a constantly growing number of excellent publications with historical, economic, sociological, or anthropological emphasis, the field is only beginning to be recognized and mined for its riches, especially now that the moment has come to reexamine some of this material critically as well as to continue to seek out and present data on 'the unknown.' In this regard, peasant women, urban women of the lower classes, women in revolutionary cultures, and women as authors, consumers, or images of mass culture come to mind.[4] Further, given the diversity of the history of regions and cultures in Latin America, such 'explorations' will surely yield innovative and stimulating material far into the future. By extension, the same might be said of studies oriented more specifically toward the literary, cultural, and artistic concerns of women in Latin America. A number of volumes—among them those written or edited by Mary Seale Vásquez and Maureen Ahern, Evelyn Picon Garfield, Beth Miller, Doris Meyer and Margarite Fernández Olmos, Sharon Magnarelli, Doris Sommer, and Fabienne Bradu—have made important contributions to these areas of interest.[5] Most recently, Electa Arenal and Stacey Schlau's volume *Untold Sisters: Hispanic Nuns in Their Own Works* (Albuquerque: University of New Mexico Press, 1989); *A Rosario Castellanos Reader,* edited by Maureen Ahern (Austin: University of Texas Press, 1988); *Women's Fiction from Latin America: Selections from Twelve Contemporary Authors,* edited by Evelyn Picon Garfield (Detroit: Wayne State University Press, 1988); Doris Meyer's *Lives on the Line: The Testimony of Contemporary Latin American Authors* (Berkeley: University of California Press, 1988); and *Knives and Angels,* edited by Susan Bassnett (London: Zed, 1990) offer international readers access to both original texts and careful critical analysis of Latin American women's writing from colonial times to the present. In addition, as I

write this introduction Jean Franco's book *Plotting Women: Gender and Representation in Mexico* (New York: Columbia University Press, 1989) has just appeared. Its valuable historical perspective on 'resisting women' in Mexican culture, women whose 'plotting' takes on a variety of forms, will undoubtedly open up fervent discussion about the representation of women in that society and in the 'Third World' in general. (Franco's introduction clarifies both the specificity of her study and its possible implications for a broader consideration of the relationships among women, expression, and power in diverse 'Third World' cultures; see especially pp. xi–xii and xxi–xxiv.) Quite promising additional materials are forthcoming as well, including Kathleen Ann Myers' edition of the Mexican nun Madre María de San Joseph's writings, *Woman's Word and World in Mid-colonial Mexico: A Critical Edition of the Autobiography of Madre María de San Joseph (1656–1719).*[6]

Within this general context, Mexico most certainly has attracted a significant amount of attention, perhaps in part because of its proximity to the United States, whose citizens sometimes tend to view this paradoxically "distant neighbor" (the term belongs to the *New York Times'* Latin American correspondent Alan Riding) as a not-so-remote object of curiosity, while at other times it is seen as a cultural Other of less stereotyped nature.[7] One need only look as far as the November 4, 1990, issue of the *New York Times Magazine* to find lurking on pages 50 and 51 an advertisement for some forty-five exhibits of Mexican art and artifacts currently on display in Manhattan, accompanied by the assurance that Mexico's "mystery and wonder" will make the atmosphere of this North American city "more exotic this Fall." Such interest is perhaps also due to the increased access to texts by and about Mexican women made possible by the activities of international publishers. Most recently, surveys and panoramic overviews of women writers, anthologies of essays dedicated to Rosario Castellanos and others, several films and biographies of Frida Kahlo in Spanish and English,[8] and the exhibit "Mexico: Splendors of Thirty Centuries" at New York's Metropolitan Museum of Art have added to the information accessible to the general public. In addition, the Diego Rivera Centennial exhibitions in several countries, including the United States, numerous biographies of the artist, and the new edition of his own autobiography, as well as memoirs by those acquainted with

him, such as the Russian artist Angelina Beloff,[9] have kindled great enthusiasm for studies of the silent or silenced women 'behind' such public figures. These exhibits and publications have also stimulated curiosity about women who have struggled on their own to create a cultural and social atmosphere in which they might live and work, perhaps not always on their own terms but if not, at least in resistance to the rules imposed by others. Add to this the burgeoning interest in testimonial and documentary narrative of all varieties by Latin American women and other 'de-centered' socioeconomic groups and one finds a climate appropriate, it seems, for a volume such as this, which modestly proposes to fill a space left in the study of women artists and writers in twentieth-century Mexican society.

Although it is theoretically possible to examine their production as an entity separate from 'outside' social concerns, it would be artificial to do so while retaining a balanced perspective that attempts to account for both coherence and discontinuity in each woman's views. Moreover, the critical premise on which this investigation is predicated is that both visual and narrative discourses of any type—the dominant as well as the marginal—are inextricably linked to their historical and social contexts, that they grow out of a total society, not autonomously in isolation from it. Particular expressions of class, gender, and aesthetic production are socially constructed. This is seen, for instance, in Ida Rodríguez Prampolini's remarks about the reciprocal relationship between Frida Kahlo and Mexico: "La conciencia del pueblo que alimenta a Frida no es un vínculo puramente estético sino está estrechado por lazos políticos y culturales que afianzan la visión artística propia y el desarrollo y sobrevivencia del nacionalismo" [The consciousness of her people that nourishes Frida is not a purely aesthetic link but rather one bound by political and cultural ties that secure her own artistic vision and {at the same time} the development and survival of nationalism].[10] Art has indissoluble links to history. Therefore, in this specific instance, the historical events surrounding the Mexican Revolution, especially the modern nation's launching itself headlong into capitalist development as it emerges from this critical period, are the points of departure for my consideration of the social and aesthetic expression of the four women included in this study. This revolution, a precursor of other successful or failed attempts at

social change in Latin America, may be a source of more questions than definitive answers, but it must be considered the focal point for any analysis of relationships between men and women, and between women and power, in Mexico during the twentieth century.

I have chosen four transitional moments in this historical process as the subjects of my examination, four steps or phases in the institutionalization of power in the Mexican state and—in the foreground—four women's voices standing out in counterpoint. Covering the decades immediately following the Revolution, the first chapter, on Frida Kahlo, attempts to present both a country and an individual coming to terms with utopian social promises for 'healing' both physical and psychological wounds. Here, Kahlo is viewed simultaneously as an individual and as a member of a collectivity reconsidering its own myths and traditions in the light of changing international relations and the technological advances of the twentieth century. The process of encoding economic and cultural values on the social body is reflected in the violence done to the human body as witnessed by Kahlo. It is also reproduced in the subsequent international appropriation of Kahlo by groups in search of forgotten heroic figures. To fortify and exalt the individual ego, a second round of violence is perpetrated by those who consume her image, projecting on it fantasies, needs, and desires quite likely alien to Kahlo's own.[11] The ultimate step in this process is the current reification of her image in what Peter Schjeldahl terms "Kahlo-iana," the accumulation of artifacts produced by and about Frida Kahlo and collected as vestigial 'traces' of her protofeminist spirit, and the mass media "Frid-o-mania" referred to in an advertisement in the December 4, 1990, issue of the *Village Voice*.

Chapter 2 is a discussion of Rosario Castellanos, whose writings from the 1940s to her untimely death in 1974 exhibit a process of reconsideration and reevaluation of the immediate past in order to arrive at a decision about her own options for social action. The answers are not always unambiguous, especially in the case of her adherence to the reforms proposed by the socially progressive government of President Lázaro Cárdenas, and the result is more individually oriented than outwardly prescriptive or proscriptive about this procedure. In her autobiographically oriented journalism, Castellanos reflects the agonizing

realization that social change so often requires individual sacrifice and that the promises of the Revolution can all too easily become institutionalized policy with little real effect on the everyday lives of the people. She is included in this study, at least in part, as the source of inspiration for many Latin American women in subsequent generations as far as intellectual commitment, aesthetics, and gender issues are concerned. Furthermore, Castellanos is an incisive participant-observer of the economic and psychological 'dislocations' in Mexican society stemming from the Cárdenas years (1934–1940) and extending through the decades of the fifties, sixties, and even early seventies. Moreover, her prose writings bridge several genres, thereby contributing to the production of cultural artifacts that continue to have vast implications for both literary and anthropological studies.

The third chapter explores two texts written by Elena Poniatowska, one of Mexico's best-known contemporary writers and a bridge between the 1960s and the 1970s. In particular, she portrays the evident results as well as the more subtle repercussions of the social movements of 1968 on the decade of the 1980s. My point of departure is her weaving together of fictional and nonfictional letters by other women into convincing and problematic testimonial accounts of the psychological stress imparted by individual encounters with external social structures. Although at first glance somewhat distanced in time and place from one another, Angelina Beloff and Gaby Brimmer speak to and through Poniatowska as the warp and woof of a social fabric that is often on the verge of being torn apart by challenges to institutionalized authority.

The last chapter deals with Angeles Mastretta, a novelist and newspaper journalist as yet relatively unknown outside Mexico in spite of her popularity in that country, and the polemic aroused by what has been viewed by some as the somewhat delicate political nature of her novel *Arráncame la vida* (Mexico City: Océano, 1985; translated as *Mexican Bolero*).[12]* Her appropriation and alteration of the concepts and genre of

*In cases in which works have appeared in English translations, the title of the work in English is given in parentheses. The titles of works that have not been translated and the titles of paintings that have commonly accepted English titles are given in brackets.

the historical novel is the object of study here—how this narrative structure is inverted into the vehicle for a 'female-centered version' of the bildungsroman in the 1980s—based on the accounts of a woman involved in the early stages of modern Mexican development in the 1930s and 1940s—and what the results are in both autobiographical terms (Catalina Guzmán) and biographical terms (Angeles Mastretta). The author uses the traditional form of the novel of formation and social integration as the medium for the female character's voyages of self-discovery, in physical as well as political terms.

Since the word *text,* referring to a written narrative work, owes its origin to *textus* (*texere* from the Latin), the same root that gives us *texture* and *textile,* or the weaving together of strands into a fabric of artistic creation, it seems natural to discuss painting, literary journalism, epistolary/testimonial novels, and a female bildungsroman all within the scope of one book. It also must be taken into account that, for Mexican society, women's participation in the fields of literature and the plastic arts represents what Elizabeth A. Meese has called a "trespassing" into traditionally male domains, an activity that Kahlo, Castellanos, Poniatowska, and Mastretta all have in common.[13] The same holds true for their characters, which produces an intricately woven creation. The foreseen and unforeseen consequences of these incursions into the territory of multiple scenarios of power, their effect on the socialization process for the individual,[14] and the complex intergenerational networks of relationships generated by and between women such as Poniatowska-Beloff, Mastretta-Guzmán, and Poniatowska-Brimmer, for example, are central to each chapter. In every case the parallels between the female body/body-politic and the respective states of health or 'disease' (unease, disrepair, malfunction, misalignment) ascribed to them form a crucial part of this study, whether in terms of the emergence of the concept of a 'self' via the tools of autobiography, self-portrait, or confessional letters, or the use of popular music as private testimonial, or the development of the constituent elements of a Mexican social body and its models of discourse in the formative decades from the postrevolutionary 1920s through the 1940s. The aforementioned issues appear both in firsthand accounts such as those of Kahlo and Castellanos and in the retrospective works of Poniatowska and Mastretta.

xvi

These four essays represent moments of confrontation and social change, from the decades right after the 1910 Revolution to the years during and subsequent to the late capitalist 'revolution' of the 1960s. They make an effort to view these four points as markers in a complex sociohistorical trajectory that forms the backdrop for the works under consideration here. In the words of Mexican historian Luis González, "Todo presente da la impresión de ser ruptura del pasado" [The present always gives the impression of being a break with the past].[15] I propose to examine how this perspective does *not* hold true for Kahlo, Castellanos, Poniatowska, and Mastretta. They all exhibit, each in her own way, an intense awareness of history.

TEXTURED LIVES

1. Frida Kahlo's Cult of the Body: Self-Portrait, Magical Realism, and the Cosmic Race

> The body is the site where the political and the
> aesthetic interpret the material.
>
> Elizabeth A. Meese (*Crossing the Double-Cross*)

Kahlo in Context

Frida Kahlo (Carmen Frida Kahlo Calderón de Rivera) is neither the first nor the only artist to employ what might be called "medical" images,[1] both as the overwhelmingly central subject matter of her paintings and as the impetus behind their production; wounds, operations, abortions, birth, and amputations all form part of Kahlo's pictorial repertoire. Several aspects of her particular case, however, merit examination. One is the Mexican cultural context in a transitional phase of self-examination and self-definition after the Revolution during which she produces her paintings. This consists of a period of synthesis or consolidation as well as an analysis of the constituent parts of the nascent state and its institutions in order to reach the desired unity of purpose and power deemed necessary by intellectual and political leaders. A second element is the use of the personalized point of view of the female victim/patient, not the power of the "male gaze"[2] of the doctor, the pictorial representation of physician-analyzed pathology and clinical dissection, nor the process of the development of medical science in an objective form. Kahlo offers the

individual woman's body and presence not as an object of aesthetic perfection for male contemplation or consumption, mechanical reproduction, or interpersonal attraction but rather as a physically and psychologically naked, conscious presence seen through her own eyes and functioning as a valid focal point of artistic "narrativization."[3]

None of Kahlo's paintings, whether overtly 'autobiographical' self-portraits or only indirectly self-referential,[4] portray possessive/possessed, dominated objects of pornography (clothed or unclothed, as befits the scopophilic perspective of the viewer), nor do they reinforce the codified myths of Mexican society's reverence for the virginal woman.[5] On the contrary, what they show is a centered or framed series of real, aging, often infirm, almost palpable, wounded or mutilated bodies, thus reversing a process of "silencing," "banishment," and "marginality"[6] generally imposed on the female body in modern discourse. At the same time, Kahlo effects the reconnection of the subject "I" and "desire"[7] to reconfirm what the following words, used as an epigraph by Jean-Pierre Guillerm for his article on painting and medicine in the nineteenth century, underline as the basic facets of life of which an individual *must* be *conscious* to complete the category of human being. Otherwise the body is fragmented or dissociated, clinically analyzed, perhaps, but without a final synthesis of its functions.

> On a beaucoup trop oublié les deux éléments qui s'ajoutent à la biologie pour que l'HOMO BIOLOGICUS devienne un être humain. C'est-à-dire la conscience de la sexualité et de la mort.

> [It has been too often forgotten that there are two elements that are added to biology in order that HOMO BIOLOGICUS become a human being. Namely, the consciousness {both} of sexuality and of death.][8]

The idea of bringing both sexuality and death out of the subconscious or repressed level of human consideration into the objective, conscious arena of everyday life is what Frida Kahlo indeed manages to reproduce in her artwork in a series of images that fundamentally reinforce these two principles in dynamic contention. As Georges Bataille states in his proposed reconciliation between eroticism and death, a desire provoked by the horror of and fascination with the death process imbues the latter

with a sensuality in its release of passionate energy at the very passing from the living to the dead. By calling this "an orgy of annihilation" and a celebration of nature, Bataille views sexuality and death not as radically opposite but as in constant intimate tension with the forces of life.[9] 5

Kahlo's own pictorial mingling of the erotic, the reproductive, and the dead (as in *The Deceased Dimas,* and *Unos cuantos piquetitos* [*A Few Small Nips*], in her scenes of abortions, and in *Mi nacimiento* [*My Own Birth*]) may signal to us a parallel consideration. In addition, she simultaneously regains a form of control over her own alienated body by studying it piece by piece within the context of the concurrent expression of life functions and death functions. It is almost as if Kahlo herself were able simultaneously to examine her own body as an object of scientific interest and to offer it as an intimate object of sacrifice to the observer (an affective or subjective voluntary act of submission). After a mutilating and near-fatal accident in 1925, Kahlo developed a hypersensitivity to or hyperconsciousness of life as constantly inhabited by reminders of death, a cultural component of Mexican life as witnessed, for example, in the Day of the Dead celebrations each November, in which indigenous rituals and church rites coexist in synchronous dynamic tension. This is complemented by a growing emphasis on self-affirmation through sexual expression as a means of communication, of breaking through solitude, and of reaffirming a life force (an individual 'self') at the same time. In order to understand the singular impact of these ideas and the ways in which Kahlo presented them in visual images, her historical moment and cultural milieu must be taken into account. This positioning is especially critical and enlightening since, as Fredric Jameson points out in his recent essay on Third World cultural production in general, we can consider her paintings as possible "private allegories" of "the embattled situation of the *public* third-world culture and society."[10]

In 1910, when the popular uprisings of the Mexican Revolution break out, feudal morals were still reflected in Porfirio Díaz's Mexico in that society's defense of the natural right of possession of women and land (both as property) as well as in the veneration of the male as the center of family life and social values. In the aftermath of the violence of the Revolution, nevertheless, came the natural obligation to construct (not *reconstruct* in the same image, it is hoped) a new society after

centuries of subjection to cultural, social, and economic imperialism as a colony of both internal and external forces. This would not be an easy task, given the classes and factions into which the country was divided, in addition to the double bind of Mexico in both geographical and cultural terms: maintaining a national identity in the face of the constant push of twentieth-century capitalism and technology, represented by the United States immediately to the north, and the pull of its own historical tradition. It is within this context that the politicians (Calles, Cárdenas, Avila Camacho, and others) and cultural figures (Vasconcelos, Orozco, Rivera, Siqueiros, and others) sought a national unity and equilibrium, a utopian harmony of competing economic, social, and ideological forces somehow kept together under a theoretically ideal state. The contemporary Mexican writer and critic Juan García Ponce has categorized this postrevolutionary tension as "el antiguo sueño romántico; pone[r] en movimiento la búsqueda de una identidad perdida en la que deberán unirse tradición y revolución [de la economía, del capitalismo]" [the old romantic dream; to put in motion the search for a lost identity in which both tradition and {economic, capitalist} revolution must be united].[11] A parallel to this (always frustrated, incessantly problematic) ideal of integration—between tradition and change, between national and supranational interests, between the individual and the collectivity—is visible throughout Kahlo's works.

Toward the 1920s, the acquisition, or more accurately, the forging of a national identity with aspirations of originality and *genuine* Mexican values—the "despertar de una conciencia americanista" [awakening of an Americanist consciousness][12]—was based on the Mexican intellectuals' confidence in the democratic ideals of progress and development.[13] Paradoxically, what this liberal, future-looking attitude did not take into account was the role of women in the new Mexico and this role's still fundamentally unchanged character, which became sedimented and institutionalized in the postrevolutionary decades.[14] It appeared that the "tradición" of Juan García Ponce's quote, and not the "revolución," was to be the orientation for women. Even the women who had taken part in the Revolution itself became mythified by society. The *soldaderas,* for example, became the image of women who take orders faithfully, conceive and give birth to children on the battlefield, and follow their men

unhesitatingly and supportively wherever they go. In general, women still fell into one of three archetypes according to rigid class divisions: the doll-like beauty, the subjugated wife and mother, and the prostitute.[15] And the treatment of the physical presence of women remained the same for all three groups: they are "mujeres-objeto pertenecientes a una sociedad en la que . . . se les impide decir su vida" [women-objects belonging to a society in which they are prevented from talking about their lives].[16] If a woman spoke up, she was no longer dependent on others, nor on their interpretation and control of social reality, and consequently she was a threat to the status quo. This was particularly true in the halcyon days after the 1910 Revolution when men (politicians, philosophers, military leaders) were forging mechanisms of power and held a monopoly on all varieties of social discourse.

7

As far as the art world in particular was concerned, the 'rules' of artistic construction separated the male professional from the intimate, discreet role of the woman. If they were not altogether silent, thereby signaling to society an absence of the capacity to contribute any worthwhile production, women were expected to maintain their artistic interests at the level of a trivial, private hobby or to dedicate themselves to the 'contemptible' objects of popular culture. Art as a professional occupation and a medium of exchange value was for men; women were relegated to art (craft?) as a domestic pastime. Perfect subjects for women to portray were, of course, what they 'know best': children and the home or scenes from nature, of which women were considered to form an almost undifferentiated element.

Although she never painted scenes of domestic tranquility or traditional family life, preferring instead to portray the violence of human relationships (such as the suicide of Dorothy Hale), the loss of a child, or the woman covered with multiple knife wounds inflicted by her lover, Kahlo's dolls and abortions can be seen as a dramatic and tragic parody of this cultural prescription for women's art. Reclining or seated on beds, usually unclothed, her dolls stare out almost accusingly at the observer; her bloody scenes of abortions or even her own (still)birth remove any consideration of passivity from the realm of the spectator and seem to trap the observer's gaze in the visible remnants of the pain, horror, and loss shown explicitly in the process. In her paintings there is a repeated

element of rupture between mother and child, between husband and wife, and even between different aspects of oneself: both life forces (sex, procreation) and death forces (suicide, mutilation, abortion) seem to converge with violence and then shatter, producing separation rather than amalgamation (synthesis). Contemporaries of Kahlo, although undoubtedly familiar with the graphic details of the mass media's emphasis on gruesome images of suffering and mutilation as seen in the photographs of the revolutionary era and the illustrated satirical broadsheets popularized by José Guadalupe Posada, are most likely drawn even more closely into (or perhaps are even both attracted to and repulsed by) the shocking world of her paintings as a direct result of the fact that the conditions of the women's bodies that are represented are not 'familiar' to the general observer as commonplace objects of public consumption produced as documentation of firsthand experiences. Like Posada, Kahlo seems to have an affinity for using images of the monstrous and the grotesque. Yet their repertoire is not drawn from exotic flights of the imagination; rather, they are composed of elements from everyday events as reflected in popular, graphic form. As forerunners, in a way, of today's immensely popular tabloids, they explore and exploit the public's ambiguity toward such representations. By challenging the viewer to look at the freaks, disasters, and atrocities of Mexican society in the last decades of the nineteenth century and the early part of the twentieth (he died in 1913) through the filter of satirical humor, Posada asked the public not to look away but to confront these metaphorical embodiments of its fears. Kahlo sets us up to watch her do the same. If Ilán Staváns finds Posada's "subversive element"[17] in the artist's use of humor as a vehicle to criticize social flaws by mocking the visible scars they leave behind, perhaps Kahlo's transgression lies in making observers discover (and admit?) how much they are drawn to look at representations of the marginal and the 'grotesque.'

A morbid curiosity about the effects that pain, death (especially in childbirth), and disease wreck on the human body does indeed exist, as witnessed by the mummified corpses on display in the underground tunnels of the Mexican city of Guanajuato. But it must be reiterated that these tortured and grotesque vestiges of men, women, and children are not on public display but are hidden from view except by explicit

(tantalizing? transgressive?) invitation. The complicity suggested be-
tween the purveyors of glimpses of these bodies somehow in limbo
between life (their preservation through mummification) and death (the
absence of individualizing human characteristics such as names and 9
faces; their reduction to specimens) and their voyeurs is strengthened in
the case of Kahlo's works by the fact that there *is* public access to her life-
and-death struggles and that a *representation* of her body is on display. It
is not the object itself that is consumed by the spectator/intruder but an
interpretation of it based on her own vision and point of view, which are
conditioned by cultural values. As Jordanova states in her excellent
discussion of the confluence of science, medicine, and images of the
female body, "The sight of unfamiliar injuries, lesions and malforma-
tions can be deeply shocking. . . . Colour photographs of healthy bodies
do not have the same impact, nor do line drawings of medical sub-
jects. . . . Not all depictions have the same effect."[18] The tranquil
'domesticity' of women's art is thus exploded by Kahlo's use of familiar
figures (a mother and child, for example) in public, unconventional,
'abnormal' states and conditions—circumstances reflected in neither the
anonymous torsos of medical texts nor the peaceful inhabitants of static
scenes of domestic bliss.

In the conflicting circumstances from the 1920s through the 1940s of,
on the one hand, a new interest in the 'oppressed' (referring specifically to
the indigenous Mexican population) and a search for 'la mexicanidad' or
'lo mexicano' (Mexicanness; the unchanging philosophical essence of the
Mexican) in politics, the social structure, and art, and on the other, a
restrictive sense of social and economic participation for women, Frida
Kahlo grew up, was educated, and began to paint. Although it does not
appear feasible to postulate an immediate and direct relationship of cause
and effect between each set of circumstances and her responses, there are
certain intellectual and artistic ideas in Mexico City, in the Escuela
Nacional Preparatoria [National Preparatory School], in her acquain-
tances, and in her readings[19] of which she most definitely must have been
aware as she represented herself and Mexican culture in painted images.
In short, one can mention the importance of the founding of the intellec-
tual group called the Ateneo de la Juventud [Young People's Atheneum]
in 1909 as a reaction against positivists such as Justo Sierra of the Escuela

Nacional Preparatoria (which Kahlo herself began attending in 1922) in order to seek new liberal ideals for the country in literature and philosophy. (Interestingly enough, Diego Rivera and José Vasconcelos were both members of the founding group of the Ateneo.) In addition, the publication in 1925 of the book *La raza cósmica* [The cosmic race] circulated among a vast audience the ideas of the philosopher José Vasconcelos,[20] a problematic national intellectual figure with whom Kahlo undoubtedly was acquainted. As national education secretary he was the prime motivator of Rivera's return from Europe to begin his vast series of mural projects. Vasconcelos' proposals for the redemption of Mexico—and by extension of all humanity—by means of the doctrine of an all-embracing Christian love in the future formation of a universal race may be tied to Kahlo's own visions of Rivera as the embodiment of a series of cosmic forces, the origins of her own mestizo family, and her Indian nurse as a unitary figure fusing the energies of the sun and the moon. Her personalization of the images of the vast expanse of Mexican, European, and North American cultures seems to allow them to be reduced, in her pictorial cosmography, to manageable proportions for the individual. Her absorption and interpretation of these dual images is reflected directly in her portraits of Diego, for instance, and her self-portraits as single androgynous figures or double ones (*The Two Fridas*), or as a mestiza accompanied by an Indian nurse surrounded by the powerful (simultaneously protective and threatening) forces of nature.

The burgeoning artistic interest in native Mexican Indian culture as a site for the preservation of the 'real essence' of Mexico's past and as an ahistorical, unchanging 'anchor' in the tempestuous surges of modern history offers a third vital link to understanding Frida Kahlo's cultural contributions. There has been a somewhat natural temptation to try to explain her work within the tenets of the Surrealist movement pioneered by André Breton both in France and in the 1930s with Trotsky in Mexico, with its early-twentieth-century posture centered on the 'discovery' of the exotic and 'primitive' components of the New World as a renovating force for an Occident in decay. The images used to describe this 'discovery' tend to describe it as pure, unbridled energy, "un mundo de naturaleza desbordante y de conductas absurdas, un mundo de objetos mágicos y de pensamiento salvaje" [a world of overflowing nature and

absurd actions, a world of magical objects and savage thought].[21] Such an 'irrational,' conflicting set of images opens up both internal and external frontiers for the artist; the continent "present[s] fertile new pastures for the Surrealist explorer, who [finds] in the ancient, the popular and the self-conscious political art of Latin America a visual language of opposition [to European culture]."[22] Nevertheless, it is much more fruitful and consistent with her cultural ties to examine Kahlo not as an integral part of the "Surrealist salon," with which she had what has accurately been called an "ambivalent relationship,"[23] but instead in relation to the concept of "magical realism." This perspective is particularly enlightening in view of the simultaneous burgeoning of the Mexican film industry and its promotion of the celebrity cult, as well as the retrenching of a nationalist spirit (and economics) during the 1930s and 1940s after the devastating crisis and international financial collapse of 1929.

The descriptive category of magical realism was first proposed by the German art critic Franz Roh in the context of the visual arts in Europe, but it was later appropriated for the narrative of the American continent and recontextualized by Arturo Uslar Pietri, Angel Flores, and Alejo Carpentier in *El reino de este mundo* (translated as *The Kingdom of This World*) and an essay in *Tientos y diferencias* [Touches/contacts and differences]. Magical realism glosses over social and economic discrepancies in favor of promoting an 'exotic' artistic whole, one in which the discrepancies themselves form the primary attraction, such as that seen in Pablo Picasso's appropriation of African masks and designs into European art in the early twentieth century. Magical realism packages the 'inexplicable' and supposedly unmediated (the 'natural') to make it consumable. The disjunction in postrevolutionary Mexico between pre-Columbian historical and cultural tradition, modern European ideas (among them Surrealism itself), and a pact with mass consumption on an international level falls squarely into the category of the criteria suggested by Fredric Jameson as basic to the production of magical realism. Jameson accurately proposes that magical realism "depends on a content which betrays the overlap or the coexistence of precapitalist with nascent capitalist or technological features."[24] In the case of Mexico, the pre-Columbian past—which was generally just as remote to the early-twentieth-century citizen as European fashion trends or North Ameri-

can advanced technology—is frequently foisted on the society in bits and pieces through the mass media by a state eager to present a modern national identity with clearly homogeneous cultural antecedents and goals. The corpus[25] of Kahlo's art may thus be interpreted in terms of her consciousness of being caught in just such a bind: as a Mexican, as a woman, and as a physical 'victim' trapped between co-existing technology (science, medicine, cinema, the 'developed' countries) and tradition (Mexico, superstition, the *ex-voto* [votive offering], native handicrafts); between the everyday presence of "la pelona" [bare-boned death] and a world in which it is slowly being recognized "how much harder it has become in advanced industrial societies to come to terms with death."[26] The lines separating life and death are tenuous at best—in the annual rituals celebrated at family cemetery plots on the Day of the Dead, for instance—they have become even more blurred as a result of the intervention of medical technology, making death itself clinical and impersonal.

Given all these historical and cultural factors, the next step is to move ahead with the consideration of Frida Kahlo's construction of an autobiographical discourse—both as the representation of an individual and as an image of the society reflected back on it—which grants her status as part of objective reality, not merely an isolated subjective voice of pain. Her self-portraits of the 1930s and 1940s are particularly revealing since they were produced during a time when Mexican society was beginning to lose its 'revolutionary' vision of the masses (in the media, in national projects, in economic policy) and was turning instead to cultivating the individual bourgeois personality through the movie star network, with its wide-screen projection of illusions for vicarious social fulfillment. Somewhere amid the rapid rise of film stars like Emilio (*El Indio*) Fernández, Mario Moreno (*Cantinflas*), María Félix, and Dolores del Río lie the painted portraits of Frida Kahlo. And, like film images themselves, Kahlo's self-portraits utilize and play on consumer society's reification of the face as the icon of feminine beauty—suggested by cinematic close-ups juxtaposed with nationalist epic long-shots—explicitly to draw the observer into the game of seduction by surface appearance. The mask, whether literal or figurative, covers the 'shadowy' space behind it, which is composed of an uncharted and unconquered terrain that she

suggestively exploits and explodes. This tantalizing lure of the 'exotic' or the Other is represented by Kahlo through the cracks and fissures in the mask that promise insight or revelation but that neither exhaust nor ever completely reveal, leaving intact a certain element of the unknown—a 13 Hollywood-type mystique, as it were—after the viewer's gaze has been enticed to draw nearer. On this surface, then, Kahlo unites cultural and individual fantasies of knowledge/self-knowledge in one problematic space of attraction and concealment (masquerade) in a perpetual cycle of gaze and countergaze. Her self-portraits reproduce this point of confrontation and re-evoke its enticing closure with only the cracks for the observer to peer voyeuristically through, perhaps simultaneously conjuring up an image of the outsider's looking at Mexico through the spaces of the so-called *cortina de nopal* [cactus curtain].

Apocalypse and Rebirth: Pain as a Filter for the Observation of Reality

While the English Romantic writer Samuel Taylor Coleridge may seem to have very little in common with the Mexican artist Frida Kahlo, nevertheless one may establish a strong connection between them on a very basic level: between Coleridge as the almost-lifelong sufferer of chronic rheumatism in the English Lake District and Kahlo as a long-term victim of a trolley and bus accident as well as of childhood polio and what was later diagnosed as congenital scoliosis. Both experienced a physical 'apocalypse' of a sort that had an effect on their subsequent artistic production (much as Mexico suffered the consequences of the apocalyptic moment of revolution). Coleridge even theorizes in his essays about the relationship between illness, creation, and the drug addiction that his pursuit of a painkiller eventually caused, just as Kahlo suffers from the abuse of alcohol and morphine. In his correspondence, for example, Coleridge states that his suffering is, paradoxically, also a source of creation since it presents both mind and body with stimuli for speculation and meditation: "I shall look back on my long and painful Illness . . . as a Storehouse of wild Dreams for Poems, or intellectual Facts for metaphysical Speculation."[27] Taking this situation one step further, into the content of his notebooks and the well-known "Rime of the Ancient

Mariner," Richard Holmes has observed that after his critical experiences in the sea (of life?), "the Mariner becomes the traditional figure of the Wandering Jew who tells his story over and over." His "permanent role and duty within the human community [is to] make other people share everything he has undergone and learned through suffering. His tale [is] to *teach,* by a constantly repeated act of the imagination. . . . Chronology is immaterial here, for it is a note that, once struck in someone's life, will resound again and again."[28] Such a tale, told and retold, creates a pattern for both the sufferer (in the constant re-creation of the moments of confrontation with pain) and the observer (in the recognition of the Other's suffering at such moments). This pattern is somewhat reminiscent of the penitent or pilgrim whose journey entails repeated ritual traversing of the same geographical and psychological terrain.

The permanent wounds, both physical and psychological, of her accident and operations created for Frida Kahlo a "note that resounds again and again" in her art, through which she not only communicates her experiences to others in the "kingdom of the well" to "teach" them, via her own suffering, about the fragility and the essentially painful nature of life. She also engages in a dialogue with herself, involuntarily bound by the constraints of "the kingdom of the sick."[29] In the yearlong first round of recuperation from the accident, she began to become acutely aware of her body as part of a complex series of relationships with the surrounding social order, which it must resist in order to survive. Her painted and sketched bodies are not isolated objects. Rather, they are surrounded by *people* such as Rivera, her parents, her nurse, Dr. Eloesser, and others. They appear amid *things* such as factories, technology, buildings, furniture, scenes of Mexico, artifacts of industrial society, and articles of clothing. There are bodies accompanied by *animals* such as monkeys, hummingbirds, and dogs, or encircled by *nature* in the form of vines, jungles, clouds, leaves, and oceans, for example. (The 1938 *Self-Portrait with Monkey,* for instance, combines animal, vegetable, and mineral elements to frame Kahlo's face; nevertheless, she portrays herself here as enigmatic, a mystery surrounded by serpentine tropical foliage and a pet monkey.) The resistance to the social milieu by this painted body takes the form of a series of responses to external situations as well as a coming to terms with internally assimilated challenges, including the

"material, discursive, psychic, [and] sexual"[30] ones that Kahlo external-izes.[31] Her body, concurrently the theme and construct of this externaliz-ing process, assumes the role of a scenario for the shared spectacle of suffering.

When questioned by her family and others about the reality of the existence of her pain, Kahlo identifies herself completely with its various forms, thereby recognizing and defining her own part of the relationship with the 'outside,' which has both literally and figuratively invaded her body. In one of her letters she writes: "Así es que *yo* y nadie más que *yo* soy la que sufro" [So it is that *I* and no one else but *I* am the one who suffers].[32] This self-consciousness confirms and substantiates the quote taken from Dr. François-Bernard Michel (see text at note 8) in that Kahlo has extended the passive biological aspect of human existence to the active remembrance and consideration of human biological functions in the context of sexual activity *and* the ever-narrowing separation between life and death. It might even be concluded that Kahlo creates an aesthetic of pain in which eroticism and death, or suffering and pleasure, are as closely entwined as she and Rivera, or as she and nature, are represented in her paintings. To paraphrase, the painted 'Frida' suffers, therefore she *is*; and each time she conjures up another portrait of this pain she reaffirms that identity. In this aesthetic created out of physical and emotional death/eroticism, Kahlo appears to seek what Bataille calls an act of substitution wherein "the individual isolated discontinuity [is replaced with] a feeling of profound continuity."[33] The continuity or attempt at integration brings strong biological life functions in close proximity to the cessation of life (death)—or Kahlo in proximate fusion with Rivera—as elements of counteraction or transgression. This is particularly true after the 'apocalyptic' accident that, because of its violent nature and physically mutilating results, seems to draw together the functions of sex and life into the realm of death, or the instant of cessation of those functions. As Rivera himself admits, Kahlo is the first to paint herself, and earn a living at it, in what Carlos Monsiváis has called "un ambiente represivo y machista" [a repressive and male-dominated en-vironment],[34] as a woman publicly conscious of her *total* physical and psychological anatomy and the effects of her surroundings on it. She produces, Rivera declares, works of "la visceralidad femenina" [feminine

"viscerality"],[35] *insides* both literally and figuratively. To this basic signifi-
cation the dictionary adds the meaning of "sensitivity," as in what is felt
as part of one's own bodily experience, a particularly apropos image in
the case of Kahlo, whose physical tissues, or *tejidos,* are used also to
display the signs of emotional ravages.

Her projection of this pain exhibits a real as well as a metaphorical
sense. Obviously, the physical impediment exists. In addition, however, a
psychological impediment is created as a result of the 'bondage' to the
inactivity of physical suffering that also functions as a catalyst to the
imagination, because mental experience does not cease with the restric-
tion of active bodily experience. Kahlo seems to paint as an outlet for or
"antidote"[36] to her pain, exorcising it in objectified images of concrete
hurt as a survival tactic in her role as victim. The suffering image, or her
body as the icon for suffering, is narcissistic in its self-examination and
exhibition, yet it is also cathartic in its public display of self-affirmation.

This psychological aspect of objectified sacrifice or suffering is evi-
dent in the artist's consideration of the body and its reactions to the social
confrontation of nature versus culture. Perhaps the clearest instance is
the portrayal of her mental anguish when she realizes that neither
uninhibited sex (liberated nature) nor controlled technology (the Ford
Hospital in Detroit, the bone specialists in the United States, the plaster
corsets, spinal fusions, braces, and weights) offers her a satisfactory
answer to her physical pain. And neither gives her a solution to Rivera's
affairs (with the exception of the strangely self-reaffirming 'sacrificial'
aspect of her own affairs in revenge).[37] For Kahlo, the body is wedged
into the space between submitting itself to be an object of scientific study
and being a material, subjective entity of senses and perceptions.[38] The
eyes—being both observer and observed, looking outward yet into a
mirror—are always gazing at themselves, as does the artist for the
creation of her self-portrait, to discover the identity being presented to
the public and to look simultaneously at the observer, possibly attempt-
ing to analyze the reaction to their appearance or solicit complicity in the
consideration of this dilemma. These two opposing sides of nature/
culture, body/body-politic may also be understood as images of the
cultural opposition between the industrialized world of the United States
and that of Latin America (the 'Third World'). In this case, the paintings

that most explicitly reveal this dichotomy are her self-portrait of 1932 (1929?) on the border between Mexico and the United States, and *My Dress Hangs There* (1933), which is a collage of her native Tehuana costume juxtaposed with fractured remnants of the 'progress' of modern technological civilization. These vestiges include breadlines, telephones, toilets, piles of trash, smokestacks, fires, columns of soldiers, Manhattan Island, and the Statue of Liberty. The ambiguities of both the abandoned native costume (an *empty* tradition?) and the icons of modern civilization (the statue of 'Liberty' among the sacrifices of progress) are articulated clearly by the juxtaposition of these images, with no central figure in or through which to unite or reconcile them. Like the slippery concept of national unity, there seems to be no bedrock on which to foster the construction of cultural, political, or personal equilibrium.

17

Kahlo offers no romanticizing of the body, whether physical or social; there is no idealizing of any physical state or emotion of the kind Susan Sontag has studied in the nineteenth century's aesthetic of tuberculosis in Western culture. Rather, like Sontag's comparative examination of the cultural judgment of TB a century ago and her consideration of the modern scourge of cancer, she represents technology and science as vehicles for opening up, for opening what has been a closed wound, whether it be women's bodies, inner thoughts and feelings, or the social body.[39] This entering into and unfolding of the body is seen in Kahlo's work from, for instance, the lithograph *Frida and the Abortion* (1932) through *Remembrance of an Open Wound* (1938), *My Birth* (1932), *The Two Fridas* (1939), and *The Broken Column* (1944) to *Tree of Hope* (1946) and the still life *Viva la Vida* (1954), in which tropical fruits are sliced open and exposed for the viewer's visual consumption. These images range from the representation of the face as an opaque mask on a vulnerable torso, thereby showing the divorce between mental and physical processes; to the transparency of a defenseless body in a technological world that leaves no 'self' in reserve since it aims to penetrate and explore beyond the frontiers or boundaries of the external; and to the disintegration of form and identity into splintered pieces, ending in the weightlessness of a body slipping away from any interaction with objective reality. In this progressive series of images, Kahlo reflects her own last years of intensifying illness, which were filled with attempts to hold on to people,

political affiliations, and concrete things such as gifts, dolls, and souvenir jewelry from friends in order to maintain her grasp on the real world as she feels it escaping her. The series of still-life paintings from 1938 to 1954 can be viewed similarly as pieces of the world being brought to the invalid to maintain some sort of connection between the two, as a gradual transference of erotic life from a failing body to vibrant nature. It is with intense color that Kahlo reproduces and seems to *fix* in her own mind's eye these fragments of the sensual world around her that are brought to her bedside.

Because she is told by all the 'appropriate' and knowledgeable authorities that she has to abandon her body to suffering and pain, Kahlo seeks to transfer pieces of her 'self' to visible levels in her paintings, thereby reestablishing a social presence and identity.[40] Against the de-realization of the invalid, who lives and relives objects and events of the world wholly in nonobjectified mental images, and the dematerialization of the woman into an entity without social weight,[41] Kahlo reduces her subject matter to her own body. Elaine Scarry observes that "It is only when the body is comfortable, when it has ceased to be an obsessive object of perception and concern, that consciousness develops other objects" (p. 39). In the meantime, self-consciousness is the most immediate and crucial perception for the invalid. This is not only the visualized body on canvas, with all its recognizable detail; it is also the observer's body,[42] from which all else is seen and in terms of which all else is interpreted. One finds such an observer's perspective in *What the Water Gave Me* (1938 or 1939) and *My Dress Hangs There* (1933). In the first instance, the very absence of the body (except for the toes emerging from the bathwater) makes it the central focus of the painting, and the observer assumes Kahlo's own space/place, seeing those extremities of her body from the perspective of her own eyes, which are turned *away* from contact with the observer's eyes. Instead, they focus on a tubful of people and objects surrounding her toes. The bathtub becomes, then, a true receptacle for the "water of life," which brings her (gives her, according to the title of the painting, as if they were offerings being made to her) numerous and varied experiences, many of which are as painful as the fissured toes and contorted figures in the tub appear to be. In this painting, shipwrecked bodies, skeletons, her parents, dead birds, a sky-

scraper emerging from a volcano, her Tehuana dress, and strange flora all encircle the lacquered toenails of her feet, which appear to act as both anchors to reality and just another piece of flotsam in the dingy water. Rather than the celebration of a perfect body immersed in a luxurious bath, Kahlo presents the observer with a lifescape at low tide, one in which all the submerged obstacles rise to the surface to challenge the would-be navigator.

Kahlo's concentration on physical violence and mutilation in her work also confirms the presence of a body: suicide, blood, knife cuts, childbirth, and operations necessarily involve the existence of someone objectively real to experience such physical intervention and pain. Kahlo's possible suicide attempts, like those of Castellanos, can be interpreted as getting rid of the body as a weight or burden, either to the individual or to society. Conversely, the acts can be considered, albeit paradoxically, as proof to the social world that one actually physically exists (or, if successful, existed). While only an object of speculation, the suggestion that Kahlo demanded or submitted to more surgical procedures than absolutely necessary would seem to confirm her insistence on identifying herself with such visible and palpable validations of her existence. Her identity as victim or martyr (in voluntary submission to her own cause and to Rivera) could be prolonged and reconfirmed in this manner just as her self-portraits revolve around the same events and people in repeated cycles of 'narrativization.'

Kahlo limits the scope of the world around her to a narrowing circle of which she herself is the center within the physically restricted boundaries of her body. In addition, the majority of her self-portraits are done from the waist up, reflecting possibly a 'less-mutilated' view—something that seems out of character with her usual perspective—but also the most natural scope of perception for a prone invalid reproducing the images of her body from a mirror. One is reminded in particular of the mirrors suspended above her bed in Coyoacán during her frequent bouts of illness and recuperation. In focusing attention on the center of pain, either as source or recipient, her frail body does not cease to exist. Instead, it recovers a hyperexistence as the constant reminder of life/death/eroticism, in addition to being a form of compensation for the imposing physical bulk of Rivera. This self-reference should be viewed as an active

projection of the ego, not a passive self-contemplation. Stephen Bygrave
has written just such a judgment about Coleridge. He states: "In general,
'egoism' comes to refer to a passive state—thinking about oneself, where
'egotism' is active—talking about or asserting oneself."[43] Kahlo "asserts"
herself by painting; by emphasizing colors, costumes, jewelry, and hair-
styles; by using vulgar, 'earthy' language to counteract the social 'exile' of
her illness; and by calling on popular rather than academic traditions of
representation. The last include the disarticulated body parts of religious
ex-voto artifacts left by the suffering at altars as supplications for divine
intercession, multicolored painted ceramics from the Mexican state of
Michoacán, 'primitive' storytelling murals from the walls of *pulquerías*
and *cantinas* [lower-class bars], and the *calaveras* [skeletons] Posada used
as the basis for his political and social satires (Ilán Staváns, for instance,
refers to Posada as the "master of street art").[44] She 'discovers' herself just
as film stars are discovered, then projects her persona (in repeatable
popular images, in series, replete with identifiably illustrated frustra-
tions, desires, and illusions) out onto the public. In addition, her paint-
ings can even be considered visual images of 'vulgar' or 'earthy' topics—
specifically, female anatomy and bodily functions—usually relegated to
popular verbal, not visual, expression, if not extirpated from the lan-
guage altogether or enshrouded in euphemism.

Moreover, she exemplifies two facets of herself produced by the
trauma of the accident by creating two personas—"I" and "she," or
"Frida"—and two perspectives—"*the* world" and "*my* world"—that
reveal a detachment or distancing from certain aspects of herself, an act
that paradoxically helps her in simultaneously observing and closing in
on herself.[45] The creation of a split between the first and third persons
(I/she) seems to have begun around the time of the accident in her
discussions with Alejandro Gómez Arias about her perception of herself
compared to how she appears to others. To others' questioning of her
morals she replies, "little by little . . . between all of you I am being driven
crazy," "even if to you I am worth nothing, to myself I am worth more
than many girls," and "to myself, naturally, I am worth much more than
a *centavo* because I like myself the way I am."[46] She exhibits her cog-
nizance of being the victim of a double standard that causes a split
between two 'selves,' one public and one private (or by extension, one

male and one female? one socialized and one 'antisocial'?). Later on, her 'doubles' assist in dealing with her pain by permitting the subjective "I" to assume a more objective "she" stance and become part of the 'outside world' witnessing the body in pain. In the words of another woman who 21 has experienced such an 'apocalypse' or moment of revelation or comprehension, "We [those in pain] found that we had developed a similar method for dealing with pain. You externalize it, or, rather, you distance yourself from it and from the body which is experiencing the pain. In a sense, you become a listener, a remote, albeit interested, observer rather than a participant in your suffering. You almost literally levitate over the body, *studying it.*"[47] Kahlo does not escape from her body. Instead, she "studies it" by painting it as it 'levitates' above her in the mirror, with ever-increasing awareness and consciousness of its functions, from its origin at conception through its reactions to experiences of various types, many of them violent and reiterated throughout several paintings. The artist herself states, "Mi pintura lleva dentro el mensaje del dolor. . . . La pintura me completó la vida" [My painting carries within it the message of pain. . . . Painting made my life whole for me].[48]

Besides finding in it an opportunity for self-observation and the objective analysis of suffering, Kahlo uses painting to influence others. Just as the pilgrim uses the ex-voto to exact a miracle or to give thanks for one already performed and the filmmaker employs glossy promotional snapshots, Kahlo seems to paint her own suffering—the eyes, the spine, Rivera—as an instrument to influence the reaction of others and perhaps to find an element of healing or acceptance at the same time. The representation of the body thereby becomes a weapon to punish or self-punish, to evoke sympathy, or to reconcile lovers (in this case, both Gómez Arias and Rivera); she *uses* her image to seduce the public's gaze. One must ask, does Kahlo paint the portraits with short hair to make Rivera feel guilty (an unlikely result) or do they represent, as in the case of Sor Juana Inés de la Cruz, a social act to punish herself for what she sees as an individual fault?[49] Does Kahlo *use* an unspoken but intimated identification with the self-inflicted martyrdom of the young Sor Juana to express some kind of public repentance or visible reflection of her grief (guilt)? When used to repay favors or debts, or to fulfill commissions to buyers and collectors, such as Edward G. Robinson, her art becomes the

representation of the consumption of pain as a salable product in society. In a way, the consumers of her paintings become part of her 'self' because she appears to have them in mind as she works. Kahlo may even paint what she thinks they may *want* to see, since she seems to be very aware of what people expect of her. One result is the reification of her own image into a repeated series of self-portraits whose forthright gaze is consumed as a recognizable commodity by the public. In her essay called "Retrato de Diego" [Portrait of Diego] for the Mexican daily newspaper *Novedades* of July 17, 1955, she reveals this consciousness of the social 'self' as a construct represented in her paintings, and she discusses its origins in her relationship with Rivera.

Autobiography and Self-Portrait: Images of the Self, Images of the Other

Kahlo's obsession with telling about herself—in both a confrontation with her own internal psychological aspects and an external dialogue (really a monologue) with the observer—is a process of self-analysis akin to Freud's "talking cure." For her, painting served as therapy, allowing her a vehicle for creating images from these confrontations to form a visual 'narrative' version of her own history, past as well as present, that in the process of retelling takes on elements of art, imagination, and invention. Kahlo's self-portraits are the plastic arts' version of the autobiography in which, in the words of Juan García Ponce, "La acción de ver nos entrega a su vez la mirada de la pintura" [The act of seeing hands over to us in turn the gaze of the painting] in a reciprocal relationship ("Diversidad de actitudes," p. 151). Paul de Man makes clear the terms one must use to interpret the product of such a process of continually creating the 'self' in the act of representation when he states that the subject of autobiography is not an objective fact but "a textual production" (p. 18). Although de Man is speaking of written autobiographies, Kahlo's visual autobiographies, her self-portraits, may be considered in similar terms. In place of words she uses space, line, and color to present her images. Rather than finding in Kahlo's artistic production a "developmental autobiography"[50] of psychological moments of conflict leading to resolution, she presents us with a permanent lack of equilibrium.

Within the enclosed space of the frame and sometimes spilling over onto it are images that serve as a constant reminder of wounds to be confronted and opened up for reexamination: her physical appearance, her family heritage, the roots of modern Mexico, motherhood, death, Rivera. The lines are simplified and recognizable in the repetition of stylized forms. The colors are reminiscent of the bold transparency and clarity of Mexican murals or popular art forms, and they are frequently used with symbolic intent[51] to create a series of emotional states experienced again and again like recurring 'apocalypses,' conjuring up and reproducing moments of revelation or of a confrontation between life and death.

She is literally "all eyes,"[52] especially as she nears death, to make up for the waning of the connection between her mind and her body, and between her body and the world. Between 1943 and 1949, Rivera also appeared in her 'mind's eye' as an (elusive?) object of obsession/possession as well as the Other, in whom she still tries to find her own identity. These images of Rivera appear in the paintings *Self-Portrait as a Tehuana* and *Diego and I,* in which the two are always connected, in mind if not in body. She also included in the paintings from her last years a third eye embodying what appears to be a special sensitivity toward life and a consciousness of omnipresent death since in at least one instance its space is filled by the form of a skull. This eye offers a site for looking inward as well as outward; it appears to act as a mirror for images of most concern to the 'Frida' portrayed. References to such an added dimension of perception can be seen in *Thinking About Death* (1943), *Sun and Life* (1947), and *The Love Embrace of the Universe, the Earth (Mexico), Diego, Me and Señor Xólotl* (1949), in which her forehead contains this extra organ of mystic origin to focus on the world and on herself. Considering her explicit interest all along in her country's social and cultural development, could this turn in the 1940s and early 1950s toward an added dimension of observation (the third eye) signal a need for the same by Presidents Manuel Avila Camacho (1940–1946) and Miguel Alemán (1946–1952) and those in charge of deciding Mexico's future direction? It seems at least possible if not highly likely that Kahlo's increasing concentration on myth, nature, cosmic forces, and popular tradition as sources of healing power may indicate a turn away from medicine and technology as answers to mental and physical suffering (moving in the

opposite direction from post-Cárdenas Mexico, which began a reorienta-
tion toward foreign capital and technology as solutions to social ills). Her
search for a more philosophical or spiritual answer to her concerns—
24 vaguely reminiscent of the prescription of fraternal love proposed by
Vasconcelos—includes a consideration of the doctrines of Marxism as
witnessed by the painting *El marxismo dará salud a los enfermos* [Marxism
Will Give Health to the Sick] (ca. 1954), which personalizes the effects
and goals of an egalitarian political doctrine during a time when the
Alemán government was leaving behind the romantic ideals and reforms
of the Revolution (and the populist Cárdenas) in favor of industrializa-
tion, bourgeois capitalism, and a turn toward private interests. The
painting also reduces this social and political theory to its individual
proponents as cult figures who seem to be conjured up as social and
spiritual 'healers.' One must begin to wonder at this point, then, whether
Kahlo's third eye was really capable of seeing in all these directions at
once and whether she sensed that she was becoming something akin to a
martyr to a past era, caught between the celebration of the individual
subject of 'stardom' and the defense of collective utopian revolutionary
ideals.

As with the process of the reduction of the world to her body, Kahlo
also selected a series of details to create her own meta-language in the
construction of her portraits. In her personal form of an ego cult, native
Tehuana costumes, tears, eyebrows transformed into birds' wings, skel-
etons, fetuses, hair ribbons, tropical flora and fauna, and the splitting or
doubling of her own image are the recognizable and recurring elements
of her artistic universe. Together they give her a very visible, concrete
existence in such a universe, just as the "monstruos sagrados" [blockbus-
ter stars] of the film industry present their public personas, which
embody social aspirations recognized by the audience and relentlessly
promoted by the culture industry.[53] She may sometimes appear to be just
part of nature, but Kahlo never disappears completely into it. These
details distinguish the artist from her surroundings and emphasize
Kahlo's desire for the indigenous or the 'exotic' as a distancing and
defining mechanism. The native costume from Tehuantepec gives her an
identity as the exotic Other in the urban center of her own country, as
well as in New York and Paris, where she was photographed by Nickolas

Muray and touted by André Breton as the living embodiment of a Surrealist vision. For Kahlo and Rivera, however, the act was a declaration of solidarity with traditional Mexico, one that followed in the footsteps of nationalist actions such as the 1938 petroleum expropriation 25 by Cárdenas. For Mexico City it signaled a connection with the lush tropical foliage and fertility of the isthmus, creating an elision of that myth with Frida Kahlo's appearance. But it was also the image of a recognizable national tradition in the face of a changing world of social, political, and economic modernization. This vision is present as well in the Rivera and Siqueiros murals depicting engines, turbines, microscopes, weapons, and the destruction of war. When Rivera included women dressed as Tehuanas in his Ministry of Education or National Palace murals, he did so to align himself with the masses through the traditional garb of indigenous Mexican cultures and to distance himself (paradoxically, given his formal training) from the colonializing or Europeanizing elements implied by those in more modern ('progressive') Western dress. (In the National Palace frescoes, for instance, a steady undercurrent of indigenous culture is represented in the series of panels spanning the ages from the Conquest to the present. At the base of each section is a monochrome panel containing scenes of indigenous cultures by region—the Huastecas, Zapotecas, Totonacas, for example—with Frida Kahlo and her sister Cristina incorporated into the superior portion of the murals in roles ranging from peasant woman to revolutionary activist.)

As Janet A. Kaplan points out in her recent study of artist Remedios Varo's life and art, there were essentially two artistic communities in Mexico in the 1930s and 1940s.[54] These consisted of, first, the Europeanist-Surrealist group, which includes Varo (a Spanish exile), Kati Horna (from Hungary), Leonora Carrington, Gunther Gerszo, and others. The opposing camp, which scoffed at the 'foreign' tendencies of the first group, revolved around Rivera, Kahlo, Orozco, and the whole nationalist concept of the *muralistas* [mural painters]. Kaplan concludes that "well into the 1940's the relationship between the groups remained strained" and that "Varo and her friends remained essentially apart, creating a community of their own."[55] In this context the Tehuana costume embodies a public statement of allegiance and opposition. In the post–World

War II realignment of cultural and economic values in Mexico, Kahlo's adorned and ornamented persona made a bold statement about her political and artistic ties to popular national tradition instead of throwing in her lot with Varo and the rest of the Surrealists. It is quite interesting to note that in 1990, after President Salinas discussed a free-trade pact with the United States, a number of middle-class women were seen on the streets of Mexico City in Tehuana dress in opposition to the government's attempt to 'polyesterize' the population. In addition, both the popular cult figure Madonna and the international world of high fashion have recently espoused Kahlo's conscious self-adornment as 'costuming' at its best and as an exemplary vehicle of character assertion for the late-twentieth-century woman.[56]

What characterizes a good number of Kahlo's paintings is her search for identity and self-definition in terms of oppositions or Others. In the often violent confrontation between men and women as seen in *A Few Small Nips* (1935), between Europe and America, or between Kahlo and Rivera, stasis appears as only momentary; all life seems to be composed instead of identities in transition, like Mexican society itself. A parallel may be drawn between her androgynous descriptions and portraits of the figure of Rivera (the embodiment of opposing characteristics and attributes) and her own symbolic social transgression of assuming male attire—a male persona—for an earlier family photograph. The male and female often seem to blur in Kahlo's work. Just as life and death confirm the existence of each other, Rivera and Kahlo dynamically complement and oppose one another in her art, embodying the contrasts of child/adult, heavy/light, young/old, and well/ill to create an almost mythical relationship of attraction and repulsion. In *Diego and Frida 1929–1944* and *The Love Embrace of the Universe . . .* (1949) this fusing of opposites is presented on several levels: Kahlo and Rivera, the sun and the moon, day and night, the earth and the heavens, life and death. In each of these examples, there is a tension in color or tone (light/dark), shape, and line between forces that Kahlo represents in words in her "Retrato de Diego" [Portrait of Diego] in *Novedades*. Here, she addresses the notions of the readers directly with regard to an assessment of her relationship with Rivera. She affirms, "Quizá esperen oír de mí lamentos de 'lo mucho que sufre' viviendo con un hombre como Diego. Pero yo no

26

creo que las márgenes de un río sufran por dejarlo correr, ni la tierra
sufra porque llueve, ni el átomo sufra descargando su energía. . . . Para
mí, todo tiene una compenetración natural. Dentro de mi papel, difícil y
obscuro, de aliada de un ser extraordinario, tengo la recompensa que 27
tiene un punto verde dentro de una cantidad de rojo: recompensa de
equilibrio" [Maybe they hope to hear laments from me about 'how much
she suffers' living with a man like Diego. But I don't think that the banks
of a river suffer because they let it flow, nor does the earth suffer because
it rains, nor does the atom suffer in giving off its energy. . . . For me,
everything has a natural mixing together. Within my role, both difficult
and obscure, as an ally of an extraordinary being, I have the compensa-
tion that a green dot has within a quantity of red: the compensation of
equilibrium].[57] The 'compensation' seems to be her visibility, both in
space (the dot or circle on a contrasting field) and in color (red against
green), where the opposing forces between the mass of one color and the
pinpoint of the other are aware of the other's existence, but they do not
annihilate one another in a permanent mixture of the two. Size is not the
issue either, because the green dot can obviously hold its own against
the mass of red. In return for an association with the red, green—the
opposite or the Other—receives its existence and identity within but
separate from the surrounding "quantity of red." The two somehow
balance each other. Knowing that this "Portrait of Diego" and, by
extension really of herself at the same time, was written during the last
years of her life indicates that Kahlo apparently simplified into this very
concise image the struggles of a lifetime in relation to her own self-
portrait as Rivera's Other. This time her words complement the painted
images of her double portraits in addition to the fairly large number of
photographic portraits of Kahlo and Rivera together.

But the paintings of Rivera and herself that she completed during
the preceding years, as well as those of her own 'doubles,' all reflect
varying facets of this same dynamic tension. Kahlo often seems to
observe herself as an object, not a subject, experiencing a detached
consciousness of her own persona. 'Frida,' with her unblinking gaze,
swirling hair, joined eyebrows, and tortured body, becomes the public
identity of the real woman Frida Kahlo, much as her beloved Mexico
reduces and institutionalizes the Revolution into icons for mass identi-

fication and consumption. In writing of the social views underlying women's judgment of themselves in modern society, John Berger comments that the early-twentieth-century woman "was always accompanied—except when she was quite alone—by her own image of herself. Whilst she was walking across a room or whilst she was weeping at the death of her father, she could not avoid envisaging herself walking or weeping. From earliest childhood she had been taught and persuaded to survey herself continually. And so she came to consider the surveyor and the surveyed within her as the two constituent yet always distinct elements of her identity as a woman."[58] This public and private split, created and fostered by the nascent mass media and developing capitalist culture industry, can also be seen to characterize Kahlo's visual doubling of her 'self.' She acts and simultaneously perceives herself acting; she paints and describes the process of painting through her product; she feels pain and watches herself react. More than anything, this simultaneous activity and commentary remind the observer of metafictional narrative in European and American literature during the past two decades. In the case of the novel, the medium is obviously language; in painting, it is pigment, tone, line, color, composition, and so on, leading to the construction of the image of the face/mask in the portrait. The *process* of combining elements, whether they be verbal or visual, forms an intrinsic part of the commentary by the final composition. But the ultimate force maintaining the division between public and private, between individual desires and social constraints, between Frida Kahlo as "I" and as "she," belongs to capitalism (as Herbert Marcuse clearly showed in his classic work *Eros and Civilization*).

It is precisely in the examination of this separation or split between conflicting and mutually unassimilable aspects of herself that one becomes aware of Kahlo's art as a response, whether conscious or unconscious, to philosophical and cultural concepts promoted during these years by liberal Mexican intellectuals such as José Vasconcelos. In her constant search for a lost utopia without pain, suffering, or mutilation, Kahlo's passionate desire to attain the paradise of a complete mental and physical body reflects the parallel search in Mexico for a utopian social body after the Revolution. This pursuit takes her through her own past and concurrently through that of Mexico, much as Vasconcelos promotes

redemption or regeneration through culture and pedagogy (education about the past and present). But in Kahlo's journey, history is seen as the inexorable passage of time that brings with it the destruction of the utopias of childhood, health, harmony, justice, and other qualities. Kahlo's search leads her to examine the other inhabitants of Mexico, native Indian culture, the medical profession, the United States, Marx, Trotsky, Rivera, and Stalin (in her *Frida and Stalin* [1954], the unfinished portrait left on her easel, on exhibit in the Kahlo Museum). In particular, in the five works *My Nurse and I, The Two Fridas, What the Water Gave Me, Two Nudes in a Forest*, and *The Love Embrace of the Universe* . . . Kahlo presents the observer with a cosmology whose confrontation between European and American components directly exposes the painter's own identity as a paradox of cultural fragmentation, not assimilation. This vision directly contradicts Vasconcelos' proposals for the Latin American continent's historical mission as the birthplace of a "fusión sincera y cordial de todas las razas" [sincere and cordial fusion of all races] in a "quinta raza universal, . . . [la] superación de todo lo pasado" [fifth universal race . . . the surpassing of all the past].[59] The idealized harmony imagined by Vasconcelos, with its evolutionary weeding-out of what he terms the 'ugly' or 'imperfect' traits of the races, would eliminate the elements in dynamic tension that form the basis of Kahlo's work. While Vasconcelos dwells on the common points of intersection and utopian homogeneity among the components, Kahlo's art flourishes on the borderlines, in the spaces of contention and opposition among races, cultures, and genders. Harmony, balance, and equilibrium are as tenuous as the drop of green in the field of red—at any time, one element of the formula may overrun the other (provoking the equivalent of, for example, tears, empty dresses, and broken dolls). After all, even a pinpoint of green can muddy a pure field of red.

29

Vasconcelos' idea of a liberal utopia is founded on the principles of education and economic well-being to forge ahead toward a goal of beauty, freedom, and global social concord.[60] His theory rests on the promise of a universal *spirit* setting the *material* free. Since Vasconcelos regards the surrounding environment, which had been an impediment to this evolutionary process, as having been 'liberated' by the Revolution, his ideas express his faith in nature or the 'natural' state of things, when

not repressed by society, as the redeeming factor for progress toward the goals outlined by the economic and philosophical theorists. In the essays contained in *The Cosmic Race,* he describes the utopian freeing of such a 'natural' sense of aesthetics in the following terms: "La pobreza, la educación defectuosa, la escasez de tipos bellos, la miseria que vuelve a la gente fea, todas estas calamidades desaparecerán del estado social futuro" [Poverty, defective education, the scarcity of perfect models, the misery that turns people ugly, all these calamities will disappear from the future social state] (p. 41). In the meantime, in the current phase of the formative process of such a future 'universal human being,' he proposes the mestizo, or racially mixed descendent of several cultures, as the genuine and optimum expression of Latin American reality. Such an individual exemplifies the desired tradition of a complete fusion or peaceful conciliation of cultures. The art critic Francisco Stastny summarizes the historical conditions that give rise to this theory and their influence on artists such as Rivera who return from an education in the European aesthetic to confront their own realities in the Americas:[61]

> Aguijoneados en su orgullo nacional por la marea ascendente de los nacionalismos europeos de los años 20 y 30, y sobre todo inquietados por una duradera crisis de identidad, los pensadores . . . [propusieron] un esquema . . . que aspiraba a abarcar la totalidad de la realidad étnica, cultural y social del continente americano y cuyo producto 'mestizo' habría de ser . . . la auténtica expresión de los pueblos del Nuevo Mundo. Este esquema liberador enunciado bajo diversas formas . . . por escritores de la talla de José Vasconcelos y J. C. Mariátegui, pronto encontró acogida. . . . El rostro mestizo de América sería, según esta nueva doctrina mesiánica, el que los nuevos lectores del inca Garcilaso de la Vega—hijo ilegítimo de un capitán español y de una ñusta incaica—proyectaron mentalmente al esforzarse por imaginar el aspecto de ese escritor solitario de quien significativamente no ha quedado ningún retrato.

> [Pricked in their national pride by the rising tide of European nationalism in the 1920s and 1930s, and above all disturbed by a lasting crisis of identity, the intellectuals . . . {proposed} a scheme . . . that aspired to embrace the totality of the ethnic, cultural, and social reality of the American continent and whose mestizo product was to be . . . the authentic expression of the peoples of the New World. This liberating plan stated under diverse guises . . . by writers of the stature of

José Vasconcelos and J. C. Mariátegui, soon found acceptance. . . . The
mestizo countenance of America would be, according to this new
messianic doctrine, the one that the new readers of the Inca Garcilaso
de la Vega—the illegitimate son of a Spanish captain and an Inca
woman—projected mentally in trying to imagine the appearance of
that solitary writer of whom, significantly, there remains no por-
trait.][62]

31

In reaction to the European cultures' search for their own national
identities, the intellectual search for such an image of the American
mestizo leads, on the one hand, to Peruvian painter José Sabogal's
representing Garcilaso "con el rostro dividido por la mitad en dos
secciones: un lado español de color claro y el otro indio, de color cobrizo.
Extrañamente esta solución repite la superposición de estilos de la ar-
quitectura cuzqueña y es, en buena cuenta, una negación del mestizaje.
Dos medios rostros distintos no crean una faz humana" [with his face
divided down the middle into two sections: a Spanish side of pale hue
and the other a copper-colored Indian. This solution strangely repeats
the superimposing of styles seen in the architecture of the city of Cuzco
and it is, in large part, a denial of the hybrid of the *mestizaje*. Two
different halves do not create a {whole} human face].[63] On the other
hand, the confrontation of cultures allows Kahlo the opportunity to use
and extend this same image to two bodies such as are represented in her
five works *Two Nudes in a Forest, The Two Fridas, My Nurse and I, La
tierra misma* [The Earth Itself] (1939), and *What the Water Gave Me* in
order to observe and analyze these irreconcilable factions within herself
and her culture in the turbulent coexistence of cultural imposition, which
Stastny has already identified in Sabogal's work. Through the use of
juxtaposed dark- and light-skinned figures, identifiably different ethnic
clothing and hairstyles, and the contrasting manners of the two Fridas
(one is seated for a 'proper' portrait, one is less formal; elsewhere one
consoles or comforts the other in the middle of a lush tropical environ-
ment), Kahlo attempts to recover the native aspect of culture, like her
own green "dot" buried under the European conquest's "quantity of
red." She thus translates her own divided self into a singular personal
reflection of the paradoxes of the culture around her, and vice versa in the
case of *My Dress Hangs There,* in which the empty dress forms part of the

surrounding elements. The two aspects never fuse, as Vasconcelos fervently wishes, into one whole, complete, harmonious body.[64] And because economic and geographical divisions in Latin America isolate the Europeans in the protected cities and "la naturaleza queda para el indio y el negro" [nature is left for the Indian and the black],[65] it follows quite logically that Kahlo should place her American 'self' amid vines, roots, leaves, jungles, and animals. Her indigenous identity forms part of nature, and as an Indian she is never quite 'integrated' into the city, just as many of her fellow citizens are not, even as the twentieth-century Latin American metropolis grows at astounding rates with increasingly alienated inhabitants. On the other hand, her scenes of cities include images of alienation and suffering such as an *empty,* or uninhabited, Tehuana dress, a suicide, and a European Frida with an open heart and a bleeding artery. Her own slow but steady suffering seems to echo that of Mexico, which reconfirms itself in daily confrontations. Consequently, the idealized mestizaje does not result, for Kahlo at least, in a symbiotic relationship but is revealed instead as two separate parts of society and two distinct aspects of her own self-portrait. Once again, tension triumphs over reconciliation.

In the partly subconscious process of opening up the discrepancies in the superficial harmony of the "cosmic race," Kahlo also exhibits an appreciation of and fascination with popular native arts and culture as expressions of a national (as well as personal) identity. She can thereby be identified with those who, after the Revolution, looked for Mexican authenticity in "lo que todavía no estaba contaminado por la cultura de Occidente" [whatever was still not contaminated by Western culture],[66] although she is acutely aware of what 'sells' in Europe and North America. It is by this very consciousness of herself as the product of such divisive and, apparently for her, irreconcilable traditions that the style and content of her work in general must be judged. Not to do so would be to fail to see her in the context of the times and of her own psychological reality as a reaction to those circumstances. Those who might be tempted to classify Kahlo as a Surrealist are one example. As Hayden Herrera notes in her use of Kahlo's own words about the subject: "They thought I was a Surrealist, but I wasn't. I never painted dreams. I painted my own reality."[67] This statement by the artist is a good point of

departure for orienting her production, not because she denies the affiliation but because her mention of dreams as opposed to reality is central to accuracy in this evaluation. One must therefore study more specifically just what forms Kahlo's split vision of those cultures trans- 33
lates into in her art.

Franz Roh, a German art critic who coined the term *magic realism* in the visual arts, defines the difference between that point of view and the Surrealists' as one of strangeness (*estrangement*) versus annihilation. He contends that "While Magic Realism turned daily life into eerie form, Surrealism . . . set out to smash our existing world completely. . . . [It] constructed a new world, a world never seen before."[68] The difference between the two ideas seems to be one of perception and effect, an idea confirmed by both the Cuban writer Alejo Carpentier[69] and the Argentine critic Enrique Anderson-Imbert. The latter agrees with Roh's description of paintings of "objetos ordinarios . . . [vistos] con ojos maravillados. . . . [Los artistas] contemplaban el mundo como si acabara de resurgir de la nada. . . . Después del fantástico Apocalipsis, [ellos] veían las cosas envueltas en la luz matinal, inocente, de un segundo Génesis" [Ordinary objects . . . {seen} with eyes of wonder. . . . {The artists} contemplated the world as if it had just arisen from out of nothingness. . . . After the fantastic Apocalypse, {they} saw things enveloped in the innocent light of the dawn of a second Genesis].[70] This would characterize what already has been said of Kahlo, that is to say, her 'apocalyptic moment' of the accident is a catalyst to stimulate a metamorphosis in her perspective toward the familiar objects of the world. The world itself is not destroyed and reborn, but she is, and the "innocence" of her vision is not naïveté, since she has already experienced the violence and fragility of life. Instead, her vision contains a simplicity and clarity of consciousness, a "singular revelation" as Carpentier puts it. This is not at all what Roh calls the Surrealists' "demonic vision," which would seek to explode or annihilate the world of that experience (p. 84). Nor does Kahlo offer an alternative world, as did the Surrealists; she is definitely obsessed with the existing one and is pursued by certain images of her own identity within it. This last fact again links her paintings with "magic realism" in the presentation of the human subject as essentially "problematic"[71] or an enigmatic "mystery"[72] to be probed and explored

34

amid the situations and objects of everyday life. Once again an element of contradiction is introduced into the visible harmony of relations between human beings, and also between the facets of one's own personality. The enigma of her own body in both its physical and psychological dimensions is projected outward on the external world as well as serving as a mirror of society's problematic dreams and illusions (of social integration, harmony, progress, and health, for example). There is no annihilation or infernal destruction of the objective world in Kahlo's works; their components are, if anything, all too recognizable even if reproduced and recombined in very personal schemas.

Kahlo's fundamental perception of the tension in what Jameson calls "the articulated superposition of whole layers of the past within the present" (p. 311) strengthens the argument of a consideration of her works in terms of magical realism. As Weisgerber writes, magical realism's practitioners "se situent de préférence en fonction du passé et du présent" [situate themselves by preference in terms of the past and the present] (p. 7); they do not propose radical future alternatives. Kahlo's paintings portray and uncover elements of her past, of the historical past, and of the synchronic coexistence of what Jameson has defined (see text at note 24) as more primitive, "precapitalist" levels of society alongside nascent technological capitalism. In her images Kahlo is concurrently fetus, child, and adult; Mexico appears as pre-Columbian and postrevolutionary at the same moment. Given the simultaneous rise of photography to power and popularity beginning in the 1920s, one is reminded of Pierre Mac Orlan's theory of the "social fantastic" in the evocation by documentary photographs of scenarios of social displacement, in which he calls on the camera's ability to evoke and record moments of confrontation between the modernizing tendencies of the present and lingering survivals of a simpler past. Christopher Phillips writes that Mac Orlan "found in photography a perfect vehicle for exploring what he called the 'social fantastic'—that realm created when deeply rooted ways of life were jarringly displaced by an emerging machine civilization."[73] This would predispose documentary photography—and perhaps documentary-oriented arts in general—to play the role of re-estranging a world that its inhabitants have become used to and which they no longer view critically. By layering contrasting economic and historical epochs in

the same frame, both Kahlo and the photographer break the facile, passive gaze of the viewer who (unconsciously?) may wish to re-create his or her own deproblematized relationship with society in the object on display. In other words, photographic or other visual images may evoke the ideologically hidden (masked) or repressed realities of economic, ethnic, gender, or class discrimination that are obscured in daily life. Whether termed "magical" or "fantastic," this realism is jarring, sometimes repulsive, and the observer often simply dismisses it as the intrinsic exoticism of a culture rather than critically examining it.

35

Undoubtedly, some of the best sources to observe these simultaneous "survivals" in Kahlo's works are *Los cuatro habitantes de la ciudad de México* [Four Inhabitants of Mexico City] (1938) and *El camión* [The Bus] (1929 or 1932). In the first, a young Indian girl in the plaza of a quite ordinary town is surrounded by a pre-Columbian fertility statue, a skeleton, a straw figure typical of native artisans, and a worker wired for electricity from head to toe. All encounter each other in the *zócalo* [central square or plaza], the pivotal public space around which, according to Hispanic tradition, all cities are built. *El camión* depicts a simple (although not "innocent," because of its connotation for Kahlo after the accident) wooden vehicle of transportation from the country to the city, which is glimpsed through the bus windows in the background. It carries a load of passengers who represent a microcosm of Mexico, especially in the contrast of (cultural and economic) worlds between the barefoot rural Indian woman and the stylish urban professional woman seated in proximity to each other. Again, these superimposed layers of past and present, of tradition and progress, find form in individuals whose daily lives converge in the public space of urban mass transportation. In the years intervening between *El camión* and *Los cuatro habitantes,* the anomalies ("survivals") have increased in size and position. From a static, almost artificially tranquil coexistence between social classes in the first case—the Indian woman with a shawl, the worker in overalls, the middle-class housewife, the dignified man and woman in modern dress—Kahlo moved to a foregrounding of more symbolic figures. Among them sits a young Indian or mestiza girl with a wide-eyed, questioning look, sucking on her fingers. As interest in Cárdenas' liberal social projects waned, especially between 1938 and 1940, did she repre-

sent the country itself as being at a crossroads, bewildered when faced with such formidable and divergent options? Did her diminutive stature signal yet another displacement, since in her book Zamora indicates that the painting's alternate title (or subtitle) is "The Plaza is *Theirs*" (my emphasis)? Is the young girl (and perhaps Kahlo herself) merely an onlooker who cannot find a way to 'fit into' the society she observes?

In *Self-Portrait on the Borderline*, from about 1932, which places it somewhere between *El Camión* and *Los cuatro habitantes* and produced during a stay with Rivera in the United States, Kahlo's own image is perched between the/her cultural past linked with the land, and the man-made inventions of the twentieth century, rapidly encroaching on the border. She also exposes the strata of a very simple and poor remnant of the past in *My Nurse and I*, *The Deceased Dimas*, and *Tree of Hope*, the last of which shows a victim on a modern hospital operating table baring her lacerated back to a twentieth-century Tehuana in native costume. Kahlo's visions of the "superposition" of these layers in her society do not give evidence of the salvation of the worker by industry, progress, and technology, as seen and sometimes parodied in Rivera's murals. On the contrary, her own accident, which seemed to stimulate her awareness of all of these elements, can even be viewed as representing the clash between technology (the new electric trolley) and precapitalist Mexico (the handmade wooden bus), between mass culture and the pull of traditional social structures. The multicultural images do, in any case, serve to disclose the enormous difficulty of sorting out one's place and identity in such a changing historical reality. In fact, Kahlo's portraits can be considered as repeated sequences of martyrdom to the multiple aspects of that reality, from the disarticulated body/body-politic to the offers of hope and salvation through either medicine (radical surgical alternatives) or fusion with the spirit of the masses (the individual body as part of the collective body). In 'Frida' they intersect; her centered countenance is used to show the victim/beneficiary of them all.

2. Rosario Castellanos and the Confessions of Literary Journalism

Situating the Essays:
The Private Goes Public

Quite a bit of criticism has been written in the last decade or so about Rosario Castellanos' poetry, novels, and short stories, including analyses of characters, language and poetic form, feminist or protofeminist ideas, *indigenismo,* patriarchal social structures, and possible autobiographical aspects of the texts.[1] The versatile Castellanos also practiced another genre, however, which has generally been omitted from discussion or glossed over briefly, only hinting at its potential richness of information. This is the essay.[2] Castellanos' short prose pieces, many of which appeared as articles in the Mexico City newspaper *Excélsior* between 1963 and 1974, form an insightful counterpoint to the corpus of Castellanos' poetry and fictional writings. For the most part, the essays touch on themes similar to those the author develops elsewhere—male-female relations, indigenous culture, motherhood, women writers, friendship and love, families, academia, and the ambiguous heritage of the Mexican Revolution—while simultaneously revealing some of the ideological underpinnings of those other works. Moreover, the articles are as much self-explorations as they are tiles in a cultural "mosaic"[3] of Mexico in the

1960s and 1970s; that is to say, in the guise of what is usually expected to be 'objective' journalism, the reader finds an autobiographical slant.

The use of cultural commentary as a self-conscious vehicle for
storytelling is not new. Castellanos' essays, represented primarily by the anthologies *Juicios sumarios* [Summary judgments] (1966), *Mujer que sabe latín* [A woman who knows Latin] (1971), *El uso de la palabra: Una mirada a la realidad* [The use of the word: A look at reality] (1974), and *El mar y sus pescaditos* [The sea and its little fishes] (1974),[4] fit into a long tradition in Hispanic and non-Hispanic societies alike. From José María Blanco White's articles on Spain from his self-imposed exile in England[5] and Mariano José de Larra's satirical *artículos de costumbres* in the early nineteenth century,[6] to the *crónicas* (narrative accounts of current or recent events based on an individual's impressions of them) of Latin American Romanticism and early-twentieth-century Modernism (Rubén Darío, Enrique Gómez Carrillo), and from Joan Didion, Susan Sontag, Oriana Fallaci, and Tom Wolfe in the 1960s to Carlos Monsiváis, José Joaquín Blanco, and Cristina Pacheco in Mexico City in the 1970s and 1980s, what has been called a hybrid genre by its proponents and a bastard one by its critics has flourished.[7]

Although several terms have been coined to describe the varied currents of this genre—among them *new journalism* and *parajournalism,* that is, a journalism that exists against or alongside objective realism[8]— the one which most accurately describes Castellanos' essays is *literary journalism*. A lively blend of the first-person voice of autobiography, the concise style of journalistic reporting, and the techniques of fictional discourse, literary journalism affords Castellanos the chance to analyze her own feelings and emotional ties to what she is reporting as she simultaneously offers an 'insider's' view of Mexican culture in order to draw the reader into the conflicting social space between the individual and the community. In a lengthy essay that reveals many subtle facets of Castellanos' personality and her relationships with others, Elena Poniatowska (another cultural chronicler, or *cronista*) identifies the link she finds between Castellanos and herself as part of a subsequent generation of Mexican women writers in the following terms: "Rosario usó la literatura como todavía la usamos la mayoría de las mujeres, como forma de terapia. Recurrimos a la escritura para liberarnos, vaciarnos, con-

fesarnos, explicarnos el mundo, comprender lo que nos sucede" [Rosario used literature in the same way the majority of us women still use it, as a form of therapy. We turn to writing to free ourselves, to empty ourselves, to confess, to explain the world to ourselves, to understand what is happening to us].[9] What distinguishes these essays, then, is not a 'newness' of form but rather the use of journalism by women in Mexico as a 'new' arena of alterity,[10] for expository writing with a public immediacy for private reaction[11] that poetry or the novel, other genres Castellanos cultivated, cannot offer.

In this instance, the perfect scenario for these observations and analyses is the newspaper *Excélsior*, because it functioned, especially during the early 1970s, as one of President Luis Echeverría's showcases for democracy. The officially sanctioned existence of its multiple liberal voices of social commentary and criticism were meant to give intellectual legitimation to the inheritors of a state that had violently repressed criticism in 1968. This acceptance of a certain amount of 'tolerable dissent' lasted a few years, but then the (unwritten) limits of tolerance were reached. For Castellanos the period between 1963 and 1974 under the guidance of Julio Scherer provided the forum, evidently not unambiguous, for what Suzanne Ruta has called the confessions of "a guilty observer."[12] What this genre implies, how Castellanos uses it, and the ideological baggage it carries with it are the subjects to be explored here.

From the 'third world's' eye (and ear) on European culture in the late nineteenth century (Gómez Carrillo's articles in and on Paris, for example) to Blanco White's expression of discontent with both liberal and conservative Spanish politics, Larra's progressive reformist protest against the overwhelming obstacles to a better society, and Wolfe's and Didion's 'crisis' reports on American culture from the 1960s through the 1980s, literary journalism has a number of aspects common to all of its currents. These aspects are almost always present and usually vary simply by degree. They include a (more or less) sarcastic or ironic tone in the self-conscious authorial voice, employed either to create distance (for instance, through black humor) or paradoxically to personify the vices and virtues criticized in others (Larra and Castellanos converge in the latter for their self-deprecating humor and feigned naïveté). Another basic aspect of this highly personal form of reportage is an implicitly

comparative play of perspectives between 'us' and 'them' (Nicaragua and France for Gómez Carrillo; *ladinos* [whites] and indigenous peoples, the ideals of the Mexican Revolution and modern technocracy, men and women for Castellanos; the Spaniards and the French for Larra; and gay and straight society for José Joaquín Blanco). In most types of literary journalism there is also a predisposition toward certain techniques adopted from fiction, such as character development through the use of dialogue and internal monologue, and the imitation of speech patterns from different classes, regions, and ethnic groups. If one were to look for a single point where the various types coincide, however, it would most likely be what Castellanos herself mentions in an essay on Carlos Monsiváis: "ese abismo entre el proyecto y su realización" [that abyss between a project and its realization],[13] the classic dichotomy between desire and reality. It is in this problematic space of discourse that theory and praxis meet head on, that fiction (imagination, the ideal) takes over where fact (reality) falls short and must be supplemented; it is the place where the writer penetrates "the crucial moments of everyday life [to confirm that they] contain great drama and substance."[14]

Persistently, compassionately, yet with mounting desperation, Castellanos reports on these everyday yet dramatic moments in Mexican cultural life in order to signal multiple aspects of the institutionalization of social and economic relations in her country. She includes her divorce, her son Gabriel, encounters with the Tzotzil residents of Chiapas, bouts with depression and her 'salvation' by Valium and psychoanalysis, society's 'conspiracy of silence' regarding the injustices committed against women, and the virtues and vices of television, cinema, radio, and even newspapers themselves. Both from 'within' (the Distrito Federal) and from 'without' (what Poniatowska calls the "larguísima nostalgia" [lengthy nostalgia; p. 67] of her stay in Tel Aviv as Mexico's ambassador to Israel), Castellanos constantly pits her own voice and experience against the backdrop of 'consensus reality.' Paradoxically, this 'reality' is portrayed as both close and remote at the same time. Prepared, at least in theory, to take part in society as a 'good' wife, a 'good' mother, a 'good' person, she is disillusioned time after time with the consequences when she acts.[15] Her painful relationship with her parents, her frustrating marriage, her miscarriages, and the social pressure against writing as a

woman's profession all thwart her utopian dreams of plenitude, a far-off state that she never seems to achieve (see "La palabra y el hecho" [The word and the fact] and "Divagación sobre el idioma" [Some thoughts on language], both in *El uso de la palabra*, pp. 59, 186).

Like Larra's pseudonymous commentator Fígaro, she develops a 'mask' or persona that takes the form of an ironic narrative voice for her confessional style of journalism, a technique that Castellanos, following Simone Weil, claims is the only way to reveal the pathos inspired in her by Mexico during these decades.[16] Her sarcastic remarks regarding gullibility and her experience of customs, habits, and prejudices cut through 'objective' observation to probe an emotional substratum of sympathy and a concurrent feeling of helplessness and displacement. When her desires find no objectification or gratification in reality, the only alternative left for Castellanos is "[el] zarpazo del humor feroz (para desenmascarar bien ese amor de compasión que, según Simone Weil, es el único que, lícitamente, puede inspirar la patria)" [{the} claw mark of ferocious humor (in order to fully unmask that compassion-love which, according to Simone Weil, is the only one that can lawfully be inspired by the homeland)].[17] If not compassion or pity, then perhaps the 'unlawful' love inspired by Mexico is either violent or *self*-destructive, a desperation akin to what Julia Kristeva terms the "cannibalistic solitude" of melancholia or depression.[18] When the woman's body and the social body are seen to entrap or entomb the hopes of full participation for a coherent 'self,' then such violence, directed either toward one's own body or that of the Other, is conceivable. This urge is described by Kristeva as a utopian longing for integration, both social and psychological, denied by one's circumstances, which distance this goal as something "impossible, . . . never reached, always elsewhere, such as the promises of nothingness, of death" (p. 13). For Castellanos, acts of self-violence, such as her attempts at suicide, suggest a search for a 'space,' a place beyond alienation from society and away from her own body. Castellanos herself describes this situation by echoing the words of Larra more than one hundred years earlier: " 'En países como los nuestros escribir es llorar' " [In countries like ours, to write is to weep].[19] Both Castellanos and Kahlo use the congealed tears on the woman's face as an iconic shorthand for this relationship. In the poem "Origen" [Origin] from *Meditación en el*

umbral (translated as *Meditation on the Threshold*), Castellanos, like Frida Kahlo in her paintings *The Dream* (1940), *Self-Portrait* (1940), and *Roots* (1943), sees the figure of the woman as growing out of a physical and social body that offers elements to nurture her growth yet also entraps her into a cycle of decay, stagnation, and metaphorical or real death. The poet writes of her life as parasitic, identifying herself with the moss or lichens that grow on dead matter and entwine their roots around the cadaver on which they feed in order to survive. Castellanos' "cadaver," quite paradoxically, can be either alive—and enchained by social restrictions—or dead. In either case, it can still serve the function of supporting the social body, which needs to feed off assimilated individuals or 'sacrificial victims,' in turn perpetuating a form of parasitism.

Turning back to Poniatowska's view of literature as a 'space' of self-analysis and "therapy" for women in Mexico, one might conclude that literary journalism, for Castellanos at least, is at once painful and curative, since the tears of the writer flow from confrontation, not evasion. And in that confrontation there is a potential for dialogue, if not for resolution.[20] Of a profession—writing—which she often sees as having little or no effect on society, Castellanos concludes that the very act of putting down one's thoughts and opinions in words has an intrinsic value for the 'self' since it concretizes and objectifies *for the individual* what is otherwise a body that lacks any social or physical dimensions. Whether mutilated on a physical or a psychological level, or both, Castellanos explores her own body as a parallel act to her exploration of the body of Mexican culture. This writing exercise she views ironically, considering it both an act of "cannibalism"—since it always provokes frustration and tears, and verges on devouring either the 'self' or the Other—and a necessity because in its very "precarious"[21] nature she finds a mirror of her own life. Of the writer's insistence on this "superfluous instrument," despite all evidence to the contrary, she states: "Dirá que es la voz de su pueblo y no será objetado porque no será escuchado. . . . Y aún reducido al absurdo, dinosaurio que no sabe cambiar de piel ni de especie, continúa escribiendo" [The writer will say that he/she is the voice of the people, and no one will object to that because no one is listening. . . . And even reduced to {such} an absurdity, {like a} dinosaur that can't change its skin or species, {the writer} will continue writing].[22]

To say that literary journalism somehow has historical links to other times and places, especially Europe or North America, is not to affirm its validity by acknowledging its source in the 'first world.' Instead, although Larra and others may have connections to the genre Castellanos adopts (and adapts) for her own purposes, and although a current of liberal commentary runs through its practitioners, Castellanos belongs to a specific cultural and historical context that must be considered in order to place what has been called her *"écriture féminine"*[23] within the broader realm of concrete options for social practice. Literary journalism is one of those alternatives since it forms a bridge between 'private' women's writing and 'public' reportage. It creates a space for discourse for what Perla Schwartz calls Castellanos' "feminismo integracionista" [integrationist feminism],[24] that is to say, her consideration of issues regarding Mexican women *within* a larger cultural and political arena that includes the relationships between men and women as well as among men, women, and power. In "Historia de una mujer rebelde" [Story of a rebellious woman], Castellanos leaves the reader with little doubt as to her "integration" of women into a total social scheme. The last paragraph of this article sums up her views:

> Nadie se salva solo, ha dicho Sartre. Y el día en que queramos encontrar una mujer auténticamente respetable será porque no existan los factores que impiden su surgimiento: el tirano y el pueblo oprimido, el opulento y el que nada posee, el verdugo y la víctima. Cuando ellos también se hayan convertido en hombres auténticamente respetables.

> [No one is saved alone, Sartre has said. And the day when we want to find an authentically respectable woman will dawn when the factors impeding her appearance no longer exist: the tyrant and the oppressed people, the opulent and the one who has nothing, the executioner and the victim. When they too have become authentically respectable men.][25]

The 'Diabolic' Space of Liberal Ideals

Finding a possible space for discourse does not necessarily imply encountering an equivalent social space, however. When examining Castellanos' case, one notes that there is a certain fragmentation of the ego brought on

by the desire to act on her ideals. How does one express one's 'self' in a society undergoing a radical process of modernization when technology, the mass media, and capitalism in general actively resist the survival of the individual? Castellanos' writings fall between the 1940s and the 1970s, decades when the forces of tradition were on the defensive against the forces of modernization and when neither the institutions of the past (preserved as the patriarchal family, the Church, and the Revolution) nor those of the future (the 'new' patriarchal state, conspicuous consumption, and woman as the media image of the health of the 'new' family) offer her acceptable alternatives. Caught between what she considers two stifling systems, Castellanos ends up as a witness—inside yet distanced—whose inability to participate in any personally satisfactory way leads her to nostalgia for the possibility of such participation. This nostalgia translates not just into the tone of her articles, which question the assumptions of conventional social identity, such as "Anticipación a la nostalgia" [In Anticipation of nostalgia]; it is also reflected in her suicide attempts and her interest in both Lázaro Cárdenas and Simone Weil as philosophical and ideological models.

The *cardenismo* phenomenon of the 1988 Mexican presidential election is related to previous social and political activities in the country, but it is not a mere carbon copy of the cardenismo of the 1930s and 1940s. The more recent promises of Cuauhtémoc Cárdenas, however, revive a national figure of mythical proportions and bring it back into center stage. That figure is Lázaro Cárdenas, Cuauhtémoc's populist and tremendously popular father, who was president of Mexico from 1934 to 1940. At the very least, cardenismo presents a dilemma for intellectuals who wish to adhere to or pursue its liberal proposals, often in spite of the vicissitudes of history. For while Lázaro Cárdenas—whom Castellanos, in her essay about his decisive influence on her own life, calls "El hombre del destino" (translated as "A Man of Destiny")[26]—represented the critical conscience of the Mexican Revolution through his democratic interest in the everyday problems of the peasants and workers of Mexico and his national policies of land reform, railroad nationalization, and petroleum expropriation, there is also a darker, more diabolic side to the relationship between the exploited and the state as their protector.[27]

The Mexican state that solidified under Cárdenas dispensed the

favors of the Revolution to the masses as it saw fit. It created an idealized bourgeois family with a benign patriarch at its head, one who writes in his diary that "La población indígena de México es sensible y consciente de sus problemas. Cuando ve que se le atiende y se les trata como hermanos, se confían y facilitan su educación" [The indigenous population of Mexico is sensitive and conscious of its problems. When {its members} see that they are being taken care of and that they are being treated like brothers, they develop trust and facilitate their education].[28] The problem is that those who "took care" of the indigenous citizens treated them like *younger,* less-capable brothers (and sisters) and took care that their 'education' consisted of very specific components.

45

A cultural and economic 'integrationist' at heart, Cárdenas visualized the heritage of the Revolution as a harmonious conciliation of all social classes, not the elimination of their privileged-underprivileged divisiveness. Founder of the Departamento de Asuntos Indígenas [Bureau of Indian Affairs] (1936), the Instituto Indigenista [Indian Institute] (1936), and the Instituto Nacional de Antropología e Historia [National Institute of Anthropology and History] (1938), Lázaro Cárdenas constantly emphasized the incorporation of native populations into a national culture via education and government action. Nevertheless, the 'socialist schools' of his educational policies had implications beyond what is immediately apparent. Not homogeneous ethnically, racially, culturally, or linguistically, the multiple indigenous communities of Mexico were to be incorporated (that is, reduced) into one seamless national structure. So the liberal 'salvation' of the Indians revealed an underlying attempt at complete acculturation. Octavio Ianni concluded of this process that

> La expansión de la escuela elemental es parte—deliberada o no— del proceso de incorporación de poblaciones indígenas y mestizas a la sociedad nacional. . . . [A]lfabetizar significa castellanizar, esto es, mexicanizar. Inducir a todos a participar de la sociedad nacional.

> [The expansion of the elementary school system is part—whether deliberate or not—of the process of incorporation of the indigenous and mestizo populations into the national society. . . . [T]o promote literacy means to Castilianize, that is, to Mexicanize. {It means} inducing everyone to participate in the national society.][29]

Citing these statements is not intended to belittle the many admirable goals of the Cárdenas government. Rather, they are included to clarify both the ends and the means of achieving those ends employed by the modern Mexican state. In general terms, the ends are "[la] democracia económica" [economic democracy], which Cárdenas frequently wrote of in his diary, and the concept of "national progress," associated almost always with "material progress."[30] The means are the education of the 'abandoned' or 'marginal' sectors of society, especially via the deployment of *agrupaciones femeninas* [women's organizations or cells] to take on this challenge and the promotion of work as the source of prosperity and well-being, with an official national ideology based on the intrinsic value of production. Specifically, Cárdenas mentions that these women's 'cells' can lend "su poderosa ayuda tomando parte en las actividades deportivas, en la campaña antialcohólica, en la desfanatización, en las obras de beneficiencia, en fomentar la Instrucción Pública y en todo aquello para lo cual esté capacitada la mujer" [their powerful assistance by taking part in sporting activities, in the anti-alcohol campaign, in the task of {religious} defanaticizing, in works of public welfare, in fomenting public education, and in all other activities for which women may be qualified].[31]

Seeking an outlet for her desire for social justice as promised by the Mexican Revolution and its subsequent 1917 Constitution, Castellanos— not unique among intellectuals but definitely so as a *female intellectual* voice—turned to Lázaro Cárdenas for an answer to the new alienation of the anonymous, technological body of capitalism that begins to replace the private female body of tradition. For Castellanos, women's bodies— their social space—become the site for two related battles. The first is the expropriation of land and the displacement of the rural aristocratic landowners' values, forcing a 'modernizing' shift to what Ruta calls "the shabby gentility and slow decline" of the metropolitan capital (p. 33). The second is a simultaneous metaphorical as well as real expropriation of 'woman' by the state; from their former abstract status, women are thrown into altogether new cultural situations. Such circumstances are reflected in the story "Three Knots in the Net," included in *A Rosario Castellanos Reader*. In this short narrative the recognizable spaces of the "high roofs, thick walls, and expansive rooms of the houses of Comitán"

are replaced for the child Agueda and her parents by the urban 'spaces of refuge' of the Alameda Park, their tiny apartment, school classrooms, stores, movie theaters, and the inward space of the imagination akin to Castellanos' own late-night writing binges.[32]

Both Ahern (p. 2) and Ruta (p. 33) see Castellanos as a woman "spared" by Cárdenas' land reform program. Forced to leave their *finca* in 1941 by the government's democratic redistribution policies and soon after left alone by her parents' death, Castellanos is abruptly removed from the security of a traditional hierarchy, even if that structure itself would have been problematic for her to live within. In the prologue to *El uso de la palabra,* her cited assessment of the situation shows that she recognizes what this new 'open' space implies. The challenge facing her, and others in similar circumstances, is "encontrar asideros, valores por conquistar y de los cuales adueñarse para sentirse digna de vivir" [to find footholds, values still to conquer and take possession of in order to feel worthy of living] (p. 6). At the end of her essay on Cárdenas himself— "El hombre del destino"—she takes stock of the changes effected in her life as a result of the implementation of these social ideals. After reviewing the changes in options, she concludes that she cannot judge which life was better, "la que Cárdenas hizo imposible [o] la que Cárdenas hizo posible" [the one Cárdenas made impossible {or} the one he made possible] (p. 235), but the latter is definitely the more challenging of the two.

Castellanos looked for her "footholds" through various means: by teaching and writing, by returning to San Cristóbal, Chiapas, to work with the Instituto Indigenista, and later on by serving in President Echeverría's administration as ambassador to Israel. Each represented a confrontational situation between internal ideals and the "mansedumbre del anonimato" [meekness or tameness of anonymity] of the surrounding urban culture.[33] The political compromise of being an intellectual affiliated with the government after Díaz Ordaz, a move later seen by some as a sell-out to Echeverría, her term as Mexican cultural representative to Israel, during which time international economic deals were also negotiated,[34] and the personal moral dilemma of her service in Chiapas all add up to a crisis in her perception of alternatives. As author of *Mi constitución* [My constitution] and *Mi libro de lectura* [My reader] (two simplified

Castilian-language versions of legal documents and the official history, myths, and heroes of the country written for the native populations of Chiapas), Castellanos participates in the same paternalistic structure that has maintained the status quo for so long. While in *Mi constitución* she writes in the second-person familiar "tú" form to the intended native recipients of these documents, the autobiographical first-person narrator of the *Excélsior* article "Incident at Yalentay" includes some frank remarks about the process of composing the Spanish-language plays used to 'indoctrinate' Indians in the Petul Puppet Theater. In the first text the reader is told that to learn about the Constitution is a necessity "[p]ara que tú no cometas delitos, y para que los demás no abusen de tu ignorancia, es necesario que sepas qué es la Constitución y lo que dice" [so that you don't commit any crimes, and so that others don't take advantage of your ignorance, it is necessary that you know what the Constitution is and what it says].[35] The newspaper article, however, contains a self-reflexive ironic statement in which Castellanos comments that she "insert[s] a strategic dose of *propaganda* within the simple plot" of the script, whose story line barely disguises the true motives of this government agency.[36] Her naïve good intentions as one of the intellectual *buenas conciencias* [good consciences][37] are, indeed, the object of self-derision at the end of the same article, since the narrator must be apprised of the reasons for the failure of her mission to obtain permission for a young Indian woman to be educated in the city *by* that young woman herself. In short, she overlooks the key role of the puppet Petul in bridging the gap between the indigenous family and official culture and thereby becomes an ideological victim of the 'incident' as well. In discussions of this article, critics usually emphasize the father's offer to sell the girl, not the conflicting values of acculturation suggested by the encounter.

The creation of a mental *zona sagrada*, a sacred space in which one can 'breathe the air of true Mexican culture,' at the same time transforms the indigenous populations into dead objects, commodities that can be either integrated into the dominant cultural schemes—'educated Lacandones,' for instance—or moralistically 'protected' and given refuge from modern society, whose capitalism constantly threatens to encroach on this space. In "El idioma en San Cristóbal Las Casas" [Language in San Cristóbal Las Casas] Castellanos defines the real *médula* or heart of

Indian culture in its atemporal "leyendas, tradiciones y supersticiones" [legends, traditions, and superstitions]. She goes on to identify the members of these indigenous groups as "Criaturas de la sombra, de la ignorancia . . . [condiciones que] existirán mientras San Cristóbal no se abra a los tiempos nuevos" [Creatures of the shadows, of ignorance . . . {conditions that} will exist as long as San Cristóbal does not open itself up to modern times].[38] Castellanos, like Cárdenas, did not seem to envision a *different* social system. Rather, they both attempted to articulate a 'better version' of the one already in motion even as they were able to identify the forces of social compulsion and the use of language as a means of coercion.

49

The ambiguities of a commitment to the modern state's well-intentioned social programs tinge Castellanos' writings, from essays such as "Teoría y práctica del indigenismo" [Theory and practice of *indigenismo*] and "Difícil acceso a la humanidad" [Difficult access to humanity] to those like "PRI, cocina, paz, ingenio, amor" [PRI, cooking, peace, ingenuity, and love] and "La diplomacia al desnudo" [Naked diplomacy]. On the one hand, Castellanos saw doors opening to her *personally* because of Cárdenas' undercutting of the rural landowners' relations of power over the native labor force (see "El hombre del destino"), and later by the chance to start a 'new life' as ambassador to another country. On the other hand, she found herself giving *de facto* support, through her participation, to a series of government programs whose underlying ideology was cultural absorption and social manipulation, not the 'democratic' coexistence of many equal voices. Moreover, she became increasingly aware of the paradox that she was also using the forum of an institution like *Excélsior,* whose authority—to publish as well as to promote an opinion—came directly from that same state.

Therefore, a second, complementary, influence on Castellanos is to be found in the writings of the European philosopher and activist Simone Weil. What this disciplined, self-sacrificing figure offered her was both an ethical stance from which to reevaluate the vices and virtues of Mexican society and to take another look at herself, and what Robert Coles calls "a wholeness of vision" that stressed the utopian desire for "a kind of patriotism that would enable a nation's various social and economic constituencies to live side by side in a spirit of camaraderie and

cooperative effort."[39] Castellanos' contribution to such humanistic "coop-
eration" took the form of her return to Chiapas as an adult not only to
observe, as did Weil in Europe, the relations among social and economic
groups, but also to echo what Castellanos perhaps most admired in Weil's
own life: "Renuncia[r] a una posición económica y social muy favorable
para vivir plenamente una experiencia de la condición obrera" [To
renounce an economically and socially favorable position to {instead} live
to its fullest an experience of the worker's condition].[40] Weil sought this
in, among other places, a Renault automobile assembly plant; Cas-
tellanos' own attempt to work with the Tzotziles was mediated by
government agencies. Both women realized that their cultural 'baggage'
could not easily be left behind, however, and this was a cause of much
frustration. In addition, both women's treatment of personal experience
as the point of departure for public commentary on the palpable 'sick-
ness' of the social body as far as their ideals of human freedom were
concerned, and their equally similar transference of this 'diseased' situa-
tion onto the individual woman's body, join them as kindred 'sacrifices'
in spite of the obvious historical and geographical separation of their
individual circumstances. In her "Prológo involuntario" [Involuntary
prologue] to *El uso de la palabra,* entitled "El escritor como periodista"
[The writer as journalist], Castellanos summarized this procedure and
perspective as "convertir una experiencia en noticia" [converting a {per-
sonal} experience into news] (p. 18). The results were predictably tragic
even if affirmative in some less obvious sense for the individual ego. If, as
Weil writes, "the individual . . . exists through society . . . and society
derives its value from the individual,"[41] then the individual might set the
example for the collectivity's ills. This 'example' would not be through
false self-beautification with plastic surgery and cosmetics to cover ugly
scars or imperfections but by exhibiting these wounds and even refusing
to be 'cured,' or assimilated into the status quo. The final result in this
case is the repression or literal elimination of the individual as the
ultimate sacrifice to the state.

Although Castellanos summarized Weil's concept of life as derived
essentially from the "evangelical" values of charity, justice, poverty,
resignation to divine providence, and unshakable hope,[42] Weil's own
conscience was taxed to the limit by injustices committed against the

50

European working classes. In her vision, the violation of the woman's body, for example, is also the greater violation of the human spirit. Consequently, on ethical grounds she resisted medical intervention to recover the health of her own body. Refusing to cooperate even passively with prescribed treatments for her tuberculosis, Weil encountered, in the words of J. P. Little, "only one possibility of positive action open to [her], and that is to consent to [her] own destruction."[43] In the interest of a broader concept of 'humanity' and through an act of undeniably utopian altruism, Weil was incorporated into the mythology of the European Left as a martyr to a cause greater than her own preservation.

But her choice is concurrently an expression of the individual will, an exposition of the *voluntad* that Poniatowska later found so admirable in Gaby Brimmer's resistance to the oppressive treatment of the physically less able. This act embodies not the self-abnegation so often challenged by Castellanos as a mechanism regulating gender relations in Mexican society but instead a more socially oriented and committed personal act. For her part, Castellanos exposed the physical and psychological 'infirmities' of her life in bits and pieces, beginning with her miscarriages and passing through a painful divorce to the self-inflicted scars on her body. She has been "enthroned"—the word is Poniatowska's—in official Mexican history by the government's appropriation of her rebellious image, and in an alternative history as well by subsequent generations of Mexican women (and writers). Enshrined in the Rotonda de Hombres Ilustres, a publicly recognized space reserved for memorials to the country's "illustrious men," Castellanos has one last facet in common with Weil. As Coles so aptly phrased it, "Among the mysteries of Simone Weil's life, her manner of dying has attracted a great deal of attention" (p. 23). So it is with Castellanos, although the "mysteries" may be partly resolved if they are considered in the context of the alternatives available to her in Mexican culture. Both Cárdenas and Weil inform what she sees as her options.

Autobiographical Ethnography?

The aspect of Castellanos' essays that remains is the act of storytelling itself—just how an individual life is exhibited through a series of

51

framing tales and what effect such a contrapuntal structure has on the presentation of the story.

Given Castellanos' practice of literary journalism as a combination of cultural critique and personal therapy (an 'exorcism' of internalized debate, an attempt to reconcile alternatives, or a discourse of opposition), and her immersion in the everyday world in order to extract from it the representation of an entire 'field' of cultural practices, it seems feasible to postulate an overlap between this genre and the fieldwork of ethnography.[44] The forms, history, and implications of the latter are currently undergoing analysis and reinterpretation by its practitioners in the field of anthropology as well as by members of the community of literary and cultural studies. The study of cultural artifacts is common to both literary discourse and ethnographic writing, and each produces, in turn, its own contribution to this collection of artifacts. One need only consult the recent work by James Clifford and Clifford Geertz to find some of the intriguing possibilities suggested by the crossovers between the two areas. This is especially true in testimonial discourse, the 'hybridization' of more traditional fiction and nonfiction genres, and the ideological implications of contacts between the 'first' and 'third' worlds in what Clifford terms accounts of "negotiated realities."[45] Not only did Castellanos benefit from the proposals extracted from this increasingly problematic cross-cultural turf, but also her writing offers a valuable contribution to the current debate.

If one accepts a general definition of ethnographic fieldwork as the study of representations of culture as witnessed in specific settings by specific people, Castellanos already appears to qualify as a participant in such representational practices. This is witnessed, for instance, by her articles "Y las madres, ¿qué opinan?" [And mothers, what do *they* think?], on birth control and childbearing, "La liberación de la mujer, aquí," about contemporary Mexican women in an international framework, "La puerta estrecha de la TV" [The narrow door of TV], which considers the uses and effects of the mass media, and "Un botón y . . . la catástrofe" [One button and . . . catastrophe], on the film *Dr. Strangelove* and the psychological toll of the threat of nuclear war. If one extends the definition to include the specific involvement or relationship between the reporter/observer and the observed Other, however, the issue becomes

even more challenging. This is particularly true when the self-referential aspect of literary journalism is remembered and fieldwork's simultaneous goals of introspection and objectification are added.[46] When the personal is introduced into the narrative as an admission of the act of self-construction at the same time that the Other is being represented, there is an *overt* politicizing of ethnography. The implicit element of comparison in these studies—the objectification of the Other, then a movement toward first-person introspective narration as the basis against which Otherness is measured—a relationship quite often denied, though present in either obvious or more subtle form, is thereby preserved and highlighted.

Anthropologist John Van Maanen clearly distinguishes two issues of ethnographic writing that shed light on Castellanos' essays. These are, in his words, "the fieldworker's rapport and sensitive contact with others in the world described" and the often ironic self-portrait created by the digressions and editorializing of the narrative voice in what he refers to as the "peculiar practice of representing the social reality of others through the analysis of one's own experience in the world of these others."[47] The techniques of fiction already mentioned—dialogue, internal monologue, parenthetical commentary and elaboration, and the frequent centering of the ethnographer as "a character in a fiction," for example[48]—as well as the choice of cultures to be observed and the editing of material, are the loci of personal intrusion in the field.

Two categories created by Van Maanen may be applied to the corpus of Castellanos' prose in order to distinguish between two types of ethnographic narrative, ones which also support and inform each other rather than being mutually exclusive. The first, not under direct scrutiny here, is the "impressionist tale," which I propose be used to refer to her novels and short stories (*Balún Canán* [translated as *The Nine Guardians*], *Oficio de tinieblas* [Ceremony of Darkness], *Ciudad Real,* and *Los convidados de agosto* [The guests of August]) since these 'show' the reader representations of culture and consequently become firsthand experience shared with the narrator. As Van Maanen stresses, "The audience [of the impressionist tale] is asked to relive the tale with the fieldworker, not interpret or analyze it" (p. 103). Closer to the oral tradition, these tales are still articulated around the teller in a communal setting.

The second category is the "confessional tale," which tells the story of the authorial voice coming to grips with the culture it is attempting to report.[49] Such a complex structure of story-plus-metacommentary belongs in this case to a written tradition (the essay), although it seems to be linked to the oral tale as well, for it most often appears in journalistic form with the understanding of immediate public consumption. Further, in "Incident at Yalentay," for example, Castellanos *shows* the reaction of the villagers to the puppet Petul and his adventures, which instruct and entertain, but she then *tells* the reader about *herself* when the narrative voice is made to sound naïve as it confesses to a lack of awareness on two levels. The first is with the indigenous family, the second with the Instituto Indigenista members to whom she later recounts the tale. The first encounter ends with the narrator looking back on the situation and presenting a genuinely bewildered individual: "But what more does he want, I argued. They were going to give his daughter a home to live in that was much better than her own and clothes. And food. And they were going to teach her *useful new things*. All this without costing him a cent" (p. 220; my emphasis). But the narrative voice is no longer ingenuous in this regard, since the "incident" has already transpired. The subsequent self-admonition at the end of the article reveals the discrepancy between the two cultures as well as between Castellanos before and Castellanos after this "incident." The first-person autobiographical voice concludes by stating that "I would have gone on indefinitely about the benefits of the boarding school [for the young Indian woman] if I had not seen the looks on *my audience's faces*. On Professor Montes' face there was a kind of gentle, mocking condescension. On my companions' faces the same seriousness as when they meditated on eternal truths" (pp. 220–221; my emphasis). The teller is aware of the tale-within-a-tale structure since there is an "audience" for the first retelling that becomes part of the story on succeeding occasions. Distance is created, therefore, between past and present, between innocence and awareness, and between the individual autobiographical voice and the Others—including its own former 'self.' Two stories are at stake here, and neither of them could exist without the other. Additionally, the ironic displacement of the commentary becomes increasingly intense as the authorial 'I' and the 'we' of the reader implicated in some collusion with the former—as seen in the "caro lector"

[dear reader] of "Aplastada por la injusticia del mundo" [Crushed by the world's injustice]—seem to impose themselves more insistently on 'them,' be they servants such as Herlinda Bolaños and María Escandón, Tzotzil natives from Comitán, or government bureaucrats as presented in "Realidad y ficción en Guatemala" [Reality and fiction in Guatemala].

The irony of Castellanos' essays resides in the spaces of slippage between versions of events and in the tendency to deflate or demythify the 'authority' of the authorial narrative voice. From the feigned or re-created ignorance of "*Pedro Páramo,* el rencor vivo" [*Pedro Páramo,* intense rancor] (from *El mar y sus pescaditos*), where the reader is addressed in mockingly superior tones when she writes, "En vista de todas las cosas que *usted sabe* y de las muchísimas más que *yo ignoro*" [In view of all the things *you know* and of the vaster number of things of which *I am ignorant*] (p. 113; my emphasis) to the discrepancy between what are first described as the magical "tiempos heróicos" [heroic times] in her childhood Chiapas that later appear as the "archaic provincial life,"[50] the narrators constantly move from an outward position to an introspective confession. And from what Ahern identifies as the "maternal colonialism" (p. 50) of the peculiar relationship between upper-class women and their female servants in Mexico (one that Castellanos finally describes in detail in "Herlinda Leaves") to the third-person but actually self-directed sarcastic remarks of "A pesar de proponérselo" [In spite of one's good intention], the authorial voice points out the growing abyss that separates individual desires and perceptions from full social realization. Castellanos' essays are cultural artifacts that tell the reader the story of the paradoxes created by her greater understanding of the world around her—the ultimate quest of women writing in Mexico as Poniatowska's words defined it at the beginning of this examination—accompanied by her own ironic identification with the plethora of shortcomings (as well as some of the more attractive virtues) of that society. At the end of "La liberación de la mujer, aquí" Castellanos adds a parenthetical note to this effect regarding the "señoras histéricas como su segura servidora" [hysterical women such as yours truly] (p. 67). The category she uses most certainly belongs to an ironic reference to socially imposed jargon, since reason and logic, not 'hysteria,' have filled the essays to this point. Indeed, 'hysteria' would still seem to be functioning here as the traditional

catchall phrase denoting social resistance or criticism by women. Castellanos' persistence in writing these articles, in spite of identifying both a personal and a cultural malaise through their content, would directly contradict their dismissal by readers as the ravings of a 'hysterical' woman.

This perspective spills over into an even more pervasive self-critique in her role as a defender of Indian cultures. While touting a (liberal) defense of including or spotlighting indigenous and marginalized groups in her texts, Castellanos simultaneously realizes that this very intellectual space for theorizing and writing is predicated on the existence of the luxury of surplus time created by the labor of those classes. In "Herlinda Leaves," an article based closely on her own life, she recognizes her unconscious role in the survival of this social and economic structure. The narrator tells us, "There I was off playing Quetzalcóatl, the great white civilizing god, while right next to me someone was walking around ignorant" (p. 268). Such a statement reveals the entire structure of the ethnographic or pseudo-ethnographic report. Always mediated somehow by politics in the most general sense, and always tinged by the power and ability of the reporter to present the Other (who cannot or is not allowed to represent itself), these essays are acknowledged as such products by their narrator. The narrator's role is made evident in short work by the rhetorical question disguised as a direct address to the (masculine!) reader in "A pesar de proponérselo": "Pero, señor . . . ¿que se imagina usted que soy tan importante?" [But, sir . . . do you possibly imagine that I am so important?] (p. 309). The direct reference has to do with her friends' sympathetic appraisal of her skill at mastering foreign languages, but there is also a suggestion of the relative unimportance of this narrator in the general social scheme. This fact is later supported by the revelation of her published piece as a recipe, not a document of 'greater significance.' The narrator directly undermines her own image of power by taking this stance.

In these essays perhaps the autobiographical voice's most painful realization is that what at first looks like 'me' against 'you' (the lone critic taking on all of Mexican culture) turns out to be an admission that 'I am one of you, too.' The relationship is demonstrated most explicitly in Castellanos' use of the first-person plural 'we' to include herself in

the "democracias criollas en las que *hacemos* juegos malabares con las grandes palabras para evitar que nunca vayan a guardar ni la más mínima correspondencia con los hechos" [Creole democracies in which *we* do juggling acts with high-sounding words to avoid their ever having even the most minimal correspondence with the facts],[51] and in the evidence of the docility of the individual in Mexican society. She emphasizes that "El futuro se *nos* presenta con una evidencia tan aterradora, que *nuestras* mejillas palidecen y *nuestras* manos sudan. Y, sin embargo, *nuestra* boca permanece muda para la protesta" [The future presents itself to *us* in such a fearful way, that *our* cheeks pale and *our* hands sweat. And nevertheless *our* mouths remain closed to protest].[52] In this manner and through this narrative structure, the ethnographic and the autobiographical indeed seem to become one.

But one of the greatest ironies of all is that Castellanos' essays and *Excélsior* articles, not to mention her other prose and poetry writings, do not give evidence of an *absolute* convergence between the 'I' and the 'we.' Instead, her texts offer the reader an especially rewarding opportunity to see the gaps or interstices that lie between the individual woman's subjective response and the objective institutions of the modernizing state. At one and the same time, the narrator is just like the woman she describes in "Costumbres mexicanas," who cannot sleep without her husband by her side even if the reason for his frequent absences is another woman, yet she also clarifies for the wife/herself just in case there is still a vestige of doubt in either one: "Las ausencias de su marido, *señora,* no son justificadas; las excusas son falsas" [Your husband's absences, *señora,* are not justified; his excuses are false].[53] The narrator *uses* these objectified personal situations to comment on the irony of accepting them as what is standard, just what she herself has done on repeated occasions. At least one step away from most of the experiences by now, Castellanos' narrative voice has gained the perspectives of time and distance, which allow her to sit in judgment on her own participation in confrontations that appear to embody embedded cultural and ideological values. She "remembers" her friend Josefina Muriel from Tabasco, whose graduate thesis on women in pre-Hispanic Mexico leads her to consider the reception of this research by Mexican society, herself included—a piece of material "que *nos* entrega ahora en una pulcra edición [su

autora]" [which {its author} hands over *to us* now in a beautifully neat edition].[54] Will it be a 'forgotten' lesson, or will contemporary women learn from it? As she ponders at the beginning of the article "La liberación del amor" (translated as "The Liberation of Love"), "Usted, *señora,* abnegada mujercita mexicana; o usted, abnegada mujercita mexicana en vías de emancipación: ¿qué ha hecho por su causa en los últimos meses?" [You, *señora,* self-sacrificing little Mexican woman; or you, self-sacrificing little Mexican woman on the road to liberation: what have you done for your cause in the past few months?].[55] Given past reactions—to Sor Juana, to the single mother (in "La palabra y el hecho"), and to the defense of an obligatory university curriculum, for example—she anticipates the culture's responses to such a call to arms. Yet the narrator also fears that her own exposition of these issues may dissolve into the same air, that is to say, if they are 'merely' taken for a "conversación," as she states in "El héroe de nuestro tiempo" [A hero for our time], or a "confesión," as she admits in "Un mundo incomprensible" [An incomprehensible world].[56] This voice has done its fieldwork almost too well, since it reveals the very problematic foundation of the cultural community. In its re-creation of these encounters, with the 'self' as well as with the Other, it has learned too much about both. The situation becomes, as we read at the outset of one early article, "sumamente humillante . . . [porque tengo que concluir que] no entiendo nada de lo que sucede ni en este país, ni en este mundo, ni en los otros planetas" [exceedingly humiliating . . . {because I must conclude that} I understand nothing of what goes on in this country, nor in this world, nor in other worlds].[57] It is not that she cannot comprehend what she sees and does; rather, it is that all of these acts have lost any reasonable meaning as far as their motivation is concerned. When she reads of the mestizos' colonization of indigenous areas of Colombia and their consequent extermination of the native inhabitants, she cannot imagine any justification. The 'incomprehensibility' of these acts is made certain, however, by the 'ingenuously disguised' response of the perpetrators of such crimes, their linguistically manipulated self-justification. Castellanos writes that their answer to the authorities "lo hace a uno poner en crisis todas sus convicciones acerca de la naturaleza del hombre, . . . [porque] ellos, los mestizos, [dijeron que] ignoraban que estuviera prohibido matar a los indios" [makes one call

58

into question all his/her convictions about the nature of man, . . . {because} they, the mestizos, {said that} they were not aware that it was illegal to kill Indians].[58] No one can be trusted to act with 'humanity' toward any Other, be they Indians, women, or any other marginalized group. In a painful act of introspection in one essay, the narrator admits that even she is capable of hypocrisy and 'treason,' elements she encounters in her fieldwork and in herself. Although dispatched with a tone of historical distance in the majority of the essay "Un acto de introspección" [An act of introspection], the conclusion is nevertheless quite directly self-incriminating. She proposes a careful examination: "Examinémonos a nosotros mismos. ¿Cuántas veces no hemos callado un elogio que era merecido para no proporcionar una satisfacción a quien lo suscitaba? ¿Cuántas otras no hemos concedido a un ánimo dadivoso una respuesta apenas condescendiente? . . . Cada una de esas veces imitamos a Judas pero en una dosis tan insignificante que no nos resultará mortal" [Let's examine ourselves. How many times have we allowed praise that was earned to go unsaid in order not to give satisfaction to the one who merited it? How many other times have we given a generous spirit a merely condescending response? . . . Each and every time, we imitate Judas but in such an insignificant dose that it won't be mortal].[59] The idea of 'good intentions' and even that of the previously mentioned *buenas conciencias* fit well here with the explicit juxtaposition between the immediate moment and the larger panorama. The irony is not lost on the reader.

If on the one hand President Luis Echeverría judges Castellanos to be a 'tolerable' voice of opposition who is allowed to express her ideas in a public forum because she does not 'name names,' on the other hand it is possible to conjecture that the personal dimension of her analyses allows cultural criticism to go veritably unnoticed or is even 'pardoned,' as a patriarch does with his aberrant but 'harmless' children. Since she is acutely aware of the potential power of the private in the public sphere, Castellanos may well be using that same fact to her own advantage with an eye toward explicitly going beyond what is 'permitted.' When asked by an Austrian newspaper colleague about ideological uses of language, Castellanos responded in a very revealing manner. His question addressed her profession as a woman writer, but she sees implied a vaster

radius of action. She says: "El idioma no sólo es problemático cuando funciono en tanto que escritora, sino cuando existo en tanto que mexicana" [Language is not only problematic when I function as a woman writer but also in my existence as a Mexican woman].[60] Journalism as a link with the factors influencing her life, and which at least in theory can be influenced by her words and acts, gives Castellanos a space for the exploration of these issues. Her essay "El escritor como periodista" ends by reaffirming that every public encounter, whether in person or on paper, leaves each individual in society "enriquecido por lo que ha tomado del lenguaje y de la vida ajenos" [enriched by what he takes from the language and the lives of others] (p. 19). For Castellanos the "enrichment" most certainly refers to 'education,' not necessarily 'pleasure,' since for her, after all, to write is to weep.

3. Updating the Epistolary Canon: Bodies and Letters, Bodies of Letters in Elena Poniatowska's *Querido Diego, te abraza Quiela* and *Gaby Brimmer*

> A life is necessarily intersected by the convulsions of history.
> Fredric Jameson

> Aesthetic action is not the same as social action.
> Elisabeth Lenk

> Gertrude [Stein] never left home in the same way I did. . . . She was always at home [in Paris] through the language, but I was at home only through her.
> Alice B. Toklas

> Before language, desire.
> Linda S. Kauffman

The Body Politic

The cultural and economic history of postrevolutionary Mexico seems to be synchronized with the rhythms of the *sexenio,* the six-year term of the country's president. In 1978 and 1979 respectively, Elena Poniatowska published *Querido Diego, te abraza Quiela* (Era) (translated as *Dear Diego*) and *Gaby Brimmer* (Grijalbo), in the *sexenio* of López Portillo (1976–1982).[1] This was ten years after the massacre at Tlatelolco and the

Olympic Games of 1968 and during the peak of Mexican oil-boom prosperity before the scandals involving Mexico City police chief Arturo Durazo ("El Negro") and the economic crises of the oil price bust of the early 1980s.[2] In this period after the proclaimed *apertura democrática,* or democratic opening, of Echeverría's term (1970–1976) a good number of Mexican intellectuals began to show signs of their resignation to the political system by becoming assimilated into it in various ways. During these six years the government attempted to defuse the class protests of radical dissidents by creating the appearance of a pluralistic liberal state through 'reconciling' into a theoretically homogeneous whole all the disparate elements of resistance remaining from the late 1960s under the official banner of social reform. This was a particularly telling move by the intellectuals, given the fact that profits from the oil industry intensified class contradictions inasmuch as the workers and producers were not the recipients of the benefits arising from such profits. Instead, the profits were channeled into the hands of the wealthy few and the politically well-connected. In response to the resultant heightening of class conflict, as Cockcroft remarks, "the bourgeoisie had to regroup and close ranks, entering into more direct participation in state affairs" (p. 238) to assure the 'correct' administration of this new source of wealth and privilege. Social critic and writer Carlos Monsiváis summed up this middle- and upper-middle-class attitude of survival in terms of "la insistencia denodada en la teoría del caballo de Troya: la revolución-desde-dentro, la transformación-de-las-estructuras-desde-el-Poder" [the resolute insistence on the theory of the Trojan horse: the revolution-from-within, the transformation-of-{social}-structures-from-{a position of}-power].[3] In a general sense, the participation of many young writers, such as Elena Poniatowska, Angeles Mastretta, and Cristina Pacheco, in the field of newspaper reporting for *Excélsior* and other government-recognized periodicals represents such a trend. In a country where if the government officially disputes the contents of publications, it can withdraw the paper or newsprint ration from that publication, as happened in the late 1970s to both Octavio Paz's *Plural* and the cooperative *Excélsior* itself owing to its 'excessive' criticism of President Echeverría's government, this "revolution from within" was an important cultural and political phenomenon.[4] Elena Poniatowska, therefore, is an intriguing

62

figure to study as a bridge between newspaper and fiction writing during this transitional period in Mexican social history.

By 1977 some reflections of the intellectuals' assimilation can be seen in a collapse of participation in and support for radical political parties and factions among the members of this group, in contrast to the continued activities of the more organized political networks of the lower classes, such as the peasant guerrilla wars of Lucio Cabañas in the mountains of the state of Guerrero and the alliances between students and the urban poor in a number of large cities. In addition, there was a generalized political and social malaise among the bourgeoisie (compensated for by an increase in consumer spending) and a rupture of cross- or interclass support for projects advocating or proposing radical social change. This cycle from opposition to absorption of Mexican intellectuals allowed for the coexistence of voices and opinions as long as none objectively threatened the continuity of either the state or the conventional networks of social and political power, such as the elite ranks of the military or the government-maintained bureaucracy. As Monsiváis wrote with regard to those who turned away from immediate social, economic, and political matters to fix their gaze instead on the more personal point of defending the individual's 'rights' to increasingly protective and comfortable levels of life "para mejor sobrevivir la crisis" [to better survive the crisis]: "La despolitización empieza advirtiendo el trágico destino de los muy politizados" [Depoliticization begins by warning of the tragic fate of those who are too politicized] (*Amor perdido,* p. 51). The most obvious recent examples in Mexico of the 'punishments' of the 'overly politicized' who break out of their habitual cynicism and move toward effecting an objective change in political institutions include the middle-class student participation in Tlatelolco and the subsequent killings and taking of secret political prisoners, large-scale police retaliation against public school and other union protesters in Mexico City in the 1970s and 1980s, the violent suppression of challenges to the PRI by opposition political forces in the northern states in local and regional elections, the repression and execution of Cárdenas supporters in the capital during and after the elections of 1988, and the use of the threat of bringing Veracruz's Laguna Verde nuclear plant on line in retaliation for citizens' protests against corruption among those responsi-

ble for its construction. (Since the end of August 1990 the plant has been functioning at close to full power in spite of lingering local protest by popular groups as well as international monitoring agencies, though not a majority of the middle class.)

In one instance directly related to this discussion, some of these symptoms of assimilation began to emerge a decade and a half ago in the forums and symposia for the 1975 United Nations–sponsored International Women's Year Tribunal in Mexico City, as documented by representatives such as the Bolivian peasant Domitila Barrios de Chungara. In these sessions a confrontation arose between two opposing orientations (that is, 'classes'). The first was characterized by an international alliance of rural and urban working-class women whose interests encompassed such everyday life-and-death socioeconomic issues as political exile, poverty, exploitation, torture, disease, and a lack of basic human necessities such as water and electricity. The second group was composed of what Domitila referred to as "bourgeois professionals" who "[speak] very different languages,"[5] since their interests center on the sexual liberation represented by birth control, gay liberation, sexual expression and satisfaction, and other issues considered to be of interest to the first group of women but more remote from them, and not the fundamental problems of the majority of the masses of women in Latin America. Betty Friedan is singled out and cited by Domitila as personifying the North American 'feminist' point of view in her "declaration of war against men" and her opinion that working-class women are being "manipulated by men" in their insistence on politics instead of "women's problems" (pp. 199, 201–202). Definitions of the 'political' and economic aspects of culture and issues of class seem to be the obvious points of contention here. This polarization in the 'lifestyles' of the participants in the Women's Tribunal directly reflects critical divisions between social classes in Mexico—as well as of Latin America in general—resulting in the process of "depoliticizing" already mentioned.

It is within this context that each of Poniatowska's texts proposes the literary rescue or recovery of an individual female figure: Angelina Beloff, one of Diego Rivera's Russian lovers in 1920s Paris, and Gaby Brimmer, a young Mexican woman suffering from cerebral palsy in the 1970s. The author's presentation of these women employs their letters as

64

a primary source in the production of both *Querido Diego* and *Gaby Brimmer*.[6] As an intermediary for these works, Poniatowska is also in essence a focal point of their composition. She is the architect of their final versions, using the concept of epistolarity as her basis for the metamorphosis of their characters from history to literary text. The terms on which these women's stories are to be construed by the reading public are Poniatowska's. Beloff, obviously unaware of publication,[7] is first filtered through Bertram Wolfe's biography of Diego Rivera, which Poniatowska acknowledged to be her source, and Brimmer is aware that what she wrote to Poniatowska would be communicated to the public in some form. Poniatowska inverted the emphasis from 'outside' events to 'inner' life as she took a marginal text—marginal at least in its accessibility to a vast field of readers—and turned it into publicly available narrative. In both cases their personal identities and proper names are used not to typify a collectivity or group but to personalize an era. This personalizing or individualizing may be considered an aesthetic consideration somewhat concomitant with the depoliticizing of the middle classes; it reflects a definite broadening or 'liberalizing' of literary content to include marginal voices. But whose voices are they and what do they tell us? As Tom Moylan writes of 'critical' or 'oppositional' literary texts in general after the social crises of the 1960s, there was a general shift in orientation. He contends that "The new movements of liberation [from political and social hierarchy, economic domination, and sexual repression] insist on a multiplicity of voices, *autonomous from each other,* but commonly rooted in unfulfilled needs centering around the practice of *autonomy.*"[8] These texts reflect neither communities nor collective interests but rather individual voices. Moreover, Poniatowska's own admitted two-year postponement of "getting involved" in something so "extra-literary" (see p. 34 of the document itself) appears to reveal a certain hesitation about even this 'cause.' In a recent interview with Gerardo Ochoa Sandy, Poniatowska seems to be very sensitive about what she herself calls this "coauthored" text: "Yo no elegí a Gaby Brimmer; Gaby Brimmer me eligió a mí" [I didn't choose Gaby Brimmer; Gaby Brimmer chose me], she writes of Brimmer's mother's persistent follow-up efforts regarding a promise by Poniatowska to keep in touch with her daughter. She continues: "El libro que escribí sobre Gaby Brimmer no

considero que sea literario. Carlos Monsiváis y Miguel Barnet, alguna vez, me dijeron que no les había gustado nada" [The book I wrote about Gaby Brimmer I don't consider literary. Carlos Monsiváis and Miguel Barnet, at one time or another, have told me that they didn't like it {the book} at all].[9] This statement certainly begins to clarify the problematic relationship between 'literature' and 'politics.'

The use of letters is a tempting and quite appropriate one in this instance since most critics and writers alike agree on the openness of the genre, both in terms of authorial voice and fictional interpretation, as well as their incorporation in a narrative as 'testimonial' or documentary material. Rachel Blau Du Plessis refers to the epistolary form as having an intrinsic "porousness"[10] that permits exploration of an individual identity by filling in the spaces, gaps, or 'slippage' between the pieces. In his preface to the issue of *Yale French Studies* dedicated to "Men/Women of Letters," Charles A. Porter recognizes that "letters . . . are discontinuous, multidirectional, fragmented," given the temporal and spatial distances involved between their composition, reception, and reaction to them.[11] Janet Gurkin Altman underscores these characteristics in her study of epistolarity by concluding that "Epistolary narrative is by definition fragmented narrative. Discontinuity is built into the very blank space that makes of each letter a footprint rather than a path."[12] The product of this process is not a typical object of consumption; rather, it is imperfect, flexible, and incomplete. The receiver of such an object, then, fills in the gaps and contextualizes it with the help of 'clues' given by the intermediary (here, Poniatowska). By such implicit participation, the consumers are made to feel as if they have actually had a hand in the composition of the text. This activity replicates at another level the hold on the individual exercised by the participatory consumption of capitalism.

Poniatowska offers to follow and bridge these "footprints" for the contemporary reading public as she takes us by the hand through the foregrounded private lives of Gaby Brimmer and Angelina (the Quiela of the book's title) Beloff, with the self "as the focal point of the world. [Wherein one's] sense of the substance of history is turned inside out"[13] in order to make an aesthetic creation out of their internal psychological states.[14] Functioning as a *bricoleuse* who reassembles already existing

66

signs or objects into new discourses and who speaks to and through others' letters, using former constructs for her emergent creations, Poniatowska establishes personas for Beloff and Brimmer. The new personas contribute potentially hidden, publicly unacknowledged, subconsciously latent, or even purely fabricated aspects of these characters, whose 'masks' or 'voices,' rather than being figures of authority, exhibit elements of contradiction not reconciled by Poniatowska. These elements in tension are often reflected in the alternating use of the first and third person: "Yo" [I] *versus* "Tu Angelina" [Your Angelina], for instance. Instead, what Steele has described as Beloff's moments of "rebeldía" [rebellion] and "autoafirmación" [self-affirmation] in *Querido Diego* directly oppose the overwhelming presence of the "tendencias autodestructivas" [self-destructive tendencies] (p. 19) in the content of the original letters. Consequently, Poniatowska's 'Quiela' is not a carbon copy of the real Angelina Beloff, just as 'Frida' is not the real Frida Kahlo but rather an image the artist Frida Kahlo constructed for public consumption.

If such 'liberties' have been taken with this text, one logically might ask what has been altered, edited, or emphasized in Gaby Brimmer's self-analyzing dialogue with her typewriter "Ché" that Poniatowska 'listens in' on. In her prologue, Poniatowska refers to this process by Brimmer as "dialogar consigo misma en una suerte de sicoanálisis" [having a dialogue with herself in a type of psychoanalysis] (p. 17). Poniatowska may be giving us a more overt hint about the production of this work in the prologue, however, where she writes of exposing "hidden feelings" that parallel Mexican society's "hiding the handicapped" (p. 13) and of the need for an artistic "will" (*voluntad*) that she finds in Brimmer and that seems to echo her interpretation of Beloff. She sets the stage for Gaby by stating that "no es lo mismo ser mujer que hombre, la condición masculina propicia la creación, la femenina lo impide" [it isn't the same being a woman as being a man, the masculine condition favors creation, the feminine impedes it] (p. 22). The images of contradiction, mutability, and movement in which life is a process opposed to stasis are in all likelihood indications of Poniatowska's adaptations of these figures to the requirements and expectations of readers in the 1970s. Steele observes that Poniatowska's creation of an appearance of plausibility or probability for a modern audience makes the narrative more approach-

able than the sentiments of the original letters, "más verosímil para el público contemporáneo que la de las cartas verdaderas" [more verisimilar {true to reality, likely} for the contemporary public than the real letters] (p. 18). Presumably, these personas also encourage more examination and evaluation, especially by female readers, than Rivera's or Wolfe's versions of Beloff or the absence of any version of her life in the case of Brimmer. In thus filling the interstices of both women's letters, it appears that Poniatowska proposes to subvert any idea (or accusation?) of direct mirror identification between literature and history, the supposed representation or reflection of objective reality, by offering in its place subjective interpretation. The reader is left with no doubt that this is a mediated discourse whose 'rules' are those of fictional narrative.

It is worthy of comment at this point that the only work of Elena Poniatowska so far produced in the form of a film available to international audiences is *Gaby Brimmer*. Titled *Gaby—A True Story,* it is a U.S. production directed by the Mexican Luis Mandoki and includes an international cast that ranges from Liv Ullman to Robert Loggia and Rachel Levin. Perhaps one reason for the mass media's choice of this text is the fact that, as the handicapped daughter of Holocaust survivors, Gaby Brimmer might attract increased enthusiasm from audiences who identified more strongly with European culture and the lone individual's fight for recognition against general social odds than with more the specific social and economic realities of the Third World (and their causes). For instance, scenes of family portraits in eastern-European-like settings and upon arrival in the 'New World' underlie the opening credits, thereby emphasizing this cross-cultural tie, one which is never really developed to any extent in the written text except in offhand remarks by Gaby's mother. Otherwise, the character Jesusa Palancares of *Hasta no verte Jesús mío* (translated as *Until We Meet Again*) might have made just as strong a statement in visual form about a woman's personal testimony, albeit with a quite different underlying 'message' that is more historically and politically charged than Brimmer's. Each woman, however, tells an "idiosyncratic" story,[15] dependent on the personality of the individual as well as on the listener to whom it is told. Nevertheless, a historical connection to the time of the Mexican Revolution and this character's more problematic statements with regard to gender and class

relations in the country might have been more difficult to put into 'digestible' cinematic images for consumption by a varied international audience.

The question of aesthetic obstacles or complications for the film representation of a testimonial text based on monologic discourse should not be the focal point of the selection, however, since both literary works have similar if not fundamentally parallel structures. As the product of interviews and correspondence with Poniatowska as the interlocutor or intermediary for the interpretation and selection of material from their 'confessions,' opinions, or memoirs, these two works pose not very different challenges to film production than a work of James Joyce like *Ulysses* or *The Dead,* both of which have appeared in cinematic versions. It is not form or structure, then, but content that must be considered as the factor inhibiting or stimulating choice and distribution. By extension, the same can be said of Poniatowska's selection or editing of the two texts under consideration here. What she chose to include responds to certain personal and social criteria of the time in which she was working.

Alien(ated) Bodies

The epistolary genre makes available to Poniatowska a repertoire of certain characteristic elements or formulas that she can exploit to construct new textual possibilities for the exploration of women's egos within these two examples of very different discourse. Several of these conventions are especially pertinent to a study of the texts under consideration—the function of the letter as an attempt to recover a loss or absence, for example, and the idea of reciprocity or "correspondence." Composing a letter, after all, presupposes a desire for a reply, which is the characteristic that distinguishes this genre from the writing of autobiographies and diaries.[16] This need to confront or recover oneself in, and create an exchange with, the Other and what occurs as the Other withdraws is central to what Poniatowska defines as her project. In the case of Gaby Brimmer, she views this as a lack, "La necesidad . . . de sentirse mirada en otros ojos" [The necessity . . . of feeling herself perceived {seen} in other eyes] (p. 33). Poniatowska also explores the ambiguous situation of the letter's synchronous power and powerlessness

to function as an address to and replacement of a physical presence, be it individual or collective. The letter simultaneously connects the writer with the reader and establishes on paper the distance between the two. A third important facet of epistolary narrative is its reduction and concentration of time into subjective moments that create a vehicle for the literary expression of individual 'epiphanies' or 'apocalypses' in the development of the character even if these moments at times seem disjointed.

In addition, letters are frequently defined as offering an opportunity for uncensored expression[17] since the Other is not present face-to-face. Is this true for Beloff and Brimmer? Did the 'real' Beloff censor what she wrote to Rivera, with Poniatowska restoring her 'completeness'? Is Brimmer performing a role 'as expected' in what she writes? Whose expectations are they? Is Poniatowska a censoring or suppressing factor, or a 'liberating' one? Finally, what are the intentions of both the epistolary sources and the created texts? Are they, as Porter contends, "to seduce, to deceive, to request, to respond, or to continue a subject already begun" (pp. 3–4)? Is a coherent project articulated in either instance? The following pages attempt to address and explore these issues, returning in the end to a discussion of the implications of the cultural contexts involved in the production of these discourses.

Though previously they were secondary or background figures at most, Poniatowska now centers the reader's attention on both Beloff and Brimmer as individual, if contradictory, 'heroines' of a sort who are facing similar difficulties and whose different historical moments are subsumed under Poniatowska's own. Unlike Rigoberta Menchú[18] or Domitila as representative or 'typical' members of a community, these personas are *in and of themselves* a 'cause' to be made public. This is true at least in terms of the 'public' composed of the classes that consume these works, a public that is obviously quite limited in a country whose readers tend to favor, if anything at all, serial pulp novels, tabloids, and other items of what is commonly considered mass or popular culture. The psychological self-analysis and 'confessional' aspects of both texts—on one level, the 'confidants' of these confessions are Rivera and Poniatowska; on another, they are the readers of the 1970s and 1980s—reveal an emphasis on psychological conflicts[19] that seems to confirm the tendency

to search for the roots of conventional conduct in psychology rather than in history that Monsiváis notes in Mexican literary texts since the social crises of the 1960s. He cites the strengthening of "la . . . vertiente de los derechos individuales, hacer del egoísmo una aventura ideológica, reivindicar el psicoanálisis como derecho civil de la burguesía" [the . . . wellspring of individual rights, making egotism an ideological adventure, vindicating psychoanalysis as a bourgeois civil right] (p. 41). This category, the bourgeoisie, is one to which all three women belong. The letters of Beloff and Brimmer, and Poniatowska's own exploration of herself through them, all stress this individual focus. And the 'recovery' of the epistolary form is seen by Stratton et al. as signaling a return to a preceding phase in the development of the centralized ego, leading to the form of the modern bourgeois novel.[20] Poniatowska herself makes a telling statement on this subject in a 1974 interview with Beth Miller regarding a project in progress at that time, based on the figure of Mexican railroad leader Demetrio Vallejo. Poniatowska comments: "[This book] has me lying on the floor, at my wits' end. . . . The whole thing has been an enormous amount of work because I'm not familiar with the working-class milieu. I know nothing about unions. And he personally bores me because he talks in clichés. . . . So it's taken a lot of time and effort to immerse myself in that environment and invent characters and sentiments for those characters. I don't even know how they think, I don't even know what they like or, rather, I do know what they think and it's not interesting to me."[21] In a more recent interview with Cynthia Steele, Poniatowska reiterates her feeling of distance and alienation from the content of her Vallejo manuscript, by now finished in draft form but judged by her as so boring that "el propio Vallejo . . . se dormía mientras yo le leía los capítulos. Le servía de somnífero" [Vallejo himself . . . fell asleep as I was reading him the chapters. It worked like a sleeping pill on him].[22] She seems to orient the two narratives of Beloff and Brimmer toward the 'liberation' of individual, disconnected bourgeois women's voices, toward a milieu with which she *is* more familiar and which she evidently finds more personally rewarding and stimulating for publication.

In the absence of the Other, writing for both Gaby Brimmer and Angelina Beloff becomes a compensatory activity which, as Altman

affirms, is both metaphoric in that it "conjures up interiorized images and comparisons" and metonymic (p. 19) because the letter itself is perceived as *becoming* the body of its writer, which will eventually come into physical contact with that Other. For Brimmer, the absence is double: it is the lack of a political and economic place in the body of society as well as the lack of a 'voice' of her own, creating an alienated distance from her own 'self.' She writes that in questions of decisions regarding her life, "A mí nadie me pidió mi opinión" [No one asked my opinion] and "siempre habrá un intermediario para todo. Legalmente no cuento . . . no soy dueña de nada. De lo único que soy verdaderamente dueña es de mi rebeldía" [there will always be an intermediary for everything. Legally, I don't count . . . I possess nothing. The only thing that I am the true owner of is my rebelliousness] (p. 73). Her letters take the place of her alienated body in trying to establish a connection with the distanced elements of society, her family, and the multiple psychological dimensions of herself. In addition, the act of writing represents a continual effort to stave off both actual and metaphoric death (a state of nonexistence, silence, disappearance). The intended recipients of her writings are simultaneously contemporary Mexican readers or Others via Poniatowska—whose initial reaction to Brimmer's request for a public forum is silence—and herself in sorting out her own thoughts on paper.

On the other hand, Beloff suffers from the absence of Diego Rivera, who returned to Mexico to pursue his artistic career in the wake of the Revolution and in the name of educating the masses through mural art. (And who was looking for a 'signature' of some type to guarantee his fame, just as Picasso 'discovered' Africa; Rivera found it in the art of Mexican nationalism.)[23] In Poniatowska's version, her unanswered letters to him also form the body of a self-exploratory monologue, since the dimension of "reciprocity" inherent in an epistolary narrative never becomes concrete. When he departs, she feels disconnected from his circle of friends in Paris as well as from the artist himself. Even as late as 1922, in one of her last letters to Rivera, Beloff is still trying to explain away his silence, whose effect on her she refuses to admit either to herself or publicly. She writes: "tu silencio [lo] atribuyo a tu exceso de trabajo, al cambio, a los proyectos emprendidos, a las largas discusiones que suscitas" [I attribute your silence to an excess of work, to the move {back to

Mexico}, to the projects taken on, to the long discussions that you provoke] (p. 60). Her one-sided correspondence therefore serves several functions at once.

Beloff's first letters are a reply to his leaving. They are full of 73 metaphorical images and memories of past moments together as well as subjective feelings vacillating between "debilidad" [weakness] (p. 45), "enfermedad" [illness] (p. 43), and the contagion of Rivera's artistic spirit to herself in a "fiebre" [fever] (pp. 23, 25) that invades her painting and writing during the liminal hours of dawn and twilight. Lacking a response from Rivera (he sent money but no messages, either oral or written), Beloff's subsequent letters are self-motivated and actually seem to respond to each other rather than to the absent lover, whose body (both literary and corporal) appears to have been replaced by the process of letter writing itself. One such instance is Beloff's taking on or incorporating the image of Rivera's body into her own as she swells up to fill the studio—"estoy llena de ti" [I am filled up with you] (p. 21) she writes as she transfers the expression from her love for him to a love of art and production—just as his "imaginación volcánica" [volcanic imagination][24] fills his canvases and conversations. She carries on an imagined conversation with Rivera and with herself as she writes the letters, alternately taking on aspects of *both* personalities.

Just as Brimmer transfers her desires for corporal expression, social participation, and recognition into the concrete form of letters, so Beloff displaces her desires for physical and artistic fulfillment into 'things.' At first these are objects left behind by Rivera: an easel, canvases, or a smock;[25] later the letters themselves come to symbolize her conscious and unconscious desires. Through their content as well as by their objective existence, Beloff is metaphorically and metonymically embodied. If Frida Kahlo paints a created self, Beloff attempts the same with words. Despite similar processes, however, the products are quite different. Both Beloff's and Brimmer's texts seek to expose individuals who direct their pleas as well as their challenges to the absent, distanced body. In the process they wrestle with the acceptance or rejection of illusions and delusions such as Rivera's return or Mexico's unbiased acceptance of the mental if not physical capacities of the handicapped.[26] Brimmer's challenges are related to her confrontations with physical impediments

in going to school and meeting friends, for example; Beloff's are part of the persona created by Poniatowska to counterbalance an image of passivity. "Al llegar a la casa me puse a pintar, estaba carburada" [Upon arriving home I set to painting, I was energized] (p. 20) she communicates in colloquial, contemporary Spanish to Rivera instead of once again expressing loneliness and despair. Beloff even challenges him directly with the question "¿Ya no me quieres, Diego?" [Don't you love me anymore, Diego?] (p. 42), although this appears only in one of her last letters to him. While Brimmer tries to break down society's superficial image of *her* as witnessed in her consciousness of her brother's intolerance, her mother's shame and guilt, and her peers' fear and embarrassment, Beloff's letters still contain the survivals of Rivera's images of *her* as small, weak, fragile, and domestic. This is in addition to a reinforcement of her mythification of *him* as the filter through which she perceives all reality, herself included. Rivera's work can be considered the erection of public monuments to himself as the artistic interpreter of recent Mexican history, while Beloff—and even Kahlo, at times—is also an image mirrored in his public figure. It is Rivera who gives her the nickname "Little Blue Dove," and her identity among European artists, at least initially, rests on her affiliation with him.[27]

When Beloff takes up her paintbrush and 'usurps' Rivera's easel in imitation of his own gestures, she comments quite aptly, "Siento que he vuelto a nacer" [I feel I have been reborn] (p. 21). It is to this giant, noble "primitive savage" or pure "recién nacido" [newborn being] (p. 48) that she directs her pleas in order to find some force and purpose that can give her life meaning.[28] Beloff writes: "sin ti, soy bien poca cosa, mi valor lo determina el amor que me tengas y existo para los demás en la medida en que tú me quieras" [without you, I am really very little, my worth is determined by whatever love you feel for me, and I exist for others {only} to the extent that you love me] (p. 17). The rebellious dimension that Poniatowska adds to Beloff's voice counteracts to some extent the reactive, dependent aspects of her original self-portrait. Her recounting of visits to the Louvre, late-night painting frenzies, and the production of numerous etchings for publication tends to break through the overwhelming need for mediation via Rivera and his Montparnasse circle. This is a paradox if we consider it in the light of Brimmer's rejection of a

reliance on her maid and companion, Florencia, whom she strongly wishes *not* to have to rely on unless it is absolutely necessary for reasons of either physical mobility or facilitated communication. (It is also a paradox if the reader considers that the criticized mediating role of Rivera has been replaced by that of Poniatowska.) Beloff's letters show that she lives for the acceptance and approval of others, especially patriarchal figures. Before Rivera there was her father to impress with art lessons and a fellowship (see *Memorias,* p. 33). There were also the teachers at the Fine Arts Academy in St. Petersburg. On the other hand, her memoirs hint at another dimension of her personality when she expresses decisive statements about her relationship with Rivera, such as, "Aquella época [después del nacimiento del hijo] fue terrible para mí, pues al llegar de la clínica me encontré a esta mujer en gran intimidad con Diego. Pensando que estaban muy enamorados, decidí separarme de él inmediatamente" [That period {after the birth of their son} was very difficult for me, since when I arrived home from the clinic I found this woman living intimately with Diego. Thinking that they were very much in love, I decided to separate from him immediately] (p. 56) and, "Tenía que defenderme; así pues, le dije rotundamente que no iba a cenar sola en la casa" [I had to defend myself; so I told him forcefully that I was not about to eat dinner at home alone] (p. 61). Such firm, unwavering language belies the weakness generally associated with the tone of her letters to Diego. Could this discrepancy once again signal the difference between the form and content of letters with a specific purpose or destination in mind and what is told in confidence to a diary or retold in old age in one's memoirs?

If we approach these two narratives as projects of the individual 'recovery,' of one's own rights and of the absent Other, peppered with 'epiphanies,' or moments of enlightenment and revelation about themselves as well as others based on information derived from the bodies of their letters,[29] it is also plausible to view the texts as quests for the 'redemption' of the physical and psychological bodies involved. That is to say, Brimmer and Beloff both suffer from a 'paralysis'—in the first case literal and in the second figurative[30]—that impedes access to a real place in society. The two of them are like outsiders, in limbo: one because of her psychological dependence, the other because of her physical depen-

dence. Beloff will not move from the "sacred territory" of Rivera's studio until she hears from him (p. 32). Any "initiative" to cross the ocean must be his (the term *initiative* is Beloff's own; it appears in Wolfe, p. 124, and is echoed in Poniatowska's text, p. 59, followed by an ellipsis to create suspense, indecision, or an opportunity for the contemporary reader to fill in the text). When she longs for another child, it is he whom she sees as the force in control of decisions concerning her body—"me lo negaste" [you denied it to me] [p. 18], she writes to him.[31]

Brimmer, on the other hand, is trapped by her body, actually paralyzed due to possibly preventable complications at the time of her birth. She continually voices her desire to be able to get around by herself and be free from the weight of her wheelchair-bound body and society's a priori conceptualization of its limitations. Her only alternative is thought and imagination: "Desde niña he viajado mental y espiritualmente. Viajar es cambiar, renovarse, ver otras cosas" [Since I was a child I have traveled mentally and spiritually. To travel is to change, to renew oneself, to see other things] (p. 94). The one quality she demonstrates that she does not share with Beloff is the strong power of her will to escape this paralysis, similar to Frida Kahlo's first reaction when she suffered her catastrophic accident. Brimmer turned to poetry as Kahlo turned to painting,[32] to express her frustration and exorcise her pain. For both, in the end, the life of the mind substituted or compensated for the immobilized life of the body. "Yo no sé caminar," writes Brimmer, "sé volar" [I do not know how to walk, I know how to fly] (p. 47). Walking is done with the full force of gravity on the weight of the body, whereas flight lifts thought far above the earth. Brimmer emphasizes that "Paciencia es la palabra que más odio, sinónimo de esperar, esperar, esperar" [Patience is the word that I hate the most, {it is a} synonym for waiting, waiting, waiting] (p. 177). The body may have to wait passively while the imagination continually invents, an obviously tragic situation in the case of Brimmer's cerebral palsy, which prevents any integration between mind and body.

If the epistolary message can indeed metaphorically invoke internalized images of the past and present, and if it metonymically becomes the body of the writer as well, there is one more facet of paralysis to mention. An unanswered letter of Beloff's can also be considered a

paralyzed body of words, just as the information in an unpublished or nonpublic letter of Brimmer's is unless the obstacle is overcome by the existence of narratives such as these, mediated as they are. By making such bodies of women's inner thoughts available to a wider audience, Poniatowska perhaps simultaneously creates another form of compensatory activity. This time it occurs in her own era when faced with the lack of a political dimension as defined earlier by Monsiváis. Her motivation in presenting Beloff's and Brimmer's self-analyses to a public rigidly divided between classes may well be to suggest a self-analysis of the social body parallel to the private level of evaluation witnessed in the texts. But what the outcome would be in such a case is difficult to say. Given the limited participation, if any, in actual political events, would a bourgeois reading public merely become more interested in its own psychological characteristics and 'internal affairs'? Or could it conceivably be stimulated to reach and read beyond its own boundaries, again into the preoccupations of other classes? Since radical class division does not seem to have been bridged but rather attenuated in recent years, perhaps these epistolary products are instead the example of a phenomenon of more concern to international markets of readers in search of neglected heroines than to the rapidly diminishing Mexican reading public.[33]

Insofar as their letters originate from inside the cloistered walls of a Parisian studio and a suburban Mexico City home, and insofar as they describe the obstacles surrounding both Brimmer and Beloff with regard to the possibility of possessing a lover, a homeland, a family, a profession, or an education, these women in effect live in exile. In general terms, these multifaceted exiles correspond to what Paul Ilie has called the "inner or spiritual exile" of those who see themselves as Others outside the official culture in question, alien to prevailing structures of social and economic power.[34] Both feel "confined" and "imprisoned"[35] in their daily lives, even if one is more passive than the other about protesting against the circumstances. In Paris the Russian émigré Beloff lives in Montparnasse but does not feel part of its cultural circles because Rivera's friends, "tus amigos" [*your* friends] she calls them (p. 9), cease to call on her after he leaves.[36] For Brimmer, Coyoacán is just as exclusionary because she goes out to see no one and receives no visitors.

Beloff reiterates that, unlike Rivera, she finds language an obstacle,

an impediment to her cultural integration. About his French, Beloff wrote to Rivera in 1922: "inventabas el idioma, lo torcías a tu antojo y rompías la barrera" [you invented the language, you twisted it at will and broke down the barrier] (p. 56). This she considers herself unable to do. Does this not echo Toklas' remark cited in the epigraph at the beginning of this chapter? Rivera is like Stein in his role as a cultural and linguistic mediator. This exile of silence—the lack of language—is true in two senses. First, being a 'foreigner' in western Europe on the verge of World War I, Beloff fears she is part of a suspect exile community in France. She avoids addressing a policeman because she thinks that "mi acento me delataría y los funcionarios franceses no quieren a los extranjeros" [my {Russian} accent would give me away, and French functionaries do not like foreigners] (p. 14). On the other hand, the Spanish language is also the 'alien tongue' she tries to learn since she deems that doing so makes her feel part of Rivera's Mexican world. Doing so also gives her access to his conversations with other women, such as María Blanchard, from which she is otherwise excluded (see her *Memorias,* p. 29). Beloff writes continually that with Rivera "me mexicanicé" [I became Mexicanized] (p. 46), and her memoirs, in a French liberally peppered with words and expressions in Spanish, are testimonies to this. But the resultant condition is a double alienation from her actual European surroundings: "me sentiré muchísimo menos extranjera contigo que en cualquier otra tierra. El retorno a mi hogar paterno es definitivamente imposible, no por los sucesos políticos sino porque no me identifico con mis compatriotas" [I will feel much, much less foreign with you {in Mexico} than in any other land. The return to my paternal home is now definitely impossible, not because of political events but because I can't identify with any of my {Russian} compatriots] (p. 46). In spite of her claim of destroying the Spanish language when she uses it, although Poniatowska allows her the fluidity of expression of a native speaker in her letters, Beloff assumes an identity linked to the myth of Rivera and his culture as a substitute for her feeling of exile: "tú eres mi patria" [you are my homeland] (p. 55) she declares to him.

The myth of Mexico as a distant paradise, and the utopian goal of being reunited with her lover in harmony, quite often take over Beloff's texts. Paradoxically, Rivera's Mexican acquaintances in Paris are a con-

78

stant reminder for her of how "free" (p. 47) she felt while with him, and they reinforce the same image of freedom she feels exiled from in *Querido Diego*. She creates word portraits of an "Arcadian landscape"[37] of the New World as she waits for a message from Rivera, her personal representative of that 'new' world that she believes will renew European culture (and herself?) and free it from its repressions and inhibitions (see p. 47), to instigate her voyage of escape/return. America is her scenario for rebirth and liberation: she writes to Diego that "en tu país . . . sería posible forjarse una vida en que no nos daríamos el uno al otro más de lo que pudiera darse espontáneamente. . . . [Habría] compañerismo e . . . independencia . . . bajo el sol mexicano" [in your country . . . it would be possible to forge a life in which one would not give the other more than what could be given spontaneously. . . . There would be companionship and . . . independence . . . under the Mexican sun] (pp. 64–65). This is Beloff's subjective assessment of a distant society, indirectly perceived through the rhetoric of the postrevolutionary era—the phrase "compañerismo e . . . independencia," for instance, may reflect more generally assimilated social goals—and through Rivera's own admittedly 'fabulous' version of reality.[38] When Frida Kahlo stipulates that she must earn money to be an equal partner in her relationship with Rivera after their remarriage, she does so to proclaim her independence, just as she does on the physical level. When Beloff states a similar economic desire, it is for a different purpose, since she wants no more than to join him once again, following the same 'rules' as before. Beloff writes: "[Quiero] reunirme contigo y el solo pensamiento es ya un anticipo del paraíso" [{I want} to be reunited with you, and the thought alone is already a preview of paradise] (p. 28).

Conceptions of exile and utopia are not lacking in Brimmer's letters either. She conveys her feelings of separation from all other 'normal' human beings because of her cerebral palsy, which prevents her from being in control of many of her body's movements. The existence of this situation makes her feel marginalized with respect to many social and economic activities, not so much because she is physically unable to do them but because others relegate her to the fringes of acceptability due to their superficial perception of her as 'different.' This perception makes Brimmer an Other just as Kahlo and Beloff are to Rivera. It is the

absence of any recognition of her mental processes and physical desires that she repeatedly depicts in her analysis of this *imposed* exile, one contrary to Beloff's more self-imposed exile. In her assessment of this process of dehumanization and 'disappearance' from society, Brimmer observes: "no me siento una persona incapacitada porque he aprendido que cada ser humano tiene límites, problemas consigo mismo y con la sociedad" [I don't feel like a handicapped person, because I have learned that every human being has limits, problems with himself and with society] (p. 50). The liberal message of this statement seems to judge the idea of tolerance—not liberation—as the fundamental aspect of society's aims for individuals living collectively within its ranks. In her letters Brimmer promotes this sympathetic attitude toward diversity and in doing so gains recognition for herself as not being different from anyone else. There are many varieties of handicaps and levels of capacity that are thereby acknowledged not as superior or inferior but as essentially equal within the category of 'human being.' Brimmer states that she frequently dislikes what human beings do to each other—they are egotistical, manipulative, violent—but her most fervent desire appears to center on being one of the crowd, "como toditos los seres humanos" [like every last one of the human beings] (p. 87).

As a second step she professes certain 'libertarian' leanings in her politics. The equation of political liberty with freedom of the body is a fairly natural and logical consequence of the plea for tolerance of all individuals whose pluralism simultaneously neutralizes opposition and ideological commitment. It is also utopian, however, since it admits that no existing society meets its expectations. Yet it does not propose a practical alternative, with one exception: "Para decir la verdad, yo soy anarquista. No me gustan los gobiernos de ningún pueblo del mundo porque poco a poco he ido desengañándome de todos" [To tell {you} the truth, I am an anarchist. I don't like the governments of any of the countries of the world because little by little I have become disenchanted with all of them] (p. 109). This certainly is one answer to exile. Yet does it not at the same time promote another form of distancing in its place— that of an exile or withdrawal from an objective historical and political context into yet another (individual) utopia?

Brimmer rarely extends her discussion of exile and alienation to

encompass the complexities of the relations between men and women. She clearly states her awareness of the roles played in Mexican society by women as created personas resulting from the attributes promoted by the mass media, the cosmetics industry, and clothing manufacturers, among others, and that the majority of these images are produced in accordance with characteristics and attributes judged to be 'feminine.' Although she recognizes the economic underpinnings of this image of consumption, Brimmer does not mention its class basis. She writes: "Creo que el monstruoso equipaje supuestamente femenino lo han inventado los comerciantes para su beneficio" [I believe that this monstrous, supposedly feminine baggage has been invented by the salesmen for their own benefit] (p. 91). But the discussion ends there. In addition, Brimmer observes her own conformity to some of the gender-constructed social roles. At times she excuses the behavior because it makes her feel "like the rest" of the women around her; at other times she is overtly annoyed by the coercion exercised by the traditional double standard. It is possible to see the ambiguity in the following two fragments from her letters.

> Yo he aprendido a ser así porque muchas de mis amigas lo han hecho conmigo y . . . tienen razón; es más divertido y de más provecho estar con un chavo que con una amiga, por más que tú la quieras.

> [I have learned to be like this because many of my girlfriends have done the same to me and . . . they are right; it is much more fun and of more use to be with a guy than with a girlfriend, as much as you may like her.] (pp. 87–88)

> Nunca en estos tres años me he dado el lujo de llamarlo [a su amigo Quique] y decirle claramente: "Ven porque te necesito" para que el caballero no se sienta presionado o se vaya a enojar. En cambio él sí tiene absoluta libertad para hacer y deshacer a su antojo.

> [Never in the past three years have I taken the step of calling him {her friend Quique} and saying to him clearly: "Come because I need you" so that the gentleman won't feel pressured or get angry. On the other hand, he *does* have the absolute freedom to do or undo things at his own free will.] (p. 174)

In these instances she differs only in degree from Beloff in her consciousness toward the acculturation implicit in her reactions. Company, if not solidarity, is always a weapon against solitude.

Brimmer's corporal and social paradise of 'belonging' to a society in which all members are imperfect in some way and therefore tolerant of others' imperfections is counterbalanced by another utopia put forth continuously since her birth by her mother, Sari. It consists of what Brimmer calls the "gran ilusión" [great dream] (p. 43) of finding a cure for her daughter in the United States. In this manner she can *truly* 'lose' her handicap and become 'normal.' In this scenario the United States is to Sari what Mexico is to Beloff (and in a sense to Kahlo): a distant image of satisfaction, plenitude, hope, and—in this case—an almost millenarian 'salvation' at the hands of the North American doctors, who are like priests at the altar of technology and science. Brimmer is caught up in an ambiguous situation reminiscent of Kahlo's. Mexico is her homeland, but it offers little help for her physical needs; the United States is more advanced in therapy and education but alienates her even more. The question, however, really is whether it is Gaby's 'salvation' that she seeks or Sari's own salvation from the "dagger" (p. 43) constantly hanging over her head and the "tragedy" (p. 43) of the stigma of having a handicapped child. What Gaby Brimmer learns at some of the clinics she is sent to in San Francisco and Baltimore is that she must face the fact that she has certain incurable disabilities, that "no se debe marginar a nadie" [no one should be marginalized] (p. 46), and that she does not want to be left alone or to be excluded from the activities of the rest of the world (p. 46). She finds no cure. Solitude is the conclusion in the case of both Brimmer and Beloff, but the hoped-for remedies of incorporation into the social body imply two opposing views: one toward the nostalgia of a 'golden' past, one toward a 'golden' future. In the meantime, both women are stuck in the very real limbo of the present.

Stitching Together a Text

What are the characteristics in Poniatowska's versions of Beloff and Brimmer that qualify them for presentation to Mexican, North American, or European audiences in the late 1970s and, in subsequent editions, in the early 1980s? Is it merely that the readers are more 'understanding' or 'sensitive' to specific issues than at other times in history? Is there only an immediate 'practical' reason behind the publication of the thoughts of

Gaby Brimmer, that of opening up the possibility of other individuals visiting and reading to her, as is stated in Poniatowska's preliminary remarks? Or is there also a personal feeling of guilt or responsibility on the part of the mediator of her words, as Poniatowska remarks briefly in her prologue (p. 34)?[39]

83

In order to make a persona more acceptable to the expectations and desires of readers in the 'postapocalypse,' post-1960s, postmodern decades, the authorial voice (here, of Poniatowska) has to consider which traits of the 'real' person combined with which added, emphasized, or fabricated details will be more seductive for the public. Poniatowska chooses to circumvent, displace, in some instances contradict, and otherwise 'censor' or edit any 'official' perspectives of these women, such as those offered on Beloff by Rivera, by Wolfe in his editorializing on Rivera's stories, by Debroise, or by the voices of Florencia, Sari, her brother David, or any other spokesperson for Brimmer. As intermediary she thereby creates a perfect scenario for the first-person exposition in their letters of what Monsiváis enumerates as fundamental aspects of the liberal hero/heroine: a life of "sacrificio, abnegación, martirio" [sacrifice, abnegation {denial of one's desires}, martyrdom] (p. 41) in the hope of vindication at some time in the future. For the readers of these texts, the myths of the natural right to a citizen's individual freedom and the liberty from the imposition of arbitrary authority must be addressed as applied not to the social or political body, currently abandoned by these sectors, but instead to the "sacrificed, denied, and martyred" private body of these women. Their individual initiative—a hidden but undaunted *voluntad,* or will—is made the true focus of the narratives. For these reasons, Poniatowska quite aptly selected Angelina Beloff and Gaby Brimmer to portray this set of values: they are socially 'excluded' individuals whose literary 'redemption' is appropriate since it is not used to imply the necessity of any radical social or political change. It is even conceivable that if the Mexican state itself were to promote or support any actions to benefit Brimmer or the handicapped, for example, it would actually be seen as heroic and 'democratic,' a truly charitable and generous patriarchal structure of authority that is willing to gather up its weakest members in a gesture of benevolence.

Beloff's Paris of the 1910s and 1920s belongs to the successors of the

belle époque, an era described by Olivier Debroise as "el símbolo de una vida fácil nacida de la excepcional estabilidad política y económica que permitía todos los excesos" [the symbol of an easy life born of exceptional political and economic stability that permitted all types of excess] (*Diego de Montparnasse*, p. 15) for the frustrated artists fleeing from the cultural tensions and vacuums of their own countries. But it is an era of brutal change as well, since this bohemian[40] mecca was about to fall into the chaos of World War I, taking with it many of the facile divisions and categories applied to social as well as gender relations until then. In her insightful and intriguing study of British and American expatriate women who contributed to the birth and development of literary Modernism in Paris during this time, Shari Benstock describes the attraction of this transitional era even today: "One suspects that our hesitation in closing the historical door on this period is due to a sense that the shock waves these years produced are still resounding through our culture."[41] Poniatowska's 'recovery' of Beloff as a problematic figure in such an atmosphere of radical change appears to corroborate this statement, for even if she is far removed from the currents of Modernism, she nevertheless exhibits reactions to those around her who most certainly do form part of those changes.

Beloff—who has accurately been described by critics like Steele as a bourgeois eastern European, and "una joven de San Petersburgo salida de la típica burguesía burocrática del imperio ruso" [a young woman from St. Petersburg from the typical bourgeois bureaucracy of the Russian Empire]—is an exception within this exotic context of excesses.[42] In her memoirs she wrote of being from "una típica familia intelectual rusa" [a typical Russian intellectual family] and that "vivíamos sin preocupaciones" [we lived without worries] (pp. 17, 18). Even she considers herself a triple social outsider as "rusa, . . . sentimental y . . . mujer" [Russian, . . . sentimental, and . . . a woman] (p. 14). This confirms the traditional presentation of Beloff as an element of stability and conservative tendencies. She is portrayed as "domestic," "sweet," and "understanding";[43] in fact, among Rivera's friends she is seen as playing the role of 'wronged wife' to Rivera's other Russian lover, Marevna. Poniatowska tempered Beloff's original feelings of sacrifice by permitting or creating glimpses and flashes of an otherwise hidden (repressed?) willpower to

84

show through: "in spite of everything" she tries to work on her art (p. 51), and even without Rivera she declares "me lanzo sola" [I throw myself {into working on etching samples}] (p. 50). When Beloff writes conclusively in her last letter to Rivera that "Es inútil pedirte que me escribas" [It is useless to ask you to write to me] (p. 71), she finally seems to accept that all is over and she is on her own, although the real Beloff still went off to Mexico more than ten years later. In the last pages of her memoirs, in fact, Beloff even underlined the fact:

> Casi nunca dependí de Diego materialmente, será por orgullo, pero cuando estuve enferma de escarlatina, aquí en México, él mandó 500 pesos al hospital francés. Al salir del hospital, le mandé los 500 pesos dándole las gracias y diciéndole que por el momento no los necesitaba, y si necesitara algún día, le pediría.

> [I almost never depended on Diego economically, maybe for reasons of pride, but when I was sick with scarlatina, here in Mexico, he sent 500 pesos to the French hospital. On leaving the hospital, I sent him back the 500 pesos with thanks, telling him that for the moment I did not need them, but if I were in need {of them} someday I would ask him.] (*Memorias*, p. 92)

Between the flashes of artistic dedication seen in Poniatowska's text and the portrait gleaned from her own writings, her persona no longer conforms to what Rivera's first Mexican wife, Lupe Marín, said of Beloff after they met in Paris in 1933: "she is good because she hasn't enough imagination to be bad."[44] Perhaps it is to this very statement (from a curious letter from Marín to Frida Kahlo in May of that year reproduced in Wolfe's book) that Poniatowska wishes to respond with her interpretation of Beloff, since it is exactly Beloff's artistic imagination and self-awareness that she appears to try to bolster in *Querido Diego*. Debroise would seem to support this hypothesis, since he writes that Beloff

> no adopta el papel de mártir de la *gens artística*: ésta es una visión creada *a posteriori* quizá por el mismo Rivera al entregar a su biógrafo, Bertram D. Wolfe, copias de la correspondencia íntima. Angelina nunca expuso su dolor: las memorias, escritas hacia el final de su vida, ni siquiera revelan claramente su rencor.

> [does not adopt the role of martyr to the *gens artística*: that is a vision created *a posteriori* perhaps by Rivera himself upon handing over to

85

his biographer, Bertram D. Wolfe, copies of his intimate correspondence. Angelina never exposed her pain: her memoirs, written toward the end of her life, do not even clearly reveal her rancor].[45]

86 By using Wolfe as a primary source, Poniatowska appears to be responding much more directly to Rivera's mediated portrait of Beloff than to what the artist herself has written about her own life.

Gaby Brimmer represents a 'cause' that it would be extremely difficult to dispute, from her suffering as a result of medical errors at her birth to her subsequent ostracism by other children and adults. She exemplifies perfectly the decision to develop and educate the mind as a focal point instead of worrying about the possible rehabilitation of the body, as Poniatowska comments in her prologue (pp. 15–16). Brimmer has experienced, not economic deprivation, but rather psychological stress and alienation owing to her social isolation and her lack of control over the fate of her own body. Therefore *Gaby Brimmer* does the only 'decent' thing: on liberal humanist grounds it shows that this woman is really "the same as the rest of 'us' on the inside."[46] Brimmer writes to Poniatowska, via a series of 'dialogues' with her typewriter/alter-ego, Ché, to verbalize the paradoxes of her life for others and to exteriorize them for her own benefit as well. The content of these dialogues ranges from how she could be born into suffering from the love between two people, to why some have the ability to use language but say nothing whereas she has much to say but no voice, to how her mother's temperament makes her repress much of her despair, how her father's absence leaves her feeling abandoned. What she most desires is to perform the traditional functions of a woman, such as being a mother to her adopted daughter Alma Florencia, a girlfriend, a sister to David, and a daughter to Sari.

In the intellectuals' retreat from the crisis in the social body during the 1970s, mentioned at the outset of this essay, Brimmer served the function of individualizing critical moments. In her letters, for example, 1968 becomes for her the year she meets and falls in love with fellow student Luis del Toro (see p. 124), when she visits him in Lecumberri Prison and writes him letters she never sends, when she listens to records by Atahualpa Yupanqui when she wants to escape the confines of her house and feel part of the outside world, when she cuts her hair to make

it easier to care for, and when she learns that Luis is released from jail and marries without coming to see her again. Brimmer's feelings and opinions are contextualized on this personal level of abandonment, one which, interestingly enough, parallels the country's own retrenchment and withdrawal. She reached the conclusion in 1979 that from these experiences she must be resigned to "aceptar que la política es lo más sucio que hay en este mundo, [y] que los políticos son unos putos" [accept that politics is the dirtiest activity in the world, {and} that politicians are all crooked sons of bitches] (p. 198). Her observations are always based, however, on one-to-one contact with other individuals, such as Luis, not on a systematic analysis of the panorama of Mexican social history.

All in all, Poniatowska combines the fragments of both Beloff's and Brimmer's letters, filling in the interstices with multiple possibilities that create new openings and additional questions regarding their lives. Both *Querido Diego, te abraza Quiela* and *Gaby Brimmer* present real contradictions, ones that are not resolved in the texts but that are personalized in imaginary dialogues between fragments of the 'self' communicated via the vehicle of the letters as interpreted, selected, and organized by Poniatowska in the crucial function of interlocutor.

4. Popular Music as the Nexus of History, Memory, and Desire in Angeles Mastretta's *Arráncame la vida*

> Esto del amor sólo lo entienden los poetas y los cancioneros.
>
> [This business about love is only understood by poets and popular songbooks.]
>
> <div align="right">Angeles Mastretta</div>

Building a Modern Society

As the title of the work reflects, Angeles Mastretta's best-selling 1985 novel suggests for the reader an immediate association with the Mexican popular song genre, in particular during the 1930s and 1940s, which is generally considered the Golden Age of this music.[1] These are also, not surprisingly if one considers their significance for the West in general, crucial decades for the formation of the modern Mexican state. But after the initial reaction of recognizing and identifying the origin of the title from the *bolero* (ballad) of the same name, what function does it have in Mastretta's retrieval of a historical era and of a female figure within it? More accurately, how does this popular music bridge the space between the foregrounded female narrator and the panoply of re-created historical events and figures, what Gabriela Mora terms "la intromisión de la historia" [the intrusion of history][2] into the discourse of the individual? In a work in which, according to Concepción Ortega Cuenca, there has been an inversion in emphasis of what might have been a historical novel

into an *historia de amor* [love story],[3] the threads of three levels of movement and change are woven together using popular music and song. These three levels are the individual, the national, and the aesthetic. In the interstices opened up by the orchestrated use of these lyrics, the reader encounters points of intersection between public and private spaces of discourse. In addition, these points signal simultaneous but opposing versions of history and social relations, one being official and dominant (that of the state) and the other representing individual dissent. How and why this occurs through the music lyrics, as well as the implications for a critical consideration of this narrative, constitute the substance of the discussion that follows.

In the 1930s and 1940s Mexico was in the midst of a process of modernization and industrialization. Its leaders were charged with making crucial decisions about the future direction and orientation of the nation and its economy, in addition to deciding what relative 'weight' the past should have in this development. Clearly, this was the period of postrevolutionary Mexico's 'coming of age,' its emergence into the twentieth century's framework of advanced capitalism, which Mexico, in the Revolution's aftermath, welcomed with open arms. As Héctor Aguilar Camín states regarding this critical period of transition: "Lo que llamamos hoy el Milagro Mexicano fue una mezcla eficaz de dominación política tradicional—clientelar, paternal, centralizada, autoritaria— puesta al servicio de un proyecto económico particularmente exitoso— modernizador, industrial, urbano, capitalista" [What we today call the Mexican Miracle was an efficient mixture of traditional political domination—patronage-based, paternalistic, centralized, authoritarian—placed at the service of a particularly successful economic project—modernizing, industrial, urban, capitalist].[4] These decades—which Cockcroft says contain "the roots of the modern state"[5]—form the backdrop of the narrator Catalina Guzmán de Ascencio's own 'coming of age' (narrated through the structure of the bildungsroman) as a woman in modern Mexico and at the same time, on another level, parallel or echo her process of development and self-discovery. At a time when society is undergoing vast upheavals and shifts—such as massive urban migration, rapid industrialization, and incorporation into international schemes of production and consumption—the 'regularized' process of absorption or progress

into adulthood becomes problematic. Uncertainty rather than assurance becomes the common denominator for the identity of the individual in this 'novel of transition,' because social roles are in a state of flux.[6] In this context, the musical connecting links between the individual and culture allegorize consonance and dissonance; they reflect points of possible integration, separation, and social compulsion. What specific type of music, when and where it is performed or heard, what purpose it serves, and who is involved in it as either participant or audience all reflect society's norms of conduct. Sometimes these norms are reinforced by the music; at other times they are blatantly transgressed, as in the case of many popular genres or parodies. The music can represent, in short, "an outlet for those affects that have to be either regulated or repressed" on both social and individual levels.[7] The main function of music in all its manifestations in this work of fiction, then, is to make audible "a world of contradictory thoughts and emotions . . . [which then] calls for response."[8]

As a writer in the complex and sophisticated social, political, and economic Mexican state of the 1980s, Mastretta examines via her character Catalina Guzmán the process of national formation, both lyrically and nostalgically, from an individual woman's point of view. At the same time, she analyzes the historical roots of her own situation through Catalina's responses to the pressures and contradictions brought out in the potentially liberating lyrical/emotional interludes of the narrative. It seems plausible to affirm that by means of the narrator's developing subversion, if not complete mastery, of her environment Mastretta attains both an understanding of Catalina's choices and decisions and a clearer portrait of her own. What has been said elsewhere about Elena Poniatowska and the narrator Jesusa Palancares of *Hasta no verte Jesús mío* holds true in this case as well: through her encounters with Palancares (as well as with the actual informant for this character), Poniatowska in effect reaches "una consagración de su *propio* ser" [a confirmation of her *own* self].[9] That is, *Arráncame la vida* is the author's affirmation of the narrator's assertions, and her own self-affirmation as well. Moreover, Catalina can be considered as a possible role model. If, little by little, she assumes control over her own life, managing to replace the traditional place/space of the father or husband and in spite of her fear of the uncharted openness suggested by this new-found freedom, Mastretta and

others can take heart in and justify their own daily encounters with society. On the other hand, there is also the realization of constant ambiguity in Catalina's small 'triumphs.'[10] Each time she 'puts one over' on Ascencio she also reaffirms the fact that the power he represents is not just individual but is constructed on gender and is deeply embedded in the structure of society. At the same time, the necessity for change, adaptation, and confrontation is emphasized in Catalina's narration of the events and individuals that shape her life and to which she learns she must continue to respond even if the response resides only in lone figures such as herself.

Constructing a Woman's Life

"Ese año pasaron muchas cosas en este país. Entre otras, Andrés y yo nos casamos" [That year a lot of things happened in this country. Among others, Andrés and I were married].[11] So begins Catalina Guzmán's personal account of the making of this modern Mexican upper-middle-class woman as reflected in her first-person encounters with society. The series of narrated episodes forms one example of what may be viewed as a relatively new, innovative, and promising literary phenomenon in Latin America: the female bildungsroman.[12] This "life-novel"[13] (a narrative of transition from youth and inexperience through adolescence into the adult world, of learning and attempted initiation into society with the concomitant questions of personal identity, education, marriage, professional goals, and individual happiness)[14] merges Mastretta's contemporary questioning voice with that of Catalina into a retrospective portrait of a string of epiphanies. These revelations, self-revelations, and discoveries of the foci of power are combined in a process of demystifying traditional cultural values which if adopted would, in theory, make the adult Catalina merely repeat the role of previous generations of women.[15] This foregrounding of the woman's voice personalizes history to reveal both Catalina and Mexico as the result of change and experience; they are neither eternally docile social, political, and economic subjects nor stagnant entities. Rather, they embody the dynamic forces of conflict between the control and expression of one's own 'desires' (either national or individual), and the imposition of limits or restrictions from

'outside' (dictated norms that exclude, repress, or forbid by public pro-scription or private internalized self-censorship). This is shown to occur in the novel at three general levels: the family (via the husband, Andrés Ascencio), the state (through the military generals, political bosses or *caciques,* and emergent official party ideology), and international rela-tions (particularly with the United States). Instead of the bildungsro-man's expected stance of "looking at normality *from within,*"[16] the female narrator is increasingly aware of her nonconformity with the socially defined 'acceptable' role for her as one of the parts incorporated into the whole of the social structure. Her attempts at achieving independence from the traditional concepts of the masculine and the feminine as personified by her relationship with Andrés, both in life and in death, as his wife and widow, center on a series of confrontations with a Mexico in similar stages of self-definition. During this process she most certainly begins by "looking from within" social institutions as Moretti has de-fined it, but her gaze progressively scrutinizes 'normality' until Catalina unhesitatingly confirms that its social mechanisms are fundamentally 'abnormal.' Whether the two, Mexico and Catalina Guzmán, approach the questions in similar fashion or reach the same conclusions needs to be studied. In particular, we must ask whether the sentimental expression of the "national voice"[17] in the popular song is a moment of collective liberation in the way that it is one of individual liberation and recogni-tion for the female narrator. That is to say, what do these moments of 'epiphany' reveal?

In Catalina's emergence from innocence and selflessness to con-sciousness and 'self-centeredness' in the construction of an identity and the attempt to control her own nascent desires, there occurs a sequence of related moments of 'vision' and comprehension. These can be gener-alized as steps leading from images of geographical and psychological confinement to ones of rebellion (not programed collective revolution) and freedom. Her points of awareness are connected to both the personal and the social spheres, and they acquire more lucidity owing to her examination and narration of the events from the critical perspective of an adult. The narrator comments, for example, on the intervening years and their influence on her character: "Nos arrepentimos [de habernos casado], pero años después" [We regretted {having married}, but that was

years later] (pp. 10–11). She uses popular songs to punctuate these critical moments, frequently at the end of chapters or sections in the novel, as in chapters 10, 15, and 16, forming a kind of ceremony or ritual that announces and reveals her private feelings in a discourse accessible to the public. The songs summarize and close phases of her life; they encapsulate emotion in a kind of lyrical 'shorthand' not far removed from Kahlo's use of iconic semblances. On a more literal level, this vehicle of discourse reflects the actual development of technology in mass communication in Mexico via the singers and composers of the "Hora Azul" of XEW radio, since 1930 the promotional medium of this music and the instrument for the incorporation of Mexico into an international marketplace of universalized popular artifacts. By means of the figure of General Andrés Ascencio and his cronies it also concurrently taps into the vein of institutions such as the Institutional Revolutionary Party (PRI) and the Regional Confederation of Mexican Workers (CROM), whose political power was centralized and consolidated under individual figures of authority during the 1930s and 1940s.

Popular music—that is, commercial music intended to please a mass audience and simultaneously to promote and reflect a set of standardized norms of taste—is generally considered banal, childish, innocent, and at best only remotely concerned with social and economic realities.[18] Songs belonging to this category tend to have easy, repeatable melodies, universalized and unanimously sanctioned sentiments, and atemporal 'formulas' for success. The song fragments included in Mastretta's narrative, for example, talk of love, obsession, wounded hearts, being forgotten, bitterness, betrayal, the ruins and ashes of hope, and so on (see pp. 141–142, for example). Once established in the repertoire of popular culture, they remained, in the words of Manuel M. Ponce, one of their most renowned composers, a "nostalgia viva" [living nostalgia][19] against which the "nueva ola" [new wave] of rock and roll crashed in the 1960s. Curiously similar to the codified postrevolutionary political system and its personalization of power, the Mexican romantic *bolero* refuses innovation and adaptation in favor of solidifying (institutionalizing) its success with trite sentimentalism over and against changing economic and social conditions. An entire system of popular mythology has been built around both the writers and the performers of this musical genre, which

93

attempts to offer the public stability and tradition in the midst of 'chaos.' The themes of the unfaithful woman and the suffering, abandoned man who swears revenge and who attempts to conjure up retribution (by divine or natural forces, such as in "Relámpago" [Lightning bolt]) on those who betray him are permanently ensconced in the popular ballad for the moral support of those who continue to identify with them. The lyrics neither protest the exact circumstances nor explain the details of the situation, however; they merely offer cathartic outpourings of what is assumed to be universal grief and sorrow (or joy and pleasure, before the inevitable pain). In "La barca de Guaymas" [The launch from Guaymas], for instance, the traveler through life's seas is happy until a woman leaves him anguished, sobbing over his broken sails/heart. In "Relámpago," on the other hand, the wrath of the heavens is invoked by the man to carry the woman far away, beyond the reach even of death, as punishment for the 'evil' she has done him. The scenario is repeated and recognizable. As Morales points out, "al arribar a la cumbre [la música popular] se aferró a sus fórmulas de triunfo y se negó a evolucionar para mantener su vigencia entre los nuevos públicos" [on arriving at the top {popular music} held fast to its triumphant formulas and refused to evolve in order to keep up with new audiences] (p. 8). The usually romanticized cult images of Toña la Negra (Antonia Peregrino), Pedro Vargas, and Agustín Lara form important facets of Mastretta's narrative, since they are at the same time overt or covert allies of Catalina, vehicles to transmit her rebellion to her daughter Lilia, and figures that link Catalina's activities and perceptions to a broader national historical panorama.

Catalina's appropriation of this music abrogates its disconnection from the historical surroundings by shifting the frame of reference from the general to the particular. Her use of this music as a vehicle for the public performance of private desires substitutes for the loss of communicative language in interpersonal relationships, especially in the case of Andrés' censoring power over her life and over others, and the necessity to self-censor the spontaneous expression of her pleasure. This alternative space for feminine discourse, which is normally restricted to statements supporting the opinions and decisions of the male, allows an individual release of energy through a publicly accepted medium. All of this occurs at a moment when memory, desire, and history unite in the

personal interpretation of the standardized components of song, immediately forcing these elements into configurations with new connotations. In addition, the romantic ballad, the *paso doble,* the *ranchera,* the waltz, the *bolero,* and the *chotís* all link two centers of power that concurrently 95 exercise a certain erotic seduction: music and politics, the most compelling sites for individual assertion. The use of popular music as alternative discourse becomes an extension of the arena for the exercise of political power in its performance at General Andrés Ascencio's hacienda during critical social gatherings. Just as the social appearance of the dinners masks their underlying political significance, so the public enjoyment of the music is used to cover its hidden personal agenda of seduction for Catalina. The song lyrics are performed as a public spectacle, offering a scenario that proffers a mask (masquerade) for the private.

The personification of the climactic point of this encounter of forces—and the scapegoat for 'crimes' on the political as well as the personal level—is the symphony conductor Carlos Vives. In this character, classical and popular music as well as dissident political activity and the transgression of traditional social norms are joined. Vives represents a particularly vivid epiphany in Catalina's development; both his life and his death make her confront aspects of social reality and of herself heretofore unrecognized or repressed. This is especially true of her relationship with the power and ambition represented by Andrés. When the opposition between the two worlds becomes clear, Catalina remarks of her lover, Carlos: "Hasta que anduve con Vives, nunca se me ocurrió temerle [a Andrés]" [Until I began to go out with Vives, it never occurred to me to fear {Andrés}] (p. 147). Carlos is a threat to the stability and permanence of the world Andrés and his political pals have sought to impose on Mexican women, families, and institutions in general. His presence in the text reveals, for both Catalina and the reader, the violence, propaganda, and secret dealing involved in establishing the official political party and maintaining it in power. Without the contrapuntal activity of Carlos Vives, the narrative would have a less vivid focus for the musings of Catalina Guzmán about her husband. They would remain at the level of mere suspicion (or perhaps even paranoia).

Marriage is not, as might be considered standard in the classic bildungsroman, the definitive act for solidifying Catalina's identity and

establishing her as a consenting adult. Rather than stopping her growth, the wedding of an adolescent to a middle-aged general is the catalyst for her personal search for independence as a compensation for this relationship. While Andrés complacently falls asleep, Catalina walks the grounds all night, obsessed with a passion to "feel" [*sentir*]. She yearns for "experiences" and learns of a physical center for pleasure in her own body from a gypsy woman, not her husband. She concludes this first phase of her sexual experiences with these words: "Todo lo importante estaba ahí, por ahí se miraba, por ahí se oía, por ahí se pensaba. Yo no tenía cabeza, ni brazos, ni pies, ni ombligo . . . ahí estaba todo" [Everything of importance was located there, through {that spot} one saw, one heard, one thought. I had neither head nor arms nor feet nor navel . . . everything was there {in that one place}] (p. 13). This desire to feel, to test the limits, and to try out new things governs her actions throughout the novel, from her confessed "absoluta ignorancia" [absolute ignorance] (p. 10) about life at the moment her father hands her over to Andrés in a military wedding[20] in accordance with the general's orders (see pp. 14–20), to her husband's wake, where she narcissistically delights in being the center of attention—"eso me gustó" [I liked that] (p. 220) she says after turning men's heads at the funeral—and to which she is tempted to wear red, not black, in order to feel alive in her own right, not just as an extension of the deceased general. Just as in marriage she was not the traditional Mexican wife, in mourning she does not conform to the established code for the 'correct' Mexican widow. These changes reflect what Anderson calls the "displacement" of history (*histoire*) into subjective or private history (*récit*), the reduction of the scope of vision to personal experience (see p. 16).

The pursuit of Fernando Arizmendi, the private secretary of an old-boy politician, is the first step in her attempt to refocus her life in a direction defined by herself rather than by others. Instead of enduring the boredom and passivity of waiting for something to 'happen' to her or passively suffering the demythified realities of marriage ("todos los días durmiendo y amaneciendo con la misma barriga junto" [day after day going to sleep and waking up with the same belly at your side] p. 14) and motherhood ("una pesadilla, . . . estar continuamente poseída por algo extraño" [a nightmare, . . . being continually possessed by something

foreign] p. 31), Catalina decides to act on her feeling of passion, only to have it revealed to her that Andrés is still the architect of her desires or at least of her acting on them. Andrés does not remove the object of her desire from her reach, but he knows that Arizmendi is 'unreachable' from the start. In the narrative, her statement disclosing to the reader that "Desde que vi a Fernando Arizmendi me dieron ganas de meterme a una cama con él" [Ever since I laid eyes on Fernando Arizmendi I felt like jumping into bed with him] (p. 75) assumes the form of a public challenge to the general's social and political status at a dinner engagement and public function. Since she cannot, or does not, literally jump on Arizmendi, Catalina instead talks incessantly and dominates the conversation, and in doing so does not conform to her proper role as the wife of such a well-known figure as Andrés. The desire of the *body* is displaced onto a *language* of desire wherein the words of a woman stand in for the actions she cannot or does not take. The result is basically the same, nevertheless. In voicing her opinion, and by speaking up at all, Catalina commits almost as great a transgression as if she had actually gone to bed with Arizmendi. His response to his wife's 'indiscretion' of almost literally hanging on to every word that the secretary utters and even going so far as to put her hand on his thigh (p. 77), is Andrés' disclosure of just how much power he has. He "permits" (p. 79) and even encourages Catalina to see Arizmendi as much as she wants, allowing the flirtation, the "noviazgo" (p. 79), to continue until, at the last minute, he sees fit to tell her that the object of her desire is gay. Andrés, not Arizmendi, leads her on. Catalina's "desgracia" [misfortune], as she calls it, leaves her frustrated and Andrés victorious. She can only reveal her defeat in this deception to another woman, Pepa, the wife of another aging politician, who has found herself a lover and thus is an understanding though passive accomplice.

Before the manipulation is revealed, Catalina's indirect manner of expressing the liberating feeling of this semi-imagined relationship is by means of song.[21] After dining with a newspaper reporter (who serves as a source of information outside the limits and perspective imposed by Andrés), the agriculture secretary, and Arizmendi, she returns home— "entré cantando a nuestra recámara como a las doce" [I went singing into our bedroom at about midnight] (p. 83), she tells the reader—where she

97

is greeted by Andrés' snores, a sign of the usual boredom of their daily routine and lack of interest in each other. Nevertheless, Andrés' unperturbed attitude also reflects the security he feels about his absolute control over Catalina. In addition, the quest for Arizmendi extends her perception of the world beyond provincial Puebla into the intricate power structure of Mexico City and the president's Residencia de los Pinos mansion. Trips to and from this growing metropolis, the future single center of political and economic power in the country, are bridged in anticipation as well as in remembrance by the lyrics of popular melodies that accompany the travelers. In one instance, Catalina asks her driver and ally, Juan, to sing "Contigo en la distancia" [Together with you in the distance] while she reminisces about her recent innocent yet exciting rendezvous. She comments in retrospect: "me acostaba en el asiento del Packard negro a oírlo y a extrañar. Les buscaba varios significados a sus frases más simples y casi llegaba a creer que se me había declarado con disimulo por respeto a mi general" [I leaned back in the seat of the black Packard to listen to him and to miss {Arizmendi}. I looked for several meanings in his simplest sentences and almost managed to believe that he had declared his love for me in concealed form out of respect for my general] (p. 78). Just as the supposed "hidden" meaning of his words sends personal messages to Catalina, the songs also speak to her emotions. She personalizes and thereby actualizes the lyrics of these stock public expressions of sentiment. For Catalina, she herself becomes the "tú" of the song, and it is Arizmendi who confesses to her through its lyrics that he cannot bear to live apart from her, or at least this is the message she reads into the lyrics in a moment of wishful thinking. This moment reflects part of her gradual process of learning about the causes of her feeling both literally and figuratively locked up or constrained inside the house and the endless routines of women's league meetings, cooking classes, and charity work organized for her by Andrés. The 'distance' of the song is a metaphor for the social perspectives Catalina longs to learn about and of which she wants to become a part, leaving behind the limits of 'proper' domesticity. Even if Arizmendi has turned out to be a 'dead end,' the very same day she learns of Andrés' manipulations Catalina is provoked to make a decision of her own. She declares: "Yo me había dejado encerrar sin darme cuenta, pero desde ese día me

propuse la calle" [I had allowed myself to be closed in without realizing it, but from that day on I intended to move out into the street] (p. 111). The narrative then shifts scenes from inside to outside the frontiers of the house for the confrontations between Andrés and Catalina.

Arizmendi is merely a warmup, a practice session for the main event, Carlos Vives. When Catalina wanders into the concert hall in Bellas Artes (the Palace of Fine Arts) one afternoon, she is attracted by a sad, mysterious piece of music the orchestra is rehearsing. Instead of being able to reproduce it easily after leaving the theater, as she does with popular melodies, Catalina finds that both Carlos and the more formal, foreign-educated 'aesthetic' he represents do not fall into the categories of serialization as do Andrés and the romantic ballad she is more accustomed to hearing. More than just the music itself, however, she is transfixed by the power of the orchestra leader to make the instruments start or stop playing. Echoing the movements of a political figure who orchestrates social classes through his commands, Catalina identifies the musical sounds produced with the physical vehicle of direction, the conductor Vives. Just as the individual politician, or *cacique*, symbolically embodies the whole Mexican myth of political power and the orchestration of its movements, Vives becomes the incarnation of the music. She remembers: "me dejé llevar por los sonidos que parecían salir de los brazos del director" [I let myself be carried away by the sounds that seemed to emanate from the orchestra leader's arms] (p. 115). Even Andrés Ascencio is forced to admit the confluence of political and artistic power in the figure of Carlos Vives. After a concert, the general declares: "Este muchacho tiene aptitudes políticas, nadie sin aptitudes políticas puede sacar tantos aplausos de un teatro. Míralo nada más, parece que ha hecho el discurso de su vida" [This young man has political talent, no one without such talent can get so much applause from an audience. Just look at him, it's as if he just gave the political speech of a lifetime] (p. 131). In a larger sense, the encounter between the two men is also the confrontation of two political generations. One is represented by Andrés, Fito (the future president), military governments, the interests of the foreign and postrevolutionary domestic bourgeoisie, and worker and union repression masquerading as nationalism. In opposition are Carlos, civilian popular governments, insurgent workers' movements, independent trade

unions, and plural political parties.[22] Carlos Vives functions as the narrative vehicle for multiple epiphanies in the life of Catalina Guzmán; their relationship leaves a trail of broken myths behind. These fragments must serve the survivor as sounding boards for piecing together a new life.

Catalina gradually distances herself from the rhetoric of both political and personal entrapment as Carlos, her own children, Andrés' political rivals, and conversations with rural workers and their families expose the ideological uses to which public discourse is put. At first preferring willful ignorance, she gradually takes more control over her life. Catalina initially opts for passive resistance: "Yo preferí no saber qué hacía Andrés" [I preferred not to know what Andrés was doing] (p. 55), she admits. But this attitude changes as she becomes his target. Although the general takes revenge on Carlos, not directly on herself, as the object of her desire *and* as Ascencio's political opponent, Catalina is the ultimate 'enemy.' She moves out of Andrés' bedroom into her own and locks the door, opens her own checking account, threatens Andrés with exposure to the press about his slaughter of striking miners in Atencingo, resists the general's physical desires for her after he lies about his participation in politically motivated assassinations, and in general removes herself from her role as his "official accomplice" (p. 55). The discrepancies between theory and practice, between political propaganda and real events, are most vividly revealed in Andrés' public defense of women and their rights in his election campaign speeches, while Catalina simultaneously becomes aware of both the restrictions imposed on her own freedom of expression and of the coercion exercised on the political opposition. In the latter instance, candidates are often forced to flee the country while their supporters, such as Catalina, must demonstrate, at least in public, their agreement with official policies. Catalina's own outward adaptation to these circumstances is witnessed in the words she speaks after just such a flight to Venezuela by the opposition leader she has supported in a presidential election. She says: "Como yo, el gobierno de los Estados Unidos optó por reconocer y apoyar el triunfo del gordo {Fito}" [Like me, the government of the United States chose to recognize and support the triumph of the fat man {Fito}] (p. 101). With great sarcasm, Catalina observes the political situation in the country and hints at its implications for the individual:

Ese año la legislatura poblana les dio el voto a las mujeres, cosa que sólo celebraron Carmen Serdán [la mujer del gobernador] y otras cuatro maestras. Sin embargo, Andrés no hizo un solo discurso en el que no mencionara la importancia de la participación femenina en las luchas políticas y revolucionarias.

[That year the legislature in Puebla gave women the vote, something that only Carmen Serdán {the governor's wife} and maybe four other schoolteachers celebrated. Nevertheless, Andrés didn't make a single speech in which he didn't mention the importance of women's participation in political and revolutionary struggles.] (p. 45)

Thus Catalina juxtaposes rhetoric and reality, inverting the roles Andrés and she have had up to now concerning access to and control of information. The case of Carlos' disappearance is a good example. In spite of Andrés' public assertion of his own innocence, Catalina exhibits her knowledge of secret political detention centers as she instructs authorities exactly where to search for her lover. Before this moment she had never revealed to Andrés her knowledge of the government's violent police tactics. Hitting too close to home, the attack on Carlos is the catalyst that motivates her to take action. The ambiguity of her concurrent "shame" for depending on another person—the older Andrés, or even Carlos at first—and "happiness" (p. 121) at finally finding a partner is resolved when the unequal relationships slowly even up during her process of self-affirmation and distancing from the restrictive space of Andrés. She begins with almost adolescent 'tests' of Andrés, such as staying out late, going horseback riding without him, and learning to drive a car. But a certain de facto 'equality' is established between them when she arrives home at dawn, hoping to make a scandal, only to find that he too has been out all night and has yet to return home (p. 200). Her forays into society and politics become increasingly daring after this as she becomes the icon of the 'liberated' bourgeois woman.

The weekly social 'confrontations' or verbal duels between Andrés and Carlos repeatedly end with shifting musical solos and duets, as when Catalina and Carlos unite with Toña to sing together for the first time, symbolically announcing their union in spite of Andrés' adamant protests about the quality of her voice, an excuse to keep her quiet (pp. 140–143). Their duets run the gamut of romantic ballads, from "La noche de

anoche" [What a night last night] to "Cenizas" [Ashes] and, of course, the ballad "Arráncame la vida" of the novel's title. These single and multiple voices evoke auditory associations for all concerned: for Andrés the words fall somewhere between consolation and nostalgia for simpler times; for Catalina and Carlos they are confessions, cathartic assertions of freedom, emotional outlets for their mutual discoveries and pleasures. In this manner, popular romantic songs serve a function for Catalina similar to the function they serve for the commercial singers themselves. The singer Toña la Negra clarifies the suggestive power of her lyrics in the following declaration in a press interview: "Al estar frente al público es cuando desahogo mi emotividad. . . . Allí exteriorizo lo que me dice la canción y lo que estoy viviendo. . . . Por eso formo mis programas de acuerdo con mi estado de ánimo" [When I face the public I release my emotions. . . . There I exteriorize what the song says to me and what I am living. . . . For that reason I plan my programs according to my mood or frame of mind].[23] Catalina listens to the popular ballads from which Andrés normally attempts to exclude her by his demands for silence; she then responds, saying that she cannot resist participating in a liberation of suppressed desires that culminates in subtle yet open defiance of the general and his colleagues. Andrés may think it is only the lyrics, but Catalina uses the *act* of singing to state a contradiction as well. As she exclaims at one tense moment when singing itself helps her overcome doubt: "¡'Temor'! . . . Esa canción que imaginé escrita para mí" ['Fear'! . . . That song I imagined was written just for me] (p. 141). By her reference to a song whose lines suggest both physical and emotional fear, trepidation on both the objective and 'fantastic' levels, and a distressing apprehension aroused by a feeling of impending danger, the reader is made aware that in addition to her personalization of these songs, they are at the same time allegories of the struggles for political power personified in the discrepant lives and ideologies of the two men involved, Carlos and Andrés. There is Catalina's literal "fear" of Andrés' reaction to her personal liberation as carried out through her lover, Carlos, a reaction seen in the general's participation in the singing of lyrics suggesting his own state, such as "Canta, si olvidar quieres tu dolor" [Sing, if you want to forget your pain] (p. 142). But whether imagined or actual, the fear of impending danger aroused by these confrontations is further conditioned

by their symbolic resistance and challenge to the Mexico of a sacrosanct, institutionalized 'new state' promoting no space for her freedom but instead relegating her to silence. Mastretta's manipulation of this scene promotes the character Catalina as a force capable of interrupting the superficial harmony of such a popular and generally accepted musical genre. It also hints at the possibility of a culture regaining its own voice in the face of foreign imposition. Catalina sings neither Argentine tangos nor North American jazz, the two other musical genres in vogue at the time. Instead, she chooses to reinterpret a national musical tradition for herself and in doing so reaffirms her desires as well as her capacity to individualize or recontextualize the sentiments expressed in these songs.

From the very first pages of her autobiographical text, Catalina connects her fleeting instants of liberation with the image of the sea, whose vast open space and constant murmur seem to remind her continually of her inner desires, in spite of and in contrast to the surrounding society.[24] The ocean's 'music' also serves to stimulate and release memories of the time she spent with Carlos. The two even merge into one image, especially in retrospective contemplation: "El mar *era* Carlos Vives desde que nos escapamos tres días a una playa desierta en Cozumel" [The sea *was* Carlos Vives ever since we escaped together for three days to a deserted beach in Cozumel] (p. 202; my emphasis). From the early desire to escape to the ocean, the unknown, the open space of paradise when she is fourteen, by the age of thirty Catalina has learned of the possibility of specific relationships that can fulfill her changing needs. At fourteen, Andrés was the only option she was given, but as the years passed she found herself choosing others. This 'natural' voice of the free woman Catalina seeks to be is, of course, in contradiction to Andrés, who comments that "Me molesta el mar, no se calla nunca, parece mujer" [The ocean bothers me, it never keeps quiet, it's just like a woman] (p. 213). The incessant sound of someone or something not under his control threatens his obstinate hold on power, a fact that is also reflected in the manipulation of his daughter Lilia as a bargaining chip for political alliances. To this end the general orchestrates the public serenade by the XEW superstars and popular heroes Agustín Lara and Pedro Vargas to convince Lilia of her official suitor's "appropriateness" as a spouse. He does not listen to what the two women say; for him, they are background

noise, like the waves. While they create a kind of static in his field of communication, he perceives their voices as sounds lacking in meaning. The restless voice of the ocean, however, lives on from Catalina into Lilia, the young woman who inherits Catalina's rebelliousness.

104

Although this narrative reveals only the preliminary stages of her rebellion, when faced with her father's elimination of her own choice of a husband in favor of his preference (Lilia and her lover are a mirror image of Catalina and Carlos here), she goes ahead with plans for the politically arranged marriage but keeps her lover as well. This is true at least until he dies in a motorcycle accident as 'arranged' as Carlos' earlier demise. Catalina laments the perpetuation of the individual woman's sacrifice implicit in this struggle. Her thoughts of Lilia almost review her own past: "Dieciséis años y ese cuerpo, y esa cabeza a la que tanto le falta aprender, y esos ojos brillantes y todo lo demás se va a quedar en la cama de Milito [Emilio Alatriste]" [Sixteen years old and that body, and that brain which still has so much to learn, and those sparkling eyes and everything else are going to end up in Milito's bed] (p. 166). But she is vividly aware of the force Andrés is willing to exert to get his way. Lilia belongs to a new generation of Mexican women, perhaps closer to Mastretta's own, who are coming of age in the transition between her father's personal embodiment of political authority and her mother's first tentative steps toward change. She is thrust into the spaces between public and private ideologies and may be able to appropriate the potential power of that marginal space. The imposed romantic serenade for Andrés' daughter punctuates a ceremony that is increasingly revealed as muscle flexing, the grafting of a traditional mode of standardized or serialized expression onto an attempt at liberation and the exercise of choice. The serenade is a ritual, an obligatory public announcement of propriety in the social arena, where political maneuvers are responsible for most if not all personal arrangements.

The End Is Just the Beginning

Just as Andrés' life represents certain configurations of power—as a cacique revered and given homage in Puebla (p. 209), as an indispensable presidential advisor who is confident of future favors, as the unshakable

patriarch—so his last days and death suggest the death throes of that political and social order. At the very least they ironically suggest the implications of the possibility of such an order proceeding and enduring when confronted with reactions to its restrictions such as those presented here. In Andrés' deathbed confessions to Catalina, he surveys both his personal situation and the political circumstances of Mexico's future. On the one hand, he underlines for the last time the powerful effect he fervently hopes to have had on her life. With great pride he tells her: "Te jodí la vida, ¿verdad? . . . Porque las demás van a tener lo que querían. ¿Tú qué quieres?" [I really screwed up your life, didn't I? . . . Because the others {his other women} are going to get what they wanted. But just what is it that *you* want?] (p. 214). Each of them seems to have acted more in antagonism to the other than to achieve goals to which they are really committed. He finally has to admit that there is a part of her that has always escaped him, the part voiced by the sea and the song lyrics. He still hears that as unintelligible noise. Andrés tells her: "No me equivoqué contigo, eres lista como tú sola, pareces hombre, por eso te perdono que andes de libertina. Contigo sí me chingué. Eres mi mejor vieja, y mi mejor viejo, cabrona" [I wasn't wrong about you, you're really sharp, you're just like a man, that's why I let you get away with being a libertine. With you I really got screwed. You're my best old lady, my best old man, you bitch] (p. 211). But his admiration is tinged with a sense of frustration when he adds, "sé que te caben muchas mujeres en el cuerpo y que yo sólo conocí a unas cuantas" [I know that you're made up of many different women and that I met only a few] (p. 214). By calling her the equivalent of a man, the general recognizes a certain equality of spirit, if not of protection under law or social convention, that Catalina has earned through her persistent efforts at resistance. This perverse admiration only appears at the end of the narrative, however, and a deathbed confession signals closure rather than dialogue or praxis for either confessor or confessant. Andrés' death just closes *that* part of her life, not future dealings with others *like* him.

On the other hand, Andrés, not Catalina, appears shocked when he learns of the betrayal demonstrated toward him by the system of political patronage that he has embodied all his life. Although his wife secretly admits that "No me apenó verlo perder fuerza" [It didn't grieve me to see

him lose power] (p. 207) since she has felt firsthand what the effects of this power can be, Andrés has to face the fact that in Mexican politics, everyone, without exception, is ultimately expendable. When he is re-
106 placed in the hierarchy of advisors surrounding the president, he responds incredulously, "No quería creer que Fito pudiera sobrevivir sin [mis] consejos y [mi] ayuda" [I didn't want to believe that Fito could possibly survive without {my} advice and {my} assistance] (p. 205). Andrés Ascencio is one of the victims of the tactics that the triumphant bourgeoisie employed to consolidate its power between the 1920s and the 1940s, when Generals Obregón and Calles continued Porfirio Díaz's work of centralizing and unifying the power of the Mexican state. The political rules of the game of today's corporate state were established at this time. These include crushing military insurrections, offering concessions to obtain U.S. investment, provoking and then squelching the Cristero rebellion to demonstrate government control, creating the CROM to control labor activity,[25] and granting state favors to bureaucrats and international bourgeois interests. With Andrés suddenly out of politics in his old age, he immediately talks of shifting to the contemporary alternative scenario of power. This move would require an investment in the emerging system of capitalism, which is taking the place of a more 'primitive' national economic system of patronage. He learns at least the most superficial lessons of capitalism well and, among other entrepreneurial enterprises, announces plans to open a cigar factory to fulfill the demand for this product abroad and capture the international market. Catalina recounts his dreams: "Volvió a decir a todas horas que el verdadero poder es de los ricos y que él se iba a convertir en banquero" [He kept saying over and over that the real power belongs to the rich and that he was going to become a banker] (p. 207). But Andrés belongs to the past. He will not live to compete with the young financial manipulators of the 1950s and 1960s. His observations, however, are astute, because he recognizes that power and money will still be concentrated in the hands of a select few, now the technocrats, even if the funds come from international sources rather than the cacique landowners.

In the end, Catalina realizes that Andrés' death signifies a change of generations as well as of orientation in the country. Andrés calls the

government's economic plans a sellout that can only be remedied by his traditional *machista* brand of justice: "balazos" [bullets; a shoot-out] (p. 217). His patriotic fervor for the authoritarian political structure of vertical power is wounded by the invasion of foreign capital facilitated by Martín Cienfuegos, the *elegido,* or chosen one, to be groomed by Fito for future political office. Of Cienfuegos he says, "Ese cabrón hasta las esperanzas va a subastar. En un ratito enlata el suspiro de tres mil desempleados y se los vende a los gringos para cuando quieran sentirse deprimidos. Va a vender el Angel de la Independencia, el Hemiciclo a Juárez y si se descuidan hasta la Villa de Guadalupe. *Mexican souvenirs.* . . . Todo muy moderno y muy *nais,* que no se nos note lo rancheros, lo puercos, lo necios, lo ariscos. Otro Mexsicou" [That son of a bitch is even going to auction off our hopes and dreams. In a little while he'll package the sighs of 3,000 unemployed workers, and he'll sell them to the gringos for the times when they want to feel depressed. He's going to sell the Angel of Independence, the Monument to Juárez, and if they're not careful even the Villa of the Virgin of Guadalupe. Mexican souvenirs. . . . All very modern and very nice, so that they don't notice how corny, how dirty, how stubborn, how insolent we are. Another Mexico . . .] (pp. 216–217). This crossroads posits the pawning of traditional national symbols and heroes in a gesture of incorporation into the international capitalist marketplace of tourism, a future unfathomable to those such as Andrés who have protected national interests closer to home behind the facade of the Revolution. The English 'invasion' of the Spanish language ("Mexican souvenirs," "Otro Mexsicou," "nais") is merely the first reflection of a more violent economic invasion of the country and rape of its resources yet to come. As Andrés fades away, the music in this narrative dies out too. No longer does the necessity exist to seek an emotional outlet through the masking echoes of the popular ballad, at least for Catalina Guzmán. Instead, she is witness to an eclipse of charismatic provincial authority as well as the creation of a bridge into the 'new Mexico' of the mass media, complex international political alliances, and the shifting aesthetics of the developing cinema industry in place of the traditional popular romantic song. The caciques do not disappear; they just 'go Hollywood' and get packaged into superstars by the media.

Even Catalina begins to think of herself as dressing in the "Hollywood style" (p. 113) or as playing a role such as the prostitute in the classic Mexican film *La mujer del puerto* [Woman of the docks] (p. 115).
108 Enslaved by neither Andrés' reality (while alive) nor his memory (when dead), she strikes out on her own—as does Mexico, at least in theory, divorced from the myth of its 'ancient' history—toward an ambiguous freedom that requires both flexibility and courage. Catalina reflects on this open space stretching out in front of her after Andrés is buried. She comments to herself on what one critic has described as a certain "stoicism"[26] that has been building in her character: "Estaba sola, nadie me mandaba. . . . Divertida con mi futuro, *casi* feliz. . . . Me sentí libre. Tuve miedo." [I was all alone, no one ordered me. . . . {I was} pleased with my future, *almost* happy. . . . I felt free. I was afraid] (p. 226; my emphasis). Her happiness cannot be complete because an element of insecurity accompanies the uncertainties of the future and her responsibility for decisions. Moreover, a woman's happiness has traditionally been associated with dependence on another to create or supply the conditions for this emotional state. Now Catalina has to find what *her* happiness is on her own. As her friend Josefita tells her in confidence, and with a certain complicity, "La viudez es el estado ideal de la mujer. Se pone al difunto en un altar, se honra su memoria cada vez que sea necesario y se dedica uno a hacer todo lo que no pudo hacer con él en vida. . . . Con que no cometas el error de prenderte a otro luego luego, te va a cambiar la vida para bien" [Widowhood is the ideal state for a woman. You put the deceased on an altar, you honor his memory whenever necessary, and you dedicate yourself to doing everything you couldn't do with him alive. . . . As long as you don't make the mistake of grabbing on to another {man} right away, it will change your life for the better] (p. 221). Josefita is more proscriptive than prescriptive in her remarks. If Catalina does not 'latch on' to another man right away, she will have to decide what her alternative courses of action are in order to survive in Mexican society without being branded with one of the many epithets used for an unattached woman (prostitute or lesbian, for example).

At the end of *Arráncame la vida,* the 'Golden Age' of traditional Mexican culture as Andrés and Catalina know it is over. Boleros will meet rock and roll, in 1971 the government will officially sanction

'modern' music as an alternative to social protest at Avándaro (the
Mexican equivalent of Woodstock), caciques will confront the PRI and
the IMF, and women will have to respond to the demands of changing
social and economic situations in the ensuing decades. Catalina looks
109
forward, not backward, as private memory turns into public grief. For
the first time she openly mourns the loss of Carlos, transferring or
displacing the real pain over his death onto the ceremony for Andrés.
What she *sang* to Carlos was the unsayable; what she *can* cry for she uses
as a vehicle for the unmournable. Once again a public rite becomes the
locus for private desire. She finds it difficult to remember exactly what
Andrés looked like, but Carlos' image is still close to the surface. The
general's funeral is her catharsis, less for him than for all that is connected
with him: "Pensé en Carlos, en que fui a su entierro con las lágrimas
guardadas a la fuerza. A *él* sí podía recordarlo: exacta su sonrisa y sus
manos arrancadas de golpe. Entonces, como era correcto en una viuda,
lloré más que mis hijos." [I thought of Carlos, of the fact that I went to his
burial forced to hold back my tears. I could remember *him* easily and
exactly: his smile and his hands snatched away so suddenly. Then, as was
correct for a widow, I cried even more than my children] (p. 226; my
emphasis).

Rather than hold on to the past as older generations might do
through the nostalgic medium of the popular song, Catalina looks in-
stead to the future. She leaves the past behind in the cemetery, although
obviously it has been kept alive in her memory or she could not have
written these pages. Contrary to the traditional bildungsroman, Ma-
stretta's novel does not emphasize the value of the existing order and
therefore confirm it. The narrative contradicts this genre, based on its
"refusal to consider the future still 'open,' . . . [a conclusion that] is
presented as an indication of maturity. *Bildung* is concluded under the
sign of memory, of *mémoire voluntaire,* of the rationalization of the
accomplished journey."[27] In this narrative Catalina and, through her
character, Mastretta have indeed 'turned back' to consider and reconsider
the epiphanies that have occurred in the past; but it is a new woman who
steps out of the last pages of *Arráncame la vida*. If the novel begins with
what Moretti terms a "specifically 'bourgeois' dilemma—the clash be-
tween individual autonomy and social integration" (p. 67), it does not

end with the integration and "symbolic legitimation" (p. 67) of society's desires through a process of interiorizing them or grafting them onto those of the individual. Catalina is not independent of her past, but she certainly is aware of the patriarchal power that went into its formation. Whether this power disappears with Andrés or merely assumes a new guise (which can even be considered 'liberating') is one of the questions at the end of the text. The other, of course, is whether the role of the widow is as 'free' as the women seem to think it will be. As Anamari Gomís concludes in her review of this novel, "Por fin, cree la pobre [Catalina], se ha liberado, pero analizar a Catalina G. viuda de Ascencio a partir de su 'verdadera liberación' sería asunto de otra harina novelesca" [Finally, the poor girl thinks she has become free, but to analyze Catalina G., widow of Ascencio, from the starting point of her 'true liberation' would be the topic of a whole other kind of novel].[28] (The same can be said for the future of the Mexican state.) In this intricately woven text, Mastretta focuses on an example of the development of "the culture of modern individuality"[29] by foregrounding the oppositional element of the woman's reply to the voices of social sanction. At the same time, Mexico's reply to international cultural and economic pressures is also at stake. A primary vehicle of this individual voice[30] within the social intercourse of developing capitalist industrial relations is the standardized lyric of the Mexican popular song.

EPILOGUE

The principal aim of this book has been to present a study of four twentieth-century Mexican women involved in various ways in literature and the arts, with special focus on those who inhabit the zones *between* traditional genres. This includes both those women as yet little known outside their own country and those already introduced—to some extent, at least—to an international reading public. In the process of articulating the issues under discussion, I have made it a point to keep a careful eye on the English-language reader, because the cultural products contained in this study are part of a society that is frequently viewed only on the surface, or from a distance, in terms of binary oppositions or exotic cultural constructions. To this end, I have deemed it important to translate material quoted in the original Spanish and to attempt to describe the shifting relationships between emerging social structures and the individual, as well as between the centers of power and the potentially contestatory margins of Mexican culture (although in point of fact I consider this last issue to be of singular importance for an analysis of cultural production in *any* language). In the case of Castellanos, for example, this process has meant not only the consideration of women's roles in postrevolutionary Mexico but also the political and ideological manipulation of social classes and ethnic groups and, in turn, the official representation of them. For Kahlo it lies in the confrontation between Mexican and European models of art, the First World's 'discovery' of the exotic, the implementation of the organs of the mass media, and the subsequent implications for self-representation within these spheres of cultural (and economic) influence. Poniatowska presents the perspective

of the physically impaired and the socially alienated in her portraits of Gaby Brimmer and Angelina Beloff, and as author/mediator represents some of the realignment of the voices of the generation of Mexican intellectuals whose 'coming of age' occurred in 1968. For Mastretta the concerns include rural versus urban environments, province versus metropolis, national and individual dependence versus independence, and the techniques for survival of the bourgeoisie within Mexico's own capitalist 'coming-of-age.' I have therefore insisted on discussing the intimate and quite often suppressed connections between the historical circumstances of these women's cultural production and their own self-perceptions in this process of exploring their texts. That is to say, each chapter has examined the influences of society on the individual as much as those of the individual on society.

Beginning with Kahlo and continuing through Castellanos and Poniatowska to Mastretta, these chapters have attempted to offer some sense of commonality among the preoccupations of the four women while simultaneously pointing out the changing conditions surrounding them, or in some cases, the discrepancy between officially announced changes, such as those of the 1917 Constitution, and the underlying inflexibility. These women's physical and social bodies, their psychological portraits, their self-representations, and their choice of words and images are seen to be battlefields on which several skirmishes are being fought at once. Their sites of confrontation include the encounters between activity or questioning and passivity or acceptance, between protest and silence, between the self and the Other, between change and stasis, and between participation and observation. All these facets of their lives and works have taken multiple shapes. Their visual and verbal discourses interrogate not only the content of their production but also the mold into which it is put. In other words, they critically reconsider the traditional genres of self-portrait, autobiography, private chronicles such as diaries and letters, 'objective' journalism, and the historical novel itself. In each case the act of interrogation reveals these genres to be more problematic than clearly delineated. But Kahlo, Castellanos, Poniatowska, and Mastretta all adapted what they found to suit their own needs, creating in the process a series of 'hybrids' whose greatest power lies

perhaps precisely in the interstices between the 'acceptable' forms of those genres.

I hope that the contents of this volume speak at the same time to the traditional or standard perception, especially from 'outside,' of Mexican culture as a firm, steady, and permanent social structure with a smooth, homogeneous surface. I hope, moreover, that its treatment of the multiple relationships between women and the institutions of power in that country point out that oversimplification of the discussion to an ahistorical, static male/female dichotomy impedes our seeing women's seizure of the alternatives available to them at specific junctures in history within a greater cultural context. As Cockcroft points out, reducing Mexico to an image of homogeneity and stasis signals an ideological discrepancy between appearance and reality. It also conforms to what the First World might *want* to find in an Other or, in a self-fulfilling prophecy, what it *predicts* it will find and proceeds to find just that. Cockcroft concludes that

> Mexico's much-vaunted 'stability' has come to resemble that of a well-guarded zoo, with lions in cages and zebras on a grassless pasture. At night the caged animals roar to get a bone; the starving herds in the dusty compound try to swim the river around it. For the other side of the coin is that Mexico's revolution has brought forth a sophisticated centralized state that Mussolini would envy. (p. 2)

I hope these four chapters have produced a cracking or splitting open of that surface, with its glossy appearance of unanimity, suggesting in its place the presentation of what Mikhail Bakhtin calls heteroglossia, or a release of multiple testimonial voices in which no single one dominates nor is any one lost in a struggle for absolute univocal power. Each one of these four women attempted to respond to her milieu in the manner she perceived as the most plausible; the results are the diverse and multifaceted texts explored here. Rather than writing a 'coda,' in the sense of a passage that fills in all the spaces and brings this composition to a predictable or 'satisfactory' close in a chorus of coalesced voices, I suggest instead that the study undertaken here function as the starting point for continued discussion and debate. Many other voices—those of Elena

Garro, María Luisa Mendoza, Luisa Josefina Hernández, María Luisa
Puga, Cristina Pacheco, Silvia Molina, Guadalupe Loaeza, Ethel Krauze,
and Sara Levi Calderón, to name just a few—still call out for attention.
They will become clearer as we put them into networks of relations and
into cultural and historical perspective.

NOTES

Introduction

1. June E. Hahner, ed., *Women in Latin American History: Their Lives and Views,* rev. ed. (Los Angeles: UCLA Latin American Center Publications and the University of California Press, 1984), p. 1.

2. Asunción Lavrin, ed., *Latin American Women: Historical Perspectives* (Westport, Conn.: Greenwood, 1978), p. xiii.

3. Hahner, 1980 ed., p. vii.

4. In his essay on nineteenth-century European modernism, Andreas Huyssen discusses gender inscriptions on critics and readers of popular culture, the woman being consumer of the popular while the man is, in Huyssen's words, "writer [and reader, it is supposed] of genuine, authentic literature—objective, ironic, and in control of his aesthetic means" ("Mass Culture as Woman: Modernism's 'Other,'" in Tania Modleski, ed., *Studies in Entertainment: Critical Approaches to Mass Culture* [Bloomington: Indiana University Press, 1986], pp. 189–190). The political implications for Latin America of the transference of such a division between empowerment and powerlessness are devastatingly clear.

5. The works referred to, in order of authorship, are : *Homenaje a Rosario Castellanos* (Valencia: Albatros Hispanófila, 1980); *Women's Voices from Latin America: Interviews with Six Contemporary Authors* (Detroit: Wayne State University Press, 1985); *Rosario Castellanos: Una conciencia feminista en México* (Chiapas, Mexico: Universidad Nacional Autónoma de Chiapas, 1983); *Contemporary Women Authors of Latin America* (Brooklyn: Brooklyn College Press, 1983); *The Lost Rib: Female Characters in the Spanish-American Novel* (Lewisburg, Pa.: Bucknell University Press, 1985); *One Master for Another: Populism as Patriarchal Rhetoric in Dominican Novels* (Lanham, Md.: University Press of America, 1984);

and *Señas particulares: Escritora (Ensayos sobre escritoras mexicanas del siglo XX)* (Mexico City: Fondo de Cultura Económica, 1987).

6. See note 1 in Myers' review of a series of recent texts dealing with the figure of Sor Juana Inés de la Cruz in the *Michigan Quarterly Review* 29 (Summer 1990): 470.

7. One of the latest books published under the unofficial rubric of a portrait that penetrates the surface to reach the 'real' Mexico is Patrick Oster's *The Mexicans: A Personal Portrait of a People* (New York: William Morrow, 1989). In this case, mutual "misunderstandings," cultural and historical ignorance and "insularity," and even, as Oster bluntly puts it, the sheer numbers of inhabitants of "this hard-to-fathom beast called Mexico" (p. 13) motivate his study of social 'types' such as the *tragafuegos* [fire eaters], the *fayuqueros* [black-marketeers], the *pepenadores* [garbage scavengers], the *güeras* [non-Mexican-looking white-skinned blondes], and the *muchachas* [servant girls] in order to show, in Oster's words, that "Mexicans are different from you and me" (p. 287).

8. I refer to the following: Raquel Tibol, *Frida Kahlo: Una vida abierta* (Mexico City: Oasis, 1983); Hayden Herrera, *Frida: A Biography of Frida Kahlo* (New York: Harper and Row, 1983); and the more recent and even more comprehensive study by Martha Zamora, *Frida: El pincel de la angustia* (Mexico City: Privately printed, 1987), translated into English in an abridged edition by Marilyn Sode Smith as *Frida Kahlo: The Brush of Anguish* (San Francisco: Chronicle, 1990). Among a number of films on various aspects of her life and works are *The Life and Death of Frida Kahlo,* by Karen and David Crommie (San Francisco); a documentary prepared for the Whitechapel Gallery exhibition on Frida Kahlo and Tina Modotti by Laura Mulvey, Lynda Myles, and Peter Wollen (1982); and *Frida: Naturaleza Viva* [Frida: Still Life] made in Mexico and directed by Paul Leduc (1984). Mulvey, Myles, and Wollen's valuable essay written for the exhibition catalogue of the Whitechapel Gallery show is reprinted as "Frida Kahlo and Tina Modotti" in Mulvey, *Visual and Other Pleasures* (Bloomington: Indiana University Press, 1989), pp. 81–107.

9. Beloff's memoirs were published, interestingly enough, under the auspices and budget of the Editorial Board of the Diego Rivera Centennial Commission. The volume is introduced by Bertha Taracena and contains an epilogue by the art critic Raquel Tibol.

10. Preface to Araceli Rico, *Frida Kahlo: Fantasía de un cuerpo herido* (Mexico City: Plaza y Valdés, 1987), p. 11.

116

11. Kahlo's image has appeared with increasing frequency over the past few years in places as culturally and geographically diverse as t-shirts in New York City, postcards in Europe, faces on clothing mannequins in Mexico City, and the paintings of young artists such as Aurora Reyes (for instance, *Retrato de Frida frente al espejo* [Portrait of Frida in Front of the Mirror], in which the viewer observes Kahlo observing herself, revealing the nude torso, which is otherwise covered up decorously) and Juan Dávila (whose painting *Frida*—now with a universal product bar code in one corner—appears in *Transcontinental: An Investigation of Reality; Nine Latin American Artists*, by Guy Brett). Most recently there was an 'homage' held to Kahlo in the Zócalo station of the Mexico City metro on November 1, 1990. In this spectacle, a number of men and women dressed in Day of the Dead skeleton masks and folkloric native costumes rode the subway cars, to the obvious astonishment of the commuters. (See the photograph on page 1 of *Unomásuno* from November 1, 1990.) So ubiquitous and malleable is her self-portrait that in his article Peter Schjeldahl decides that he must assure us that in spite of 'lending' herself to so many different uses, "We will not use her up." His article, entitled simply "Frida Kahlo," appears in the self-styled fashion/arts/gossip/interview magazine *Mirabella*, November 1990, p. 67.

12. The following comments by Roberto Blanco Moheno reflect one direction of the widespread discussion in Mexico about this popular novel: *"Arráncame la vida* [es] una novela muy bien hecha, PERO CASI EXACTA, que describe con el pretexto de una chistosa liberación femenina, la terrible época en que Maximino Avila Camacho fue desgobernador de Puebla. El truco, viejísimo, consiste en utilizar personajes históricos, que han existido, con quienes hemos hablado algunos, a quienes todos hemos sufrido, poniéndoles otro nombre.... La señora Mastretta . . . fue hasta el sucio fondo de los hechos y la terrible subconsciencia de los personajes para crear un libro muy bien hecho cuyo truco del cambio de nombres puede tranquilamente explicarse . . . por el natural temor a una demanda judicial, o a la venganza, tan frecuente en la terrible historia de los Avila Camacho" [*Arráncame la vida* {is} a very well written, ALMOST EXACTLY ACCURATE, novel that behind the pretext of a lighthearted {tale of} feminine liberation describes the terrible era in which Maximino Avila Camacho was the ungovernor of Puebla. The trick, as old as the hills, consists of using historical characters that have really existed, with whom some of us have spoken, whom we have all had to endure, giving them another name. . . . Señora Mastretta . . . descended into the dirty depths of the facts and the terrible subconscious of the characters to create a very well written book whose ploy of

117

changing names can easily be explained . . . by the natural fear of a lawsuit, or of revenge, so frequent in the terrible history of the Avila Camacho family] ("Hablar sobre petróleo y hacerlo con la verdad," *Siempre,* no. 1869 [April 19, 1989], p. 25). The historicity of the novel, its portrayal of the 'Maximato,' and its record of violence are the focus of attention in Blanco Moheno's opinion, not the literary 'disguise' of the "lighthearted tale of feminine liberation." One of the few critical articles on this novel that I have found, aside from a brief book review in *Nexos* in July 1985 when it first appeared on the market, is a valuable essay by Danny J. Anderson entitled "Displacement: Strategies of Transformation in *Arráncame la vida* by Angeles Mastretta," (*Journal of the Midwest Modern Language Association* 21 [Spring 1988]). It contains a detailed examination of the counterpoint between *histoire* and *récit* in this novel, using analytical categories from studies by Michel Foucault, John Brushwood, and Hayden White.

13. Elizabeth A. Meese, *Crossing the Double-Cross: The Practice of Feminist Criticism* (Chapel Hill: University of North Carolina Press, 1986), p. 5. Gabriela Mora calls Latin American women's production "oppositional," a term that underscores their use of and commentary on the very structures against whose boundaries and limitations they constantly strain (through the use, for instance, of satire and parody). See "Narradoras hispanoamericanas: Vieja y nueva problemática en renovadas elaboraciones," in *Theory and Practice of Feminist Literary Criticism,* ed. Gabriela Mora and Karen S. Van Hooft (Ypsilanti, Mich.: Bilingual Press/Editorial Bilingüe, 1982), p. 160.

14. I orient the discussion of women's solitude (Brimmer's, Beloff's, and Castellanos'), for example, toward the concept of social and economic alienation or rejection as a specific modern condition in industrializing capitalist Mexico, not as a generalized category of 'crisis' that is permanently part of the human condition. The four women and their work are evaluated within the fragmented framework of social relations that quite often impede the fulfillment of their true human needs and desires, regardless of their outward appearance of full socialization.

15. Luis González, *México mañana* (Mexico City: Océano, 1986), p. 10.

Chapter 1. Frida Kahlo

1. See, for example, Francis Barker's excellent text *The Tremulous Private Body: Essays on Subjection* (London: Methuen, 1984) for a thorough discussion of Rembrandt's *The Anatomy Lesson of Dr. Nicolaas Tulp* and seventeenth-century painting. There is also a very useful article by Jean-Pierre Guillerm in the *Revue*

des sciences humaines 198 (1985) entitled "Aux couleurs de la mort: Variations sur la peinture et la médecine dans la critique picturale à la fin du XIXe siècle," which includes a study of two central issues. The first is what he calls "la profonde perversité de l'esprit de la Renaissance que préfère la bizarrerie et la maladie à la Nature saine" [the profound perversity of the Renaissance spirit that prefers bizarreness and illness to healthy Nature] (p. 73), referring to that which is excluded from the acceptable code of academy painting and the traditional aesthetic yet which puts a certain emphasis back on the human body. Second, Guillerm examines "le rejet de l'eternelle jeunesse du corps académiste" [the rejection of the eternal youth of the academist body] (p. 74), that is, the acknowledgment of the essentially historical nature of the body as opposed to an eternalizing of the 'perfection' of youth. Through their categories of analysis, both of these studies contribute to an understanding of Kahlo's paintings, as shown below. It is quite interesting, in addition, that the art critic John Berger uses the same Rembrandt painting as a point of comparison for his discussion of a UPI photograph of the recently dead Ché Guevara taken in Bolivia in 1967. He remarks on the position of the deceased's body and the doctors surrounding it in similar terms, noting "[t]he placing of the corpse in relation to the figures above it, and in the corpse the sense of global stillness." (From the British publication *The Minority of One,* cited in Léo Sauvage, *Che Guevara: The Failure of a Revolutionary* [Englewood Cliffs, N.J.: Prentice-Hall, 1973], pp. 3-4). Such a reciprocal relationship between body (corpse) and interested observer (society) is also present in Kahlo's self-portraits. In addition, the Other's dissection of Latin American revolution in the dissection of the body/embodiment of such radical political activity carries over to Kahlo's production of images. She simultaneously reflects an investigation ('dissection') of her own situation and Mexico's.

2. Barker, p. 73. Kahlo's own expressed interest in becoming part of the medical profession—she began her studies as an unofficial premed candidate—modifies the male orientation of this 'gaze' besides: Tibol cites "su vocación por la medicina, carrera que muy pocas mujeres seguían entonces" [her interest in the vocation of medicine, a profession that very few women entered at that time] (Tibol, p. 16).

3. For a detailed discussion of this concept in the film genre, see Mary Ann Doane's stimulating book *The Desire to Desire: The Woman's Film of the 1940's* (Bloomington: University of Indiana Press, 1987), especially the first two chapters entitled "The Desire to Desire" and "Clinical Eyes: The Medical Discourse."

4. Paul de Man established a much broader consideration of the term *autobiographical narrative* that seems equally suitable to visual discourse as both a capturing or constant recapturing of the life-history of its author and as a self-conscious awareness of always being in the *process* of creating one's own identity. For de Man, an autobiographical work may be "any text in which the author declares himself the subject of his own understanding." (Cited in Paul Jay, *Being in the Text: Self-Representation from Wordsworth to Roland Barthes* [Ithaca, N.Y.: Cornell University Press, 1984], p. 17.) I believe all of Kahlo's work can be considered self-referential in this broad sense of individual self-consciousness in the act of production.

5. This dichotomy was introduced and promulgated by Catholic-oriented Spanish society in the colonization of the New World. At one extreme, the cult of the Virgin Mary delimited the 'honest' woman's social demeanor; at the other, the 'public' woman, or prostitute, was seen as a confirmation of the essential and natural inferiority of women. See C. R. Boxer, *Women in Iberian Expansion Overseas, 1415–1815: Some Facts, Fancies, and Personalities* (New York: Oxford University Press, 1975), especially chapter 4: "The Cult of Mary and the Practice of Misogyny."

6. Barker, pp. 62, 63, 65.

7. Barker, p. 63.

8. Dr. François-Bernard Michel, *Le Souffle coupé,* cited in Guillerm, p. 69.

9. Georges Bataille, *Erotism: Death and Sensuality,* trans. Mary Dalwood (San Francisco: City Lights Books, 1986), p. 61.

10. Fredric Jameson, "Third-World Literature in the Era of Multinational Capitalism," *Social Text* 15 (Fall 1986): 69; my emphasis.

11. Juan García Ponce, "Diversidad de actitudes," in *América Latina en sus artes,* ed. Damián Bayón, 4th ed. (Mexico City: Siglo Veintiuno and UNESCO, 1983), p. 145.

12. Antonio R. Romera, "Despertar de una conciencia artística (1920–1930)," in Bayón, p. 5.

13. See Adolfo Gilly, *The Mexican Revolution,* trans. Patrick Camiller (London: Verso and NLB, 1983), p. 45.

14. Regarding this situation, June E. Hahner has written that "it is very questionable whether the Mexican Revolution . . . became a revolution in the status of women. Mexican women were not even permitted to vote in national elections until 1952" (1984 ed., pp. 16–17). She also cites evidence that "Although

women participated actively in the armed struggles of 1920–21, they benefited little from the victories of the Revolution, winning not much more than the right to hold land" (Hahner, "Mexico: Women and the Working Class," in *Slaves of Slaves: The Challenge of Latin American Women,* trans. Michael Pallis, Latin American and Caribbean Women's Collective [London: Zed, 1980], p. 118). These economic and legal rights, moreover, have little to do with participation in and protection by social justice in real terms. As discussed later, Rosario Castellanos equates this disjunction between legality and reality for women with that proposed for and experienced by Indians after the Revolution. Jean Franco's concise appraisal of the situation that women encountered is straightforward in its conclusion that "national identity was essentially masculine identity" (*Plotting Women: Gender and Representation in Mexico* [New York: Columbia University Press, 1989], p. xxi).

15. Margarita Peña discusses these archetypes in the novel of the Mexican Revolution in her essay "Santa: un arquetipo de prostituta," in *Entrelíneas, Textos de Humanidades* 34 (Mexico City: UNAM, 1983), pp. 99–100.

16. Peña, p. 100.

17. Ilán Staváns, "José Guadalupe Posada, Lampooner," *Journal of Decorative and Propaganda Arts* 16 (Summer 1990): 56.

18. Ludmilla Jordanova, *Sexual Visions: Images of Gender in Science and Medicine Between the Eighteenth and Twentieth Centuries* (Madison: University of Wisconsin Press, 1989), p. 140. For a detailed evaluation of "Medical Images of the Female Body," see especially chapter 7.

19. Diego Rivera's own library, to which Kahlo obviously had access during their years together and which is now in her studio of the Calle Londres house in the Coyoacán district of Mexico City, includes among its numerous volumes works by Walt Whitman, W. H. Hudson, Nicolás Guillén, Guadalupe Amor, Pablo Neruda, Paul Eluard, Carlos Pellicer, H. G. Wells, Marcel Proust, Plato, Lenin, Marx and Engels, Stalin, Martín Luis Guzmán, Rómulo Gallegos, Azorín, and Juan Valera. Also among the volumes are *War and Peace,* an anthology of Mexican writers, the collected works of Sor Juana Inés de la Cruz, Baudelaire, and books on painting techniques, Goya, the Nazi terror in Europe, the history of Soviet civilization, and the 'truth' about North American diplomats. It is evident, therefore, that varying interpretations and ideas about Latin American, North American, and European culture were all readily available to her. Kahlo's acquaintance with the autobiographical writings of Sor Juana are of particular interest since both women have very vivid perceptions of their own appearance

and social identity. Sor Juana's deprivations and self-punishment are echoed in Kahlo's *Autorretrato con pelo cortado* [Self-Portrait With Cropped Hair] (1940) and her constant obsession with her physical body.

20. Vasconcelos was himself a graduate of the Escuela Nacional Preparatoria and admitted his debt to that intellectual formation. For more detailed information on this topic, see Gabriela de Beer, *José Vasconcelos and His World* (New York: Las Américas, 1966).

21. García Ponce, pp. 151–152.

22. Oriana Baddeley and Valerie Fraser, *Drawing the Line: Art and Cultural Identity in Contemporary Latin America* (London: Verso, 1989), pp. 101–102.

23. In her article "La pasión de Frida Kahlo," Estela Ocampo writes of "la ambivalente relación de Frida Kahlo con el surrealismo" (*Quimera* 75 [1989]: 34). Marjorie Agosín ("Ceremonies of a Sliced Body," in *Women of Smoke: Latin American Women in Literature and Life,* trans. Janice Molloy [Trenton, N.J.: Red Sea Press/Third World Books, 1989], p. 83) and Araceli Rico (*Frida Kahlo: Fantasía de un cuerpo herido* [Mexico City: Plaza y Valdés, 1987], p. 85) seem to agree with this evaluation. The art critic Lowery S. Sims describes the contributions of the Latin American artists Frida Kahlo, Wilfredo Lam, and Roberto Matta to European Surrealism as "New World Surrealism," and he points out that "the Surrealists perceived the inherent values of these traditional [non-European] cultures as antidotes to the failure of Western industrial society" ("New York Dada and New World Surrealism," in *The Latin American Spirit: Art and Artists in the United States, 1920–1970,* ed. Luis R. Cancel et al. [New York: Bronx Museum of the Arts and Harry N. Abrams, 1989], p. 157). This appropriation of 'simpler' artistic forms is an evident political statement on the differing orientations of First and Third World cultures, and at the same time on their economic and cultural interdependence. Viewed in this way, Kahlo is much more of a source for the Surrealists than their vision of the world is a stimulus for her paintings.

24. Fredric Jameson, "On Magical Realism in Film," *Critical Inquiry* 12 (Winter 1986): 311.

25. Elaine Scarry also refers to the "artifacts" of production as "bodies" of work. See *The Body in Pain: The Making and Unmaking of the World* (New York: Oxford University Press, 1985), p. 247.

26. Susan Sontag, *Illness as Metaphor* (New York: Farrar, Straus and Giroux, 1978), p. 8.

27. J. A. Appleyard, *Coleridge's Philosophy of Literature: The Development of a Concept of Poetry, 1791–1819* (Cambridge, Mass.: Harvard University Press, 1965), p. 72.

28. Richard Holmes, *Coleridge* (Oxford: Oxford University Press, 1982), pp. 96–97. 123

29. Both characterizations are from Sontag, p. 3.

30. Barker, p. 12.

31. Scarry writes of this process that "the events happening within the interior of [the] body may seem to have the remote character of some deep subterranean fact, belonging to an invisible geography that . . . has no reality because it has not yet manifested itself on the visible surface of the earth" (p. 3). Kahlo allows the interior pain to be reproduced in visual images on the 'surface' of her canvas.

32. Tibol, p. 45; my emphasis.

33. Bataille, p. 15.

34. Carlos Monsiváis, "Frida Kahlo: 'Que el ciervo vulnerado/por el otero asoma,'" *México en el Arte* 2 (Fall 1983): 67.

35. Monsiváis, p. 67.

36. Herrera, p. 347.

37. Kahlo's own responses to Rivera's infidelities range from imitating him with her own affairs in retaliation to declaring her physical and economic independence from Rivera in their reconciliation. Kahlo stipulates, and Rivera accepts, a prohibition of sexual intercourse between them and a separation of all financial accounts upon remarriage.

38. See Barker, pp. 78, 97.

39. It is interesting that one of Rosario Castellanos' last poems, "Kinsey Report," also analyzes these technological elements in words that complement Kahlo's visual representations. See *Poesía no eres tú: Obra poética, 1948–1971* (Mexico City: Fondo de Cultura Económica, 1972).

40. This process can be compared to her father trying with his camera to trap and preserve fragments of a world in flux with which he cannot always cope. The reasons for this are both physical (his epilepsy) and social (he was a European 'outsider' in the Mexican metropolitan community). Her paintings fix her own image in changing circumstances in a way similar to what his still

photographs do with urban and rural Mexico. At the same time that they document change, his photographs capture for posterity frozen scenes of traditional Mexico for the government's Patrimonio Nacional [National cultural patrimony].

41. Rosario Castellanos reflects the same idea in her poem "Entrevista de prensa" [Press Conference] from *En la tierra de en medio* in *Poesía no eres tú: Obra poética, 1948–1971*, p. 293. In this poem she writes that as an individual with both a physical and a political body, as a woman and as a 'citizen' of the nation, her materiality is so diffuse and transparent as far as the embodiment of power is concerned that she does not even cast a shadow. A material entity as weightless as she is defies the laws of nature and permits the passage of light through it, thus reconfirming her social nonexistence and unimportance.

42. Herrera perceptively calls Kahlo "the voyeur of her own emotions" (*Frida*, p. 367).

43. Stephen Bygrave, *Coleridge and the Self: Romantic Egotism* (New York: St. Martin's Press, 1986), pp. 3–4.

44. Staváns, p. 70.

45. Scarry also discusses the distancing of two bodies, such as those of Kahlo and Rivera, when one of them suffers and one does not. Although Rivera may have felt a sympathetic identification with pain and the physical and emotional handicap it produces, Kahlo still feels alone in this crucial aspect of her life ("So it is that I and no one else but I am the one who suffers," see text at note 32). It is worth mentioning, in addition, her complete identification of herself as the sufferer par excellence, the one who *must* suffer and who *is* pain itself. One instance occurs when Rivera is hospitalized for an eye disease. In reaction, Kahlo wishes it were she under observation since such things are a 'natural' part of her life but not his. This statement reflects yet another aspect of her 'martyrdom.' It is also interesting that Ruth Rivera Marín's recently published memoir of her father's life is entitled *Un río, dos Riveras* [One river, two Riveras/One river, two banks], (Memorial Series [Mexico City: Alianza Editorial Mexicana, 1990]), and its discussion hinges on the same concept of dual personality, or public and private personas, in Rivera's case as well.

46. Quoted from letters to Gómez Arias in Herrera, pp. 58, 59.

47. Kerry Gruson, "The Long Road Back," *New York Times Magazine*, June 30, 1985, p. 37; my emphasis.

48. Kahlo, cited in both Tibol, p. 56, and Zamora, *Frida*, p. 353. In Tibol's

version the sentence reads "el masaje del dolor" [the massage of pain]; in Zamora's text it is "el mensaje del dolor" [the message of pain]. The latter version reads more logically in context, although the concept of art as an alleviation of pain is quite pertinent in this instance.

49. See *Self-Portrait* (1935) after Rivera's affair with her sister, and *Self-Portrait with Cropped Hair* (1940) after the Kahlo-Rivera separation. As mentioned in note 19, one of the books in the Kahlo-Rivera library was *Obras escogidas* [Chosen works] of Sor Juana (in an Espasa-Calpe edition), in the extremely unlikely case that she were not already aware of this legendary national figure.

50. The term is used by Wayne Shumaker in *English Autobiography: Its Emergence, Materials, and Forms* (Berkeley: University of California Press, 1954), p. 86.

51. Both Tibol and Herrera refer to Kahlo's diary on this point since it contains a list of associations between emotions and tones of color. Herrera reproduces the list on page 284 of *Frida*.

52. Jean Franco discusses the idea that the eyes and their gaze have been appropriated as the focus of male authority: "Men deprive women of eyes. They rob them of the look that is power" ("Self-Destructing Heroines," *Minnesota Review,* new ser., 22 [Spring 1984], pp. 106–107).

53. See Carlos Monsiváis, "Sociedad y cultura," in *Entre la guerra y la estabilidad política: El México de los '40,* ed. Rafael Loyola (Mexico City: Grijalbo, 1990), pp. 272ff. These "monsters" include Mario Moreno, María Félix, Dolores del Río, and the singer and actor Agustín Lara.

54. Janet A. Kaplan, *Unexpected Journeys: The Art and Life of Remedios Varo* (New York: Abbeville, 1988).

55. Kaplan, p. 88.

56. See Hayden Herrera's revealing article "Why Frida Kahlo Speaks to the 90's," *New York Times,* October 28, 1990, Arts and Leisure sec., pp. 1, 41.

57. Frida Kahlo, quoted in Tibol, p. 101.

58. John Berger, *G* (New York: Pantheon, 1980), pp. 149–151, cited in Jean Franco, "The Incorporation of Women: A Comparison of North American and Mexican Popular Narrative," in *Studies in Entertainment: Critical Approaches to Mass Culture,* ed. Tania Modleski (Bloomington: Indiana University Press, 1986), p. 122.

125

59. José Vasconcelos, *La raza cósmica: Misión de la raza iberoamericana* (Mexico City: Espasa-Calpe Mexicana, 1948), pp. 30, 16.

60. The Cuban literary critic and writer Roberto Fernández Retamar calls Vasconcelos' texts "defiantly utopian"; see "Our America and the West," *Social Text* 15 (Fall 1986): 15.

61. Rivera decided that the art of the public mural, not that of the studio easel, would best reach out to the greatest number, "con el propósito educativo de crear un arte de legibilidad popular, inspirado en la historia de México" [with the educational intention to create a popularly comprehensible art, inspired by the history of Mexico] (Saúl Yurkievich, "El arte de una sociedad en transformación," in *America Latina en sus artes,* ed. Damián Bayón, 4th ed. [Mexico City: Siglo Veintiuno and UNESCO, 1983], p. 180). The pedagogical function of art is a concept central to Vasconcelos' writings.

62. Francisco Stastny, "¿Un arte mestizo?" in Bayón, p. 156.

63. Stastny, p. 156.

64. Edmundo Desnoes agrees that these two bodies of culture "se abrazan y golpean en ciertos puntos" [embrace one another and knock into each other at certain points], but they never unite in a perfect whole ("La utilización social del objeto de arte," in Bayón, p. 191).

65. Arturo Uslar Pietri, *Letras y hombres de Venezuela* (Mexico City: Fondo de Cultura Económica, 1948), p. 21. This division also corresponds to the already mentioned confrontation between Mexico (or much of Latin America) and the industrialized nations such as the United States.

66. Juan García Ponce, pp. 144–145. For an additional discussion of this historical era, see Jesús Silva Herzog, *Trayectoria ideológica de la Revolución Mexicana: Del manifiesto del Partido Liberal de 1906 a la Constitución de 1917* (Mexico City: Cuadernos Americanos, 1963), p. 91.

67. From "They Thought I was a Surrealist," *Time,* April 27, 1953, cited in Herrera, p. 266.

68. Franz Roh, *German Painting in the Twentieth Century,* additions by Juliane Roh (Greenwich: New York Graphic Society, 1968), p. 84. In the book *Le Réalisme magique: Roman, Peinture et cinéma,* ed. Jean Weisgerber (Brussels: Editions l'Age d'Homme and l'Université Libre de Bruxelles, 1988) it is noted that major portions of Roh's ideas on magical realism were translated into Spanish and published by the intellectual journal *Revista de Occidente* in Spain in June 1927. From there the concept was introduced into Latin America. (See the

preface, p. 13, and Weisgerber, "La locution et le concept," pp. 18–29.) Whether Kahlo or Rivera ever read them firsthand is unknown; the concepts undoubtedly were floating around the art world of the time, however, as were those of the Surrealists.

69. See *Tientos y diferencias* (Montevideo: Arca, 1967), p. 116. Fredric Jameson refers to Carpentier in the same terms in "On Magical Realism in Film," p. 301.

70. Franz Roh, cited in Enrique Anderson-Imbert, "El 'realismo mágico' en la ficción hispanoamericana," in *El realismo mágico y otros ensayos* (Caracas: Monte Avila, 1976), p. 7.

71. Anderson-Imbert, p. 19.

72. Uslar Pietri, p. 162.

73. Introductory notes to Pierre Mac Orlan, "The Literary Art of Imagination and Photography," in *Photography in the Modern Era: European Documents and Critical Writings, 1913–1940,* ed. Christopher Phillips (New York: Metropolitan Museum of Art, and Aperture, 1989), p. 27.

Chapter 2. Rosario Castellanos

1. In the introductory section of *A Rosario Castellanos Reader: An Anthology of Her Poetry, Short Fiction, Essays, and Drama* (Austin: University of Texas Press, 1988), Maureen Ahern (the editor) includes an excellent select bibliography of studies on Castellanos' writing (see pp. 71–77).

2. Ahern concurs with the need to explore this overlooked area, stating that "Although Castellanos' essays constitute a major point of entry to the body of her work, they are her most neglected genre in terms of translation and criticism" (p. 39).

3. Ahern, p. 39.

4. The editions of Castellanos' works used for this discussion are: *Juicios sumarios: Ensayos* (Xalapa: Universidad Veracruzana, 1966); *Mujer que sabe latín* (articles translated in *A Rosario Castellanos Reader*); *El uso de la palabra* (1974; reprint, Mexico City: Editores Mexicanos Unidos, 1982); *El mar y sus pescaditos* (1974; reprint, Mexico City: Editores Mexicanos Unidos, 1987).

5. See the works of Blanco White, with a valuable introductory section, collected in *Obra inglesa de Blanco White,* trans. and ed. Juan Goytisolo (Barcelona: Seix Barral, 1974).

127

6. For a suggestive comparative study of Larra's debt to the writings of English satirists, see Gioconda Marún's article "Apuntaciones sobre la influencia de Addison y Steele en Larra," *Hispania* 64 (September 1981): 382–387.

7. See John Hollowell, *Fact and Fiction: The New Journalism and the Nonfiction Novel* (Chapel Hill: University of North Carolina Press, 1977) for a more detailed exposition of these arguments.

8. Hollowell reviews the sources of these alternatives (see "Novelists and the Novel in a Time of Crisis," p. 11, and "Promotion and Publicity: The Reporter as Star," p. 44, in particular), as does Norman Sims in his introduction to *The Literary Journalists: The New Art of Personal Reportage* (New York: Ballantine, 1984). The former also cites the extensive definition of the term *new journalism* by Everette E. Dennis and William L. Rivers in *Other Voices: The New Journalism in America* (San Francisco: Canfield, 1974]) to aid in classifying the wide gamut of types within this general category (Specifically, see Hollowell, p. 154n.3.)

9. Poniatowska, "Rosario Castellanos: ¡Vida, nada te debo!" in *¡Ay vida, no me mereces!* (Mexico City: Joaquín Mortiz, 1985), p. 57.

10. For a discussion of the concept of alterity and the subaltern, see Gayatri Chakravorty Spivak, "Subaltern Studies: Deconstructing Historiography," *In Other Worlds: Essays in Cultural Politics* (New York: Methuen, 1987).

11. See María Elena de Valdés, "Feminist Testimonial Literature: Cristina Pacheco, Witness to Women," *Monographic Review/Revista Monográfica* 4 (1988): 150–162, on Pacheco's contributions to testimonial literature through the "immediacy" of her writings in the daily newspapers *Unomásuno, La Jornada,* and *El Día,* and the weekly magazine *Siempre.*

12. Ruta, "Adios, Machismo: Rosario Castellanos Goes Her Own Way," *VLS* no. 75 (June 1989): 33, a review of *A Rosario Castellanos Reader* and *The Selected Poems of Rosario Castellanos.*

13. Castellanos, "Carlos Monsiváis: El asedio a México" [Carlos Monsiváis: His approach toward Mexico], in *El mar y sus pescaditos,* p. 123. Elena Poniatowska sees this underlying tone as a step beyond "interpretation" toward the realm of the "moral"; see "Rosario Castellanos," p. 93.

14. Norman Sims, p. 3.

15. In the poem "Lecciones de cosas" (translated as "Learning About Things") Castellanos concludes that individuals with the institutionalized power

of parents, priests, and spouses have given her the 'lessons' that have created this situation. She begins with the acknowledgment that these lessons in life led her down the wrong path and alienated her from her own desires. In her essays she consequently exemplified how her 'goodness' and conformity, the demands of a patriarchal society, do not bring the promised rewards of prizes, love, or heaven. Her writings document an increasing disillusionment with the process of socialization, as well as with herself for her blind faith in it. See "En la tierra de en medio" [In the heart of the land] in *Poesía no eres tú: Obra poética, 1948–1971* [You are not poetry: Poetic works, 1948–1971] (Mexico City: Fondo de Cultura Económica, 1972), pp. 297–298.

16. Her poem "Autorretrato" (translated as "Self-Portrait") is complemented in this capacity by the essays "Autorretrato con maxifalda" [Self-portrait with maxiskirt] (April 18, 1970), "Hora de la verdad" [The hour of truth] (June 19, 1973), "Génesis de una embajadora" [Genesis of a woman ambassador] (February 20, 1971), and "A pesar de proponérselo" [In spite of one's good intentions] (June 10, 1974), all sarcastic self-referential word portraits of her public persona; see *El uso de la palabra*.

17. Castellanos, "Carlos Monsiváis: El asedio a México," in *El mar y sus pescaditos*, p. 122.

18. See chapters 1 and 3 of Kristeva's *Black Sun: Depression and Melancholia*, trans. Leon S. Roudiez (New York: Columbia University Press, 1989).

19. Castellanos, "El escritor: Ese absurdo dinosaurio" [The writer: That absurd dinosaur] (July 12, 1970), in *El uso de la palabra*, p. 328.

20. The sense of irony reappears, however, when the dialogue is perceived as being reduced to a one-sided monologue, as in her poem "Monólogo de la extranjera" (translated as "Monologue of a Foreign Woman"), in *Poesía no eres tú*, pp. 112–114, or her article "Historia mexicana" [Mexican history] (July 24, 1966), in *El uso de la palabra*. In the latter the narrator recounts the (autobiographical?) story of Cecilia, a young woman who is the bane of her parents' existence because, in short, "Era anormal. No es que hubiera nacido con seis dedos en los pies, ni que se hubiera enamorado de un asno, de un pavorreal ni de alguna de sus compañeras de juegos. . . . Era que hablaba. Y decía todo lo que se le ocurría" [She was abnormal. It wasn't that she was born with six toes, nor that she fell in love with a donkey or with a peacock or with one of her childhood girl-friends. . . . It was that she talked. And she said everything that occurred to her] (p. 53). The young woman's 'abnormality' is likened to a diseased body, just as it is in "De mutilaciones" (translated as "RE: Mutilations"), in which social institu-

tions attempt to cut out the growth—likened to a cancer—that begins to increase in size with her continued use of her brain by performing a trepanation, a surgical operation used since the time of the Olmecs to relieve pressure on the cranial cavity by removing a piece of the skull. These 'mutilations' obviously are metaphorical/psychological in nature rather than literal since they are designed to stop her from thinking or articulating ideas.

21. "El escritor" [The writer], p. 332.

22. "El escritor," p. 332.

23. The introductory essays in *A Rosario Castellanos Reader* offer an excellent analysis of Castellanos' writings within the French feminist tradition, in particular the details of her "writing the female body" into existence (see "On Language and Writing," pp. 50ff).

24. Schwartz, *Rosario Castellanos: Mujer que supo latín* (Mexico City: Katún, 1984), p. 63.

25. October 23, 1965, in *El uso de la palabra,* p. 42. It is interesting that nineteenth-century European liberal thought, in Larra's version at least, foreshadows similar terms for social change. The 'deformation' of women in Spain is seen by Larra as a result of poor and inappropriate education, the influence of 'bad' literature (a Romanticism that has lost touch with reality), the repetition of clichés or their reduction to silence, and other factors not too far removed from Castellanos' appraisal of the situation in twentieth-century Mexico. "Costumbres mexicanas" [Mexican customs] and "La liberación de la mujer, aquí" [Women's liberation, here], for example, underline the significance of specific external social and economic forces on Mexican women. Of Larra's articles Marún writes: "Sus ideas progresistas, racionales y liberales—[son] configuradoras de una sociedad mejor, tanto para el hombre como para la mujer" [His progressive, rational, and liberal ideas—{are} the shapers of a better society, as much for the man as for the woman] (p. 382). The same could be said of Castellanos' essays.

26. This essay appears, significantly, in the section of the *Excélsior* articles entitled "Notas autobiográficas" [Autobiographical notes] collected in *El uso de la palabra*. It is dated May 30, 1970.

27. I am indebted to Raúl Rodríguez for his valuable insights into these aspects of my discussion.

28. The source is a January 26, 1948, diary entry, cited by Jesús Silva Herzog in *Lázaro Cárdenas: Su pensamiento económico, social y político* (Mexico City: Editorial Nuestro Tiempo, 1988), p. 31. This is just one of a whole range of books

published or republished in a flurry of editorial activity around the time of the 1988 presidential election.

29. Ianni, *El Estado capitalista en la época de Cárdenas,* trans. Ana María Palos (1977; reprint, Mexico City: Era, 1987), pp. 100–101. Ianni goes on to point out that this so-called red president knew how to use language to convince intellectuals of his adherence to the more radical social goals of the Revolution; in Ianni's words, in Cárdenas "se combinan la retórica revolucionaria, el lenguaje socializante [y] las razones del Estado revolucionario" [revolutionary rhetoric, socialist-like language, {and} the foundations of the revolutionary state are combined] (p. 15).

30. See, for example, the entry of December 26, 1966, quoted in Ianni, p. 66. For a discussion of the idea of 'progress' see Arnaldo Córdova, *La política de masas del cardenismo* (1974; reprint, Mexico City: Era, 1987), p. 177.

31. From a manifesto published in *El Nacional Revolucionario,* October 21, 1929, and cited in Córdova, p. 32. See also Ianni, pp. 105–106, for the use of the 'socialist schools' to introduce the "ennobling" value of productive effort.

32. See "Three Knots in the Net," trans. Laura Carp Solomon, *Revista de la Universidad de México* 8 (1961) and included in the reader edited by Ahern (see pp. 130, 134, 142). Ahern remarks on the "patently autobiographical" nature of this text (p. 36). In addition, the story is quite interesting for its portrayal of the silent suffering of the inwardly gnawed female cancer victim, yet another 'cannibalized' body. As for the compartmentalization of social space, in "Herlinda Leaves" Castellanos writes—with some element of fact and some of self-directed sarcasm—that her maid, María Escandón, was relegated to the "sacred territory of the kitchen" and that there is an unwritten agreement "not to cross my boundaries, which were the study, the bedroom, and the parlor" (Ahern, p. 268; the article is from *El uso de la palabra* and is dated August 24, 1973).

33. Castellanos, "Establecimiento del diálogo" [Establishing a dialogue], from *Juicios sumarios,* p. 54.

34. Poniatowska writes of this period, "Gracias a Rosario y a sus buenas gestiones, los contratos petroleros entre México e Israel se llevaron a cabo y se incrementaron las ventas. Gracias a ella, México es el mayor proveedor de Israel desde que Irán suspendió el envío" [Thanks to Rosario, and her good arrangements, the petroleum contracts between Mexico and Israel were completed and sales increased. Thanks to her, Mexico is the largest supplier {of petroleum} to Israel since Iran ceased shipment] ("Rosario Castellanos," p. 82).

131

35. Cited from p. 7 of this text in Schwartz, p. 86.

36. "Incident at Yalentay," trans. Ahern, from the "Autobiographical Notes" section of *El uso de la palabra,* in Ahern, p. 219; my emphasis. It is dated July 22, 1963.

37. In "Discrimination in the United States and in Chiapas," trans. Ahern (September 4, 1965), Castellanos underlines the need for "benevolence," "generosity," and above all "a watchful conscience" against allowing negative "attitudes" to take over the relationships among ethnic groups (*El uso de la palabra,* p. 229).

38. From *Juicios sumarios,* p. 137.

39. Coles, *Simone Weil: A Modern Pilgrimage,* Radcliffe Biography Series (Reading, Pa.: Addison-Wesley, 1987), pp. 103, 76. The similarities with and support for Cárdenas' ideas have already been mentioned briefly in the first part of this chapter.

40. Castellanos, "El automatismo: Crisis moral" [Automation: A moral crisis] (October 30, 1965), in *El uso de la palabra,* pp. 44–45.

41. Weil, *Lectures on Philosophy,* trans. Hugh Price (Cambridge: Cambridge University Press, 1978), p. 74.

42. Castellanos, "El automatismo: Crisis moral," p. 43.

43. Little, *Simone Weil: Waiting on Truth* (New York: St. Martin's, 1988), p. 155.

44. I wish to distinguish my use of these terms from what Rosemary Geisdorfer Feal calls ethnobiography, defined as "an ethnologist's written version of an individual's oral autobiography" (see "Spanish American Ethnobiography and the Slave Narrative Tradition: *Biografía de un cimarrón* and *Me llamo Rigoberta Menchú,"* *Modern Language Studies* 21 [Winter 1990]: 101). The individual interviewee-transcriber relationship is missing in the case of Castellanos' literary journalism, which is based on an amalgamation of statements from informants, recollections, and observations. In addition, the intent of this writing is to exorcise one's own 'demons,' using the chosen cultural collectivity merely as a backdrop. This is particularly true when the dimensions of alienation ('guilt'?) rather than integration—a move against the traditional bildungsroman pattern—are stressed.

45. See James Clifford, *The Predicament of Culture: Twentieth-Century Ethnography, Literature, and Art* (Cambridge, Mass.: Harvard University Press,

1988); James Clifford and George E. Marcus, eds., *Writing Culture: The Poetics and Politics of Ethnography* (Berkeley: University of California Press, 1986); Clifford Geertz, *Local Knowledge: Further Essays in Interpretive Anthropology* (New York: Basic Books, 1983); and Clifford Geertz, *Works and Lives: The Anthropologist as Author* (Stanford: Stanford University Press, 1988). The quote is from Clifford's introduction to *Writing Culture*, p. 15.

46. John Van Maanen, *Tales of the Field: On Writing Ethnography* (Chicago: University of Chicago Press, 1988), p. 93.

47. Van Maanen, pp. 91, ix.

48. Van Maanen, p. 14.

49. See Van Maanen, pp. 101–124, 73–100, respectively, in reference to these two categories of 'tales.'

50. Castellanos, "Aplastada por la injusticia del mundo" (May 28, 1966), in *El uso de la palabra*, p. 211, and "An Attempt at Self-Criticism," trans. Laura Carp Solomon, in Ahern, p. 228.

51. Castellanos, "Realidad y ficción en Guatemala" (April 11, 1970), in *El uso de la palabra*, p. 144; my emphasis.

52. Castellanos, "Establecimiento del diálogo," p. 53; my emphasis.

53. Castellanos, "Costumbres mexicanas," (January 25, 1964), in *El uso de la palabra*, p. 31.

54. Castellanos, "Las indias caciques" [Women chiefs] (February 8, 1964), in *El uso de la palabra*, p. 37; my emphasis.

55. Castellanos, "La liberación del amor" (July 20, 1972), in *El uso de la palabra*, p. 68.

56. Both essays appear in *El uso de la palabra*, "El héroe de nuestro tiempo" (July 16, 1966) on p. 109 and "Un mundo incomprensible" (August 6, 1966) on p. 175.

57. "Un mundo incomprensible," p. 175.

58. "Difícil acceso a la humanidad" (February 3, 1968), in *El uso de la palabra*, p. 180.

59. "Un acto de introspección" (February 5, 1966), in *El uso de la palabra*, pp. 107–108.

60. "Divagación sobre el idioma" (June 28, 1969), in *El uso de la palabra*, p. 185.

133

Chapter 3. Elena Poniatowska

1. Subsequent page references to these editions appear in parentheses in the text.

2. James D. Cockcroft proposes that this is only part of the total problem and concludes that "The crisis of the Mexican state is a crisis of Mexican capitalism"; see *Mexico: Class Formation, Capital Accumulation, and the State* (New York: Monthly Review Press, 1983), p. 253.

3. Carlos Monsiváis, *Amor perdido* (México: Era, 1977), p. 47.

4. It is interesting that in June 1989 the main auditorium of the Nursing School of the Universidad Autónoma del Estado de México was officially named for Poniatowska, an occasion at which the author herself spoke. Such official public acknowledgment by an institution ostensibly reflects the individual's views toward alliances "from within" structures and institutions of power. (See Marco Aurelio Carballo, "Figuras de la semana," *Siempre*, no. 1876 [June 7, 1989], p. 10.) In addition, both Poniatowska and Monsiváis (as well as Angeles Mastretta, José Joaquín Blanco, Jean Meyer, Jorge Castañeda, Adolfo Gilly, Pablo González Casanova, and other liberal intellectuals) are currently on the editorial board of the formerly independent magazine *Nexos*, which has recently turned progovernment and which includes frequent contributions by President Salinas de Gortari himself on the official version of the state of Mexico's affairs.

5. Domitila Barrios de Chungara, with Moema Viezzer, *Let Me Speak! Testimony of Domitila, A Woman of the Bolivian Mines*, trans. Victoria Ortiz (New York: Monthly Review Press, 1978), pp. 201–202, 199.

6. One must read rather carefully to discover the origin of *Gaby Brimmer* in written letters (see pp. 33, 102), but the source is logical since the woman in question cannot express herself orally, as she would in interviews for testimonial literature, for example. Brimmer addresses a theoretical reading audience from the very beginning, nevertheless, since she often writes in a plural form of address: "se me olvidó decirles" [I forgot to tell you all], "Saben" [You all know], and "Tengo que confesarles" [I have to confess to you all]. Her letters are to Poniatowska, and via her they reach others, the ultimate receptors of her messages. Poniatowska's source for Beloff's letters is Bertram D. Wolfe's *The Fabulous Life of Diego Rivera* (New York: Stein and Day, 1969), already an admittedly subjective view of Rivera's life. It is even rumored, and it appears quite plausible, that Rivera had a hand in revising the final version of Wolfe's text for publication.

7. It must be noted, however, that at the insistence of her friend, fellow art student, and companion Vita Castro, Beloff did write her memoirs beginning in 1964. They were published in 1986, seventeen years after her death at the age of ninety in 1969. See Angelina Beloff, *Memorias*, trans. Gloria Taracena (Mexico City: SEP/UNAM, 1986).

8. Tom Moylan, *Demand the Impossible: Science Fiction and the Utopian Imagination* (New York: Methuen, 1986), p. 28; my emphasis.

9. "Entrevista a Elena Poniatowska," *Unomásuno*, February 11, 1989, p. 3.

10. Rachel Blau Du Plessis, "For the Etruscans," in *The New Feminist Criticism: Essays on Women, Literature, and Theory*, ed. Elaine Showalter (New York: Pantheon, 1985), p. 275.

11. Charles A. Porter, Foreword to *Yale French Studies* 71 (1986): 3, an issue dedicated to "Men/Women of Letters."

12. Janet Gurkin Altman, *Epistolarity: Approaches to a Form* (Columbus: Ohio State University Press, 1982), p. 169.

13. Robert A. Fothergill, *Private Chronicles: A Study of English Diaries* (London: Oxford University Press, 1974), p. 9.

14. Cynthia Steele discusses the internalizing aspect of *Querido Diego* in her excellent essay "La creatividad y el deseo en *Querido Diego, te abraza Quiela*, de Elena Poniatowska," *Hispamérica* 14 (August 1985): 19.

15. Jean Franco, *Plotting Women: Gender and Representation in Mexico* (New York: Columbia University Press, 1989), p. 178.

16. See Altman, p. 112n.2; Porter, p. 5.

17. See Mireille Bossis, "Methodological Journeys Through Correspondences," trans. Karen McPherson, *Yale French Studies* 71 (1986): 68.

18. Elizabeth Burgos, *Me llamo Rigoberta Menchú y así me nació la conciencia* (Mexico City: Siglo XXI, 1985).

19. Cynthia Steele defines these conflicts in the case of Beloff as "propios de un período de transición" [appropriate for a period of transition] (p. 19). This concept is worth considering in the case of Brimmer as well, since she too is a figure within a transitional period—that of Mexico's transition to late international capitalism beginning in the 1960s.

20. For an elaboration of this idea, see the excellent comprehensive prologue to Jon Stratton, *The Virgin Text* (Norman: University of Oklahoma Press, 1987).

21. Beth Miller, "Interview with Elena Poniatowska," *Latin American Literary Review* 4 (Fall–Winter 1975): 74.

22. Cynthia Steele, "Entrevista: Elena Poniatowska," *Hispamérica* 18, nos. 53–54 (August–December 1989): 91.

23. In *Diego de Montparnasse* (Mexico City: Fondo de Cultura Económica, 1979), Olivier Debroise reiterates the connection between the salons of Paris and the Third World: "Si la pintura negra había salvado a Picasso, México debería salvar a Rivera" [If Black {African} painting had saved Picasso, Mexico had to be Rivera's salvation] (p. 74).

24. Beloff, *Memorias,* p. 35.

25. In a letter of 1922, Beloff still refuses to sell the works Rivera left behind even if she is at the point of starvation, since she claims that "eran mi vida misma" [they were my very life] (p. 52). An interesting point of contrast is Alice B. Toklas' reacting to economic necessity by selling some of Gertrude Stein's paintings, an act she refers to metonymically as "eating" Picassos and Cézannes (see *Staying on Alone: Letters of Alice B. Toklas,* ed. Edward Burns [New York: Liveright, 1973], p. 41).

26. Brimmer expresses her view that this acceptance is class-related: "la gente sencilla siempre me ha aceptado mejor que la rica" [poor people have always accepted me better than have the rich] (p. 159). This appears to be a naïve conclusion, given the fact that lower- and middle-class families in Mexico so frequently hide their handicapped or retarded children from public view in shame. In addition, they are often considered 'bewitched,' the victims of spells or acts of revenge against the family.

27. To counterbalance her image of dependence, Olivier Debroise writes of Beloff, "en París, no fue una pintora famosa pero su talento fue reconocido, tenía trabajo: expuso con notable perseverancia en el Salón de Otoño a lo largo de diez años; participó asimismo en varias exposiciones de artistas residentes en París" [in Paris, she was not a famous painter, but her talent was recognized, she had work: she exhibited with notable perseverance in the Salón de Otoño for more than ten years; she also participated in several expositions by resident artists in Paris] (*Angelina Beloff: Ilustradora y grabadora,* p. 30). To this may be added her prints, lithographs, and sketches done for various editorial houses.

28. One is immediately reminded of Rosario Castellanos' search, in her essay "Génesis de una embajadora," for a "justification" of her existence in order to feel "worthy of living" (*El uso de la palabra,* p. 247).

29. Beloff's revelations occur in the art galleries, in the "exaltation" and "agitation" (p. 22) of her moments of artistic inspiration. Brimmer's appear in her daily encounters with the world: in classes, visiting a friend in jail, going to the movies, and confronting the different living situations imposed upon her 'for her own good.'

30. Beloff's physical illness as exemplified by her case of pleurisy is not caused by psychological weakness but by real economic conditions. Her lungs, however, do serve as the corporal manifestation of a certain psychological paralysis in that she refuses to communicate to Rivera about her condition until she is cured, so as not to "burden" him with worry. 'Romantic' cases of tuberculosis as the disease associated with 'bohemian' artists were long out of fashion by this time.

31. Frida Kahlo used almost the same words when Rivera reacted similarly toward another attempt to have a child after her sometimes spontaneous, sometimes therapeutic abortions.

32. Beloff does the same with her lithographs, but there is little public record of her work, with the exception of the few reproductions of oil paintings and woodcuts in her *Memorias* and expositions of her works in the "Homenaje a Angelina Beloff" [Homage to Angelina Beloff] at Mexico City's Palacio de Bellas Artes in 1967 (in collaboration with the Sociedad Mexicana de Grabadores), a collection of 132 of her works on display also at Bellas Artes in April and May 1986 to celebrate the Centenario de Diego Rivera (a celebration of a hundred years since his birth), and an exposition of Beloff's illustrations and woodcuts in the Museo Estudio Diego Rivera in the San Angel part of Mexico City in 1988 (the house connected to Frida Kahlo's, where Rivera lived and worked during their remarriage).

33. The Mexican monthly magazine *Nexos* reports on the page entitled "Numeralia" in the March 1987 issue (no. 111) that the "porcentaje de descenso en la venta de libros durante 1986 [es] 40%" [percentage of decrease in book sales during 1986 {is} 40%] (p. 17). This reflects both economic and cultural hardship. It is unfortunate, but documentation shows that the trend continues and has even been exacerbated by the worsening national debt crisis.

34. Paul Ilie, *Literature and Inner Exile: Authoritarian Spain, 1939–1975* (Baltimore: Johns Hopkins University Press, 1980), pp. 5, 6.

35. See Linda S. Kauffman, *Discourses of Desire: Gender, Genre, and Epistolary Fictions* (Ithaca, N.Y.: Cornell University Press, 1986), p. 20.

36. If we again look to Alice B. Toklas' correspondence for a comparison, we find that after Gertrude Stein's death, although Toklas had always remained in the background, Stein's friends continued to cultivate their friendship with Toklas. On the other hand, Beloff calls herself "una extranjera en el país de la pintura" [a foreigner in the country of painting] (p. 24).

37. Ilie, p. 61.

38. These were the years when Frida Kahlo was growing up and when she met Rivera. His interest in her can be interpreted, among other things, as a substitution of a certain 'nationalist' spirit for the traditional European heritage (represented or embodied by Beloff?). This is also the time when Rivera turned to mural painting and public art forms and away from studio painting on canvas.

39. It is interesting that in 1980 Brimmer, without the intervention of Elena Poniatowska, published *Gaby, un año después* [Gaby, one year later] (Mexico City: Grijalbo), an anthology of her poetry. The majority of these poems communicate her continued feeling of isolation and solitude from the rest of society and its members.

40. Both Diego Rivera's biographer, Bertram D. Wolfe, and Hayden Herrera, the biographer of Frida Kahlo (p. 81), refer to Paris, and Montparnasse in particular, in the same terms as being characterized by a bohemian lifestyle.

41. Shari Benstock, *Women of the Left Bank: Paris, 1900–1940* (Austin: University of Texas Press, 1986), p. 5.

42. Debroise, *Diego de Montparnasse,* p. 17. To her text Poniatowska adds references to the folkloric trappings of this former bourgeois life when she lists food, icons, and samovars that Beloff remembers with fondness and nostalgia (see pp. 29ff.). Perhaps she missed the security of the more comfortable bourgeois life as much as she did Rivera.

43. Debroise, *Diego de Montparnasse,* pp. 22, 33, 100.

44. Wolfe, p. 250. Also cited by Debroise in *Angelina Beloff: Ilustradora y grabadora* (Mexico City, Guanajuato, Saltillo: Consejo Nacional para la Cultura y las Artes, Instituto Nacional de Bellas Artes, Instituto Francés de América Latina, Museo Estudio Diego Rivera, Museo Casa Diego Rivera, Centro de Artes Visuales e Investigaciones Estéticas, 1989).

45. *Angelina Beloff: Ilustradora y grabadora,* p. 50.

46. This concept was discussed by Fredric Jameson in his talk "Third World Cultural Studies," given at the Conference on the Culture Industry, Cornell University, Ithaca, New York, April 10, 1987.

Chapter 4. Angeles Mastretta

1. See Salvador Morales, *La música mexicana* (México: Editorial Universo, 1981), for an excellent and thorough discussion of this genre's historical development. Danny J. Anderson places the limits of history contained in the novel between "about 1927 [and] 1943" ("Displacement: Strategies of Transformation in *Arráncame la vida* by Angeles Mastretta," *Journal of the Midwest Modern Language Association* 21 [Spring 1988]: 15).

2. Gabriela Mora, "El Bildungsroman y la experiencia latinoamericana: 'La pájara pinta' de Albalucía Angel," in *La sartén por el mango: Encuentro de escritoras latinoamericanas,* ed. Patricia Elena González and Eliana Ortega (Río Piedras, Puerto Rico: Ediciones Huracán, 1984), p. 73.

3. Mastretta's own remarks on another occasion seem to link the "love story" intimately with vaster social concerns. In a paper delivered to the group Debate Feminista for their series entitled "El amor en tiempos de democracia" [Love in times of democracy], she states: "¿Hay un amor? ¿Es el amor el único postulado político capaz de procurar desasosiego?" [Is there any love? Is love the only political postulate capable of producing uncertainty?] (Mastretta, "Sobre el silencio más fino," [On the finest of silences] *Nexos,* no. 137 [May 1989]: 5). It is of course a cliché that love and politics have often been 'strange bedfellows.'

4. Héctor Aguilar Camín, "La transición mexicana," *Nexos,* no. 124 (April 1988): 27.

5. James D. Cockcroft, *Mexico: Class Formation, Capital Accumulation, and the State* (New York: Monthly Review Press, 1983), p. 115. See also Carlos Fuentes, "History Out of Chaos," *New York Times Book Review,* March 13, 1988, pp. 12–13. Although Fuentes dissects the Revolution into three separate movements, in the end they all combined to form the modern Mexican state.

6. For a superb discussion of the bildungsroman as a crisis genre, see Franco Moretti, *The Way of the World: The 'Bildungsroman' in European Culture* (London: Verso, 1987), p. 4.

7. Alex Aronson, *Music and the Novel: A Study in Twentieth-Century Fiction* (Totowa, N.J.: Rowman and Littlefield, 1980), p. 71.

8. Aronson, p. 67.

9. Julia A. Kushigian, "Transgresión de la autobiografía y el *Bildungs- roman* en *Hasta no verte Jesús mío,*" *Revista Iberoamericana,* no. 140 (July–Sept. 1987), p. 677; my emphasis.

NOTES TO PAGE 91

10. The ambiguity is emphasized by the critic Peggy Job to the extent that she finds Catalina more fatally bogged down by her circumstances than critical of them. Job concludes: "Aunque Catalina sea una mujer simpática, ha aceptado la corrupción y el ejercicio despiadado del poder de su marido, incluso el asesinato de su amado-amante; es una mujer que al fin y al cabo se vende; su *joie de vivre,* una ilusión" [Although Catalina may be an appealing woman, she has accepted the corruption and the unrelenting exercise of power by her husband, including the assassination of her lover-beloved; she is a woman who, after all is said and done, sells out; her *joie de vivre* {is} an illusion] ("La sexualidad en la narrativa femenina mexicana, 1970–1987: Una Aproximación," *Third Woman* 4 [1989]: 130–131).

11. Angeles Mastretta, *Arráncame la vida* (Mexico City: Océano, 1985), p. 9. All future page references to this edition will appear in parentheses in the text. In addition, all translations into English are mine unless otherwise noted. Viking Press has just published an English version of Mastretta's novel, appropriately entitled *Mexican Bolero* (1989), but there are certain inaccuracies in this text owing to the subtleties and regionalisms of the colloquial language used in the original narrative. Moreover, the British flavor of the translation's phrasing and vocabulary regionalizes the story in yet another way.

12. As Latin American women's roles slowly begin to change in the twentieth century, this historical development promises to be increasingly evident in the fiction produced in these countries. This parallels what Esther Kleinbord Labovitz notes in her study of European examples of this genre. See *The Myth of the Heroine: The Female 'Bildungsroman' in the Twentieth Century* (New York: Peter Lang, 1986), p. 1, and Julia A. Kushigian's valuable contribution to the discussion of autobiographical genres in her article on Elena Poniatowska (see note 9 above).

13. Jerome Hamilton Buckley, *Season of Youth: The 'Bildungsroman' from Dickens to Golding* (Cambridge, Mass.: Harvard University Press, 1974), p. viii.

14. See Labovitz's excellent introductory section on these aspects of the genre, p. 2.

15. In her article on the Brazilian writer Clarice Lispector, Marta Peixoto describes a similar process in the case of the stories included in the anthology entitled *Family Ties*. Peixoto states: "All the stories in the collection turn on an epiphany, a moment of crucial self-awareness. In the midst of trivial events, or in response to a chance encounter, Lispector's characters suddenly become conscious of repressed desires. . . . These women experience the reverse of their

accepted selves and social roles. Their epiphanies, mysterious and trans-
gressive, bring to consciousness repressed material with potentially subversive
power" ("*Family Ties:* Female Development in Clarice Lispector," in *The Voyage
In: Fictions of Female Development,* ed. Elizabeth Abel, Marianne Hirsch, and
Elizabeth Langland [Hanover, N.H.: University Press of New England, 1983],
p. 289). Although they are more transgressive than mysterious, Catalina Guz-
mán's moments of awareness do move the narrative along to its open end.

141

16. Moretti, p. 11.

17. Morales comments on the success of this sentimental style of music even
when faced with such obstacles to popularity as American jazz, the Spanish
zarzuela, and the Argentine tango. He writes: "Hubo un tiempo en que la
canción mexicana dominó casi por entero el gusto del público nacional, se
enseñoreó en teatros y centros nocturnos, se apoderó de todos los micrófonos,
desplazó al jazz y al tango (los géneros en boga) y reunió enormes públicos en
muchos países extranjeros" [There was a time when Mexican songs almost
completely dominated national public taste, they took over theaters and night-
clubs, they dominated every microphone, they displaced jazz and the tango (the
fashionable genres) and attracted enormous audiences in many foreign coun-
tries] (p. 8).

18. Nat Schapiro and Bruce Pollock, eds., *Popular Music, 1920–1979,* 3 vols.
(Detroit: Gale Research Co., 1985), 1:17, 21.

19. Morales, p. 66.

20. As a member of the anti-Cristero forces, Andrés refuses a religious
ceremony, but he also rejects it for the ulterior motive of concealing the existence
of his other wives. Once again, the national and the personal merge in a single
moment.

21. Catalina eventually recognizes the fact that her imagination has played a
role in the 'affair' when in frustration she says, "Arizmendi era un invento"
[Arizmendi was an invention] (p. 105).

22. For an outstandingly lucid discussion of these encounters, especially in
the Mexican elections of 1940, see Cockcroft, p. 138, and Jean A. Meyer, *The
Cristero Rebellion: The Mexican People Between Church and State, 1926–1929,*
trans. Richard Southern (London: Cambridge University Press, 1976), p. 208.

23. Morales, p. 120.

24. Elsewhere, in a short story/article called "Gilberto" after a recent
devastating hurricane, Mastretta reinforces this connection between human

142

passion and the passion of the sea. She writes: "El mar es una cosa seria, saben los que viven junto a él. El mar es un amante impredecible: desconoce, abandona, lastima, pero brilla, acompaña, alimenta. El mar traga, roba, vomita. El mar abraza. El mar es un amante y quienes lo aman, entienden su locura y lo perdonan" [The sea is a serious thing, those who live close by it know that. The sea is an unpredictable lover: it forgets, it abandons, it wounds, but it shines, it accompanies, it sustains. The sea swallows, steals, vomits forth. The sea embraces. The sea is a lover, and those who love it in return comprehend its madness and forgive it] (from *Nexos*, no. 131 [November 1988]: 5).

25. Meyer calls the CROM "the agent of the new state" (*Cristero Rebellion*, p. 24); Cockcroft terms the union "a pillar of support for the bourgeois governments" (p. 108). In Mastretta's version of events, the president, his cabinet, and his advisors all use the power of these 'loyal' workers to back official policy on strikes, wages, and other issues. Carlos and the clandestine opposition try to organize workers into groups independent of government coercion and corruption. Andrés and Catalina's relationship parallels this national situation on a private level as the general manipulates people and events that form the backdrop of Catalina's affair with Carlos Vives while Carlos and she secretly try to create an alternative life (or at the very least a brief moment of passion).

26. Fidel de León, review of *Arráncame la vida* in *Chasqui* 15 (February–May 1986): 96. The reader will notice that although the novel is given a brief review in this journal, its author remains distant enough as a source to be referred to throughout as "Dolores Mastretta."

27. Moretti, p. 68; my emphasis.

28. Anamari Gomís, "Ella encarnaba boleros," review of *Arráncame la vida*, in *Nexos* 8, no. 91 (July 1985): 52.

29. Moretti, p. 66.

30. Instead of an individual voice, Theodor Adorno classified this as a "pseudo-individualization" (see "On Popular Music," *Studies in Philosophy and Social Sciences* 9 [1941]: 17–48). Bernard Gendron's excellent article "Theodor Adorno Meets the Cadillacs" offers a very articulate response to these aspects of Adorno's writings on the culture industry; in *Studies in Entertainment: Critical Approaches to Mass Culture,* ed. Tania Modleski (Bloomington: Indiana University Press, 1986), pp. 18–36.

BIBLIOGRAPHY

Abel, Elizabeth, Marianne Hirsch, and Elizabeth Langland, eds. *The Voyage In: Fictions of Female Development*. Hanover, N.H.: University Press of New England, 1983.

Agosín, Marjorie. *Women of Smoke: Latin American Women in Literature and Life*. Trans. Janice Molloy. Trenton, N.J.: Red Sea Press, and Third World Books, 1989.

Aguilar Camín, Héctor. "La transición mexicana." *Nexos*, no. 124 (April 1988): 21–27.

Ahern, Maureen, ed. *A Rosario Castellanos Reader: An Anthology of Her Poetry, Short Fiction, Essays, and Drama*. Austin: University of Texas Press, 1988.

Altman, Janet Gurkin. *Epistolarity: Approaches to a Form*. Columbus: Ohio State University Press, 1982.

Anderson, Danny J. "Displacement: Strategies of Transformation in *Arráncame la vida*, by Angeles Mastretta." *Journal of the Midwest Modern Language Association* 21 (Spring 1988): 15–27.

Anderson-Imbert, Enrique. *El realismo mágico y otros ensayos*. Caracas: Monte Avila, 1976.

Angelina Beloff: Ilustradora y grabadora. Ed. Olivier Debroise. Mexico City, Guanajuato, Saltillo: Consejo Nacional para la Cultura y las Artes, Instituto Nacional de Bellas Artes, Instituto Francés de América Latina, Museo Estudio Diego Rivera, Museo Casa Diego Rivera, Centro de Artes Visuales e Investigaciones Estéticas, 1989.

Appleyard, J. A. *Coleridge's Philosophy of Literature: The Development of a Concept of Poetry, 1791–1819*. Cambridge, Mass.: Harvard University Press, 1965.

Arenal, Electa, and Stacey Schlau. *Untold Sisters: Hispanic Nuns in Their Own Works*. Albuquerque: University of New Mexico Press, 1989.

Aronson, Alex. *Music and the Novel: A Study in Twentieth-Century Fiction*. Totowa, N.J.: Rowman and Littlefield, 1980.

Baddeley, Oriana, and Valerie Fraser. *Drawing the Line: Art and Cultural Identity in Contemporary Latin America*. London: Verso, 1989.

Barker, Francis. *The Tremulous Private Body: Essays on Subjection*. London: Methuen, 1984.

Barrios de Chungara, Domitila, with Moema Viezzer. *Let Me Speak! Testimony of Domitila, A Woman of the Bolivian Mines*. Trans. Victoria Ortiz. New York: Monthly Review Press, 1978.

Bassnett, Susan, ed. *Knives and Angels: Women Writers in Latin America*. London: Zed, 1990.

Bataille, Georges. *Erotism: Death and Sensuality*. Trans. Mary Dalwood. San Francisco: City Lights Books, 1986.

Bayón, Damián, ed. *América Latina en sus artes*. 4th ed. Mexico City: Siglo Veintiuno and UNESCO, 1983.

Beer, Gabriela de. *José Vasconcelos and His World*. New York: Las Américas, 1966.

Beloff, Angelina. *Memorias*. Trans. Gloria Taracena. Mexico City: SEP/UNAM, 1986.

Benstock, Shari. *Women of the Left Bank: Paris, 1900–1940*. Austin: University of Texas Press, 1986.

Berger, John. *G*. New York: Pantheon, 1980.

Blanco Moheno, Roberto. "Hablar sobre petróleo y hacerlo con la verdad." *Siempre*, no. 1869, April 19, 1989, pp. 24–25.

Blanco White, José María. *Obra inglesa de Blanco White*. Ed. Juan Goytisolo. Barcelona: Seix Barral, 1974.

Bossis, Mireille. "Methodological Journeys Through Correspondences." Trans. Karen McPherson. *Yale French Studies* 71 (1986): 63–75.

Boxer, C. R. *Women in Iberian Expansion Overseas, 1415–1815: Some Facts, Fancies, and Personalities*. New York: Oxford University Press, 1975.

Bradu, Fabienne. *Señas particulares: Escritora (Ensayos sobre escritoras mexicanas del siglo XX)*. Mexico City: Fondo de Cultura Económica, 1987.

Brett, Guy. *Transcontinental: An Investigation of Reality; Nine Latin American Artists*. London: Verso, 1990.

Brimmer, Gaby. *Gaby: Un año después*. Mexico City: Grijalbo, 1980.

Bruce-Novoa, Juan. "Subverting the Dominant Text: Elena Poniatowska's *Querido Diego*." In *Knives and Angels: Women Writers in Latin America,* ed. Susan Bassnett, 115–131. London: Zed, 1990.

Buckley, Jerome Hamilton. *Season of Youth: The 'Bildungsroman' from Dickens to Golding*. Cambridge, Mass.: Harvard University Press, 1974.

Burgos, Elizabeth. *Me llamo Rigoberta Menchú y así me nació la conciencia*. Mexico City: Siglo XXI, 1985.

Bygrave, Stephen. *Coleridge and the Self: Romantic Egotism*. New York: St. Martin's Press, 1986.

Carballo, Marco Aurelio. "Figuras de la semana." *Siempre,* June 7, 1989, pp. 10–11.

Carpentier, Alejo. *El reino de este mundo*. Barcelona: Seix Barral, 1969.

———. *Tientos y diferencias*. Montevideo: Arca, 1967.

Castellanos, Rosario. *Juicios sumarios: Ensayos*. Xalapa: Universidad Veracruzana, 1966.

———. *El mar y sus pescaditos*. Mexico City: Sepsetentas and SEP, 1975. Reprint. Mexico City: Editorial Mexicanos Unidos, 1987.

———. *Mujer que sabe latín*. Mexico City: Fondo de Cultura Económica/SEP, 1984.

———. *Poesía no eres tú: Obra poética, 1948–1971*. Mexico City: Fondo de Cultura Económica, 1972.

———. *A Rosario Castellanos Reader: An Anthology of Her Poetry, Short Fiction, Essays, and Drama*. Ed. Maureen Ahern. Austin: University of Texas Press, 1988.

———. *El uso de la palabra: Una mirada a la realidad*. Mexico City: Ediciones de Excésior—Crónicas, 1974. Reprint. Mexico City: Editorial Mexicanos Unidos, 1982.

Clifford, James. *The Predicament of Culture: Twentieth-Century Ethnography, Literature, and Art*. Cambridge, Mass.: Harvard University Press, 1988.

Clifford, James, and George E. Marcus, eds. *Writing Culture: The Poetics and Politics of Ethnography*. Berkeley: University of California Press, 1986.

Cockcroft, James D. *Mexico: Class Formation, Capital Accumulation, and the State*. New York: Monthly Review Press, 1983.

Coles, Robert. *Simone Weil: A Modern Pilgrimage*. Radcliffe Biography Series. Reading, Mass.: Addison-Wesley, 1987.

Córdova, Arnaldo. *La política de masas del cardenismo*. 1974. Reprint. Mexico City: Era, 1987.

Debroise, Olivier. *Diego de Montparnasse*. Mexico City: Fondo de Cultura Económica, 1979.

de Man, Paul. "Autobiography as De-facement." *MLN* 94 (December 1979): 919–930.

Dennis, Everette E., and William L. Rivers. *Other Voices: The New Journalism in America*. San Francisco: Canfield, 1974.

Desnoes, Edmundo. "La utilización social del objeto de arte." In *América Latina en sus artes,* ed. Damián Bayón, 189–206. 4th ed. Mexico City: Siglo Veintiuno and UNESCO, 1983.

Doane, Mary Ann. *The Desire to Desire: The Woman's Film of the 1940's*. Bloomington: Indiana University Press, 1987.

Du Plessis, Rachel Blau. "For the Etruscans." In *The New Feminist Criticism: Essays on Women, Literature, and Theory,* ed. Elaine Showalter, 271–291. New York: Pantheon, 1985.

Ecker, Gisela, ed. *Feminist Aesthetics*. London: Women's Press, 1985.

Feal, Rosemary Geisdorfer. "Spanish American Ethnobiography and the Slave Narrative Tradition: *Biografía de un cimarrón* and *Me llamo Rigoberta Menchú.*" *Modern Language Studies* 20 (Winter 1990): 100–111.

Fernández Retamar, Roberto. "Our America and the West." *Social Text* 15 (Fall 1986): 1–25.

Fothergill, Robert A. *Private Chronicles: A Study of English Diaries*. London: Oxford University Press, 1974.

Franco, Jean. "The Incorporation of Women: A Comparison of North American and Mexican Popular Narrative." In *Studies in Entertainment: Critical Approaches to Mass Culture,* ed. Tania Modleski, 119–138. Bloomington: Indiana University Press, 1986.

———. *Plotting Women: Gender and Representation in Mexico*. New York: Columbia University Press, 1989.

———. "Self-Destructing Heroines." *Minnesota Review,* new ser., 22 (Spring 1984): 105–115.

Frida Kahlo. Dir. Laura Mulvey, Lynda Myles, and Peter Wollen. Arts Council of Great Britain, 1982.

Frida: Naturaleza viva. Dir. Paul Leduc. Clasa Films Mundiales, 1984.

Fuentes, Carlos. "History Out of Chaos." *New York Times Book Review,* March 13, 1988, pp. 12–13.

García Ponce, Juan. "Diversidad de actitudes." In *América Latina en sus artes,* ed. Damián Bayón, 141–153. 4th ed. Mexico City: Siglo Veintiuno and UNESCO, 1983.

Garfield, Evelyn Picon, ed. *Women's Fiction from Latin America: Selections from Twelve Contemporary Authors.* Detroit: Wayne State University Press, 1988.

———. *Women's Voices from Latin America: Interviews with Six Contemporary Authors.* Detroit: Wayne State University Press, 1985.

Geertz, Clifford. *Local Knowledge: Further Essays in Interpretive Anthropology.* New York: Basic Books, 1983.

———. *Works and Lives: The Anthropologist as Author.* Stanford: Stanford University Press, 1988.

Gendron, Bernard. "Theodor Adorno Meets the Cadillacs." In *Studies in Entertainment: Critical Approaches to Mass Culture,* ed. Tania Modleski 18–36. Bloomington: Indiana University Press, 1986.

Gilly, Adolfo. *The Mexican Revolution.* Trans. Patrick Camiller. London: Verso and NLB, 1983.

Gomís, Anamari. "Ella encarnaba boleros." Review of *Arráncame la vida,* by Angeles Mastretta. *Nexos* 8, no. 91 (July 1985): 52.

González, Luis. *México mañana.* Mexico City: Océano, 1986.

González, Patricia Elena, and Eliana Ortega, eds. *La sartén por el mango: Encuentro de escritoras latinoamericanas.* Río Piedras, Puerto Rico: Ediciones Huracán, 1984.

Goytisolo, Juan, ed. *Obra inglesa de Blanco White.* Barcelona: Seix Barral, 1974.

Gruson, Kerry. "The Long Road Back." *New York Times Magazine,* June 30, 1985, pp. 24, 53.

Guillerm, Jean-Pierre. "Aux couleurs de la mort: Variations sur la peinture et la médecine dans la critique picturale à la fin du XIXe siècle." *Revue des sciences humaines* 198 (1985): 71–107.

Hahner, June E. "Mexico: Women and the Working Class." In *Slaves of Slaves: The Challenge of Latin American Women.* Trans. Michael Pallis. Latin American and Caribbean Women's Collective. London: Zed, 1980.

———, ed. *Women in Latin American History: Their Lives and Views.* Los Angeles: UCLA Latin American Center and the University of California Press, 1976. Revised editions appeared in 1980 and 1984.

Herrera, Hayden. *Frida: A Biography of Frida Kahlo.* New York: Harper and Row, 1983.

———. "Why Frida Kahlo Speaks to the 90's." *New York Times,* Arts and Leisure section, October 28, 1990, pp. 1, 41.

Hollowell, John. *Fact and Fiction: The New Journalism and the Nonfiction Novel.* Chapel Hill: University of North Carolina Press, 1977.

Holmes, Richard. *Coleridge.* Oxford: Oxford University Press, 1982.

Huyssen, Andreas. "Mass Culture as Woman: Modernism's 'Other.'" In *Studies in Entertainment: Critical Approaches to Mass Culture,* ed. Tania Modleski, 188–207. Bloomington: Indiana University Press, 1986.

Ianni, Octavio. *El Estado capitalista en la época de Cárdenas.* Trans. Ana María Palos. 1977. Reprint. Mexico City: Era, 1987.

Ilie, Paul. *Literature and Inner Exile: Authoritarian Spain, 1939–1975.* Baltimore: Johns Hopkins University Press, 1980.

Jameson, Fredric. "On Magical Realism in Film." *Critical Inquiry* 12 (Winter 1986): 301–325.

———. "Third World Cultural Studies." Cornell University Conference on the Culture Industry. Ithaca, N.Y., April 10, 1987.

———. "Third-World Literature in the Era of Multinational Capitalism." *Social Text* 15 (Fall 1986): 65–88.

Jay, Paul. *Being in the Text: Self-Representation from Wordsworth to Roland Barthes.* Ithaca, N.Y.: Cornell University Press, 1984.

Job, Peggy. "La sexualidad en la narrativa femenina mexicana, 1970–1987: Una aproximación." *Third Woman* 4 (1989): 120–133.

Jordanova, Ludmilla. *Sexual Visions: Images of Gender in Science and Medicine Between the Eighteenth and Twentieth Centuries.* Madison: University of Wisconsin Press, 1989.

Kahlo, Frida. "They Thought I Was a Surrealist." *Time,* April 27, 1953.

Kaplan, Janet A. *Unexpected Journeys: The Art and Life of Remedios Varo.* New York: Abbeville, 1988.

Kaufmann, Linda S. *Discourses of Desire: Gender, Genre, and Epistolary Fictions.* Ithaca, N.Y.: Cornell University Press, 1986.

Kristeva, Julia. *Black Sun: Depression and Melancholia.* Trans. Leon S. Roudiez. New York: Columbia University Press, 1989.

Kushigian, Julia A. "Transgresión de la autobiografía y el *Bildungsroman* en

Hasta no verte Jesús mío." *Revista Iberoamericana* 140 (July–September 1987): 667–677.

Labovitz, Esther Kleinbord. *The Myth of the Heroine: The Female 'Bildungsroman' in the Twentieth Century.* New York: Peter Lang, 1986.

Lavrin, Asunción, ed. *Latin American Women: Historical Perspectives.* Westport, Conn.: Greenwood, 1978.

León, Fidel de. Review of *Arráncame la vida,* by Angeles Mastretta. *Chasqui* 15 (February–May 1986): 96–97.

The Life and Death of Frida Kahlo. Dir. Karen Crommie and David Crommie. San Francisco, 1968.

Little, J. P. *Simone Weil: Waiting on Truth.* New York: St. Martin's Press, 1988.

Mac Orlan, Pierre. "The Literary Art of Imagination and Photography." In *Photography in the Modern Era: European Documents and Critical Writings, 1913–1940,* ed. Christopher Phillips, 27–30. New York: Metropolitan Museum of Art, and Aperture, 1989.

Magnarelli, Sharon. *The Lost Rib: Female Characters in the Spanish-American Novel.* Lewisburg: Bucknell University Press, 1985.

Marcuse, Herbert. *Eros and Civilization: A Philosophical Inquiry into Freud.* Boston: Beacon Press, 1966.

Marún, Gioconda. "Apuntaciones sobre la influencia de Addison y Steele en Larra." *Hispania* 64 (September 1981): 382–387.

Mastretta, Angeles. *Arráncame la vida.* Mexico City: Océano, 1985. Published in translation as *Mexican Bolero.*

————. "Gilberto." *Nexos,* no. 131 (November 1988): 5–8.

————. "Sobre el silencio más fino." *Nexos,* no. 137 (May 1989): 5–6.

Meese, Elizabeth A. *Crossing the Double-Cross: The Practice of Feminist Criticism.* Chapel Hill: University of North Carolina Press, 1986.

Meyer, Doris. *Lives on the Line: The Testimony of Contemporary Latin American Authors.* Berkeley: University of California Press, 1988.

Meyer, Doris, and Margarite Fernández Olmos, eds. *Contemporary Women Authors of Latin America: Introductory Essays.* Brooklyn: Brooklyn College Press, 1983.

Meyer, Jean A. *The Cristero Rebellion: The Mexican People Between Church and State, 1926–1929.* Trans. Richard Southern. London: Cambridge University Press, 1976.

Miller, Beth. "Interview with Elena Poniatowska." *Latin American Literary Review* 4 (Fall–Winter 1975): 73–78.

———. *Rosario Castellanos: Una Conciencia feminista en México*. Chiapas: Universidad Nacional Autónoma de Chiapas, 1983.

Modleski, Tania, ed. *Studies in Entertainment: Critical Approaches to Mass Culture*. Bloomington: Indiana University Press, 1986.

Monsiváis, Carlos. *Amor perdido*. Mexico City: Era, 1977.

———. "Frida Kahlo: 'Que el ciervo vulnerado / por el otero asoma.' " *México en el Arte*, n.s., 2 (Fall 1983): 64–71.

———. "Sociedad y cultura." In *Entre la guerra y la estabilidad política: El México de los '40*, ed. Rafael Loyola. Mexico City: Grijalbo, 1990.

Mora, Gabriela. "El Bildungsroman y la experiencia latinoamericana: 'La pájara pinta' de Albalucía Angel." In *La sartén por el mango: Encuentro de escritoras latinoamericanas*, ed. Patricia Elena González and Eliana Ortega, 71–81. Río Piedras, Puerto Rico: Ediciones Huracán, 1984.

———. "Narradoras hispanoamericanas: Vieja y nueva problemática en renovadas elaboraciones." In *Theory and Practice of Feminist Literary Criticism*, ed. Gabriela Mora and Karen S. Van Hooft, 156–174. Ypsilanti, Mich.: Bilingual Press/Editorial Bilingüe, 1982.

Mora, Gabriela, and Karen S. Van Hooft, eds. *Theory and Practice of Feminist Literary Criticism*. Ypsilanti, Mich.: Bilingual Press/Editorial Bilingüe, 1982.

Morales, Salvador. *La música mexicana*. Mexico City: Editorial Universo, 1981.

Moretti, Franco. *The Way of the World: The 'Bildungsroman' in European Culture*. London: Verso, 1987.

Moylan, Tom. *Demand the Impossible: Science Fiction and the Utopian Imagination*. New York: Methuen, 1986.

Mulvey, Laura, ed. *Visual and Other Pleasures*. Bloomington: Indiana University Press, 1989.

Mulvey, Laura, Lynda Myles, and Peter Wollen. "Frida Kahlo and Tina Modotti." In *Visual and Other Pleasures*, ed. Laura Mulvey, 81–107. Bloomington: Indiana University Press, 1989.

Myers, Kathleen A. "Phaeton as Emblem: Recent Works on Sor Juana Inés de la Cruz." *Michigan Quarterly Review* 29 (Summer 1990): 453–471.

———, ed. *Woman's Word and World in Mid-Colonial Mexico: A Critical Edition of the Autobiography of Madre María de San Joseph (1656–1719)*. Forthcoming.

"Numeralia." *Nexos,* no. 111 (March 1987): 17.

Ocampo, Estela. "La pasión de Frida Kahlo." *Quimera,* no. 75 (1989): 34–41.

Ochoa Sandy, Gerardo. "Entrevista a Elena Poniatowska." *Unomásuno,* February 11, 1989, pp. 1, 3–4.

Oster, Patrick. *The Mexicans: A Personal Portrait of a People.* New York: William Morrow, 1989.

Peixoto, Marta. *"Family Ties:* Female Development in Clarice Lispector." In *The Voyage In: Fictions of Female Development,* ed. Elizabeth Abel, Marianne Hirsch, and Elizabeth Langland, 287–303. Hanover, N.H.: University Press of New England, 1983.

Peña, Margarita. *Entrelíneas.* Textos de Humanidades 34. Mexico City: UNAM, 1983.

Phillips, Christopher, ed. *Photography in the Modern Era: European Documents and Critical Writings, 1913–1940.* New York: Metropolitan Museum of Art, and Aperture, 1989.

Poniatowska, Elena. *Gaby Brimmer.* Mexico City: Grijalbo, 1979.

———. *Querido Diego, te abraza Quiela.* Mexico City: Era, 1978.

———. "Rosario Castellanos: ¡Vida, nada te debo!" In *¡Ay vida, no me mereces!* 43–132. Mexico City: Joaquín Mortiz, 1985.

Porter, Charles A. Foreword to issue dedicated to "Men/Women of Letters." *Yale French Studies* 71 (1986): 1–14.

Rico, Araceli. *Frida Kahlo: Fantasía de un cuerpo herido.* Mexico City: Plaza y Valdés, 1987.

Rivera Marín, Ruth. *Un río, dos Riveras.* Memorial Series. Mexico City: Editorial Alianza Mexicana, 1990.

Roh, Franz. *German Painting in the Twentieth Century.* Additions by Juliane Roh. Greenwich, Conn.: New York Graphic Society, 1968.

Romera, Antonio R. "Despertar de una conciencia artística (1920–1930)." In *América Latina en sus artes,* ed. Damián Bayón, 5–18. 4th ed. Mexico City: Siglo Veintiuno and UNESCO, 1983.

Ruta, Suzanne. "Adios, Machismo: Rosario Castellanos Goes Her Own Way." *VLS,* June 1989, p. 33.

Sauvage, Léo. *Ché Guevara: The Failure of a Revolutionary.* Englewood Cliffs, N.J.: Prentice-Hall, 1973.

151

Scarry, Elaine. *The Body in Pain: The Making and Unmaking of the World.* New York: Oxford University Press, 1985.

Schapiro, Nat, and Bruce Pollock, eds. *Popular Music, 1920–1979.* 3 vols. Detroit: Gale Research Co., 1985.

Schjeldahl, Peter. "Frida Kahlo." *Mirabella,* November 1990, pp. 64–67.

Schwartz, Perla. *Rosario Castellanos: Mujer que supo latín.* Mexico City: Katún, 1984.

Seale Vásquez, Mary, and Maureen Ahern, eds. *Homenaje a Rosario Castellanos.* Valencia: Albatros Hispanófila, 1980.

Showalter, Elaine, ed. *The New Feminist Criticism: Essays on Women, Literature, and Theory.* New York: Pantheon, 1985.

Shumaker, Wayne. *English Autobiography: Its Emergence, Materials, and Forms.* Berkeley: University of California Press, 1954.

Silva Herzog, Jesús. *Lázaro Cárdenas: Su pensamiento económico, social y político.* Mexico City: Editorial Nuestro Tiempo, 1988.

———. *Trayectoria ideológica de la Revolución Mexicana: Del manifiesto del Partido Liberal de 1906 a la Constitución de 1917.* Mexico City: Cuadernos Americanos, 1963.

Sims, Lowery S. "New York Dada and New World Surrealism." In *The Latin American Spirit: Art and Artists in the United States, 1920–1970,* ed. Luis R. Cancel et al., 152–183. New York: Bronx Museum of the Arts and Harry N. Abrams, Inc., 1989.

Sims, Norman, ed. *The Literary Journalists: The New Art of Personal Reportage.* New York: Ballantine, 1984.

Slaves of Slaves: The Challenge of Latin American Women. Latin American and Caribbean Women's Collective. Trans. Michael Pallis. London: Zed, 1980.

Sommer, Doris. *One Master for Another: Populism as Patriarchal Rhetoric in Dominican Novels.* Lanham, Md.: University Press of America, 1984.

Sontag, Susan. *Illness as Metaphor.* New York: Farrar, Straus, and Giroux, 1978.

Spivak, Gayatri Chakravorty. *In Other Worlds: Essays in Cultural Politics.* New York: Methuen, 1987.

Stastny, Francisco. "¿Un arte mestizo?" In *América Latina en sus artes,* ed. Damián Bayón, 154–170. 4th ed. Mexico City: Siglo Veintiuno and UNESCO, 1983.

Staváns, Ilán. "José Guadalupe Posada, Lampooner." *Journal of Decorative and Propaganda Arts* 16 (Summer 1990): 54–71.

Steele, Cynthia. "La creatividad y el deseo en *Querido Diego, te abraza Quiela* de Elena Poniatowska." *Hispamérica* 14 (August 1985): 17–28.

———. "Entrevista: Elena Poniatowska." *Hispamérica* 18 (August–December 1989): 89–105.

Stratton, Jon. *The Virgin Text*. Norman: University of Oklahoma Press, 1987.

Tibol, Raquel. *Frida Kahlo: Una vida abierta*. Mexico City: Oasis, 1983.

Toklas, Alice B. *Staying on Alone: Letters of Alice B. Toklas*. Ed. Edward Burns. New York: Liveright, 1973.

Uslar Pietri, Arturo. *Letras y hombres de Venezuela*. Mexico City: Fondo de Cultura Económica, 1948.

Valdés, María Elena de. "Feminist Testimonial Literature: Cristina Pacheco, Witness to Women." *Monographic Review/Revista Monográfica* 4 (1988): 150–162.

Van Maanen, John. *Tales of the Field: On Writing Ethnography*. Chicago: University of Chicago Press, 1988.

Vasconcelos, José. *La raza cósmica: Misión de la raza iberoamericana*. Mexico City: Espasa-Calpe Mexicana, 1948.

Weil, Simone. *Lectures on Philosophy*. Trans. Hugh Price. Cambridge: Cambridge University Press, 1978.

Weisgerber, Jean, ed. *Le réalisme magique: Roman, Peinture et Cinéma*. Brussels: Editions l'Age d'Homme and l'Université Libre de Bruxelles, 1988.

Wolfe, Bertram D. *The Fabulous Life of Diego Rivera*. New York: Stein and Day, 1969.

Yurkievich, Saúl. "El arte de una sociedad en transformación." In *América Latina en sus artes,* ed. Damián Bayón, 173–188. 4th ed. Mexico City: Siglo Veintiuno and UNESCO, 1983.

Zamora, Martha. *Frida: El pincel de la angustia*. Mexico City: Privately printed, 1987.

———. *Frida Kahlo: The Brush of Anguish*. Trans. Marilyn Sode Smith. San Francisco: Chronicle, 1990. Abridged ed. of *Frida: El pincel de la angustia*.

INDEX

Acculturation, of indigenous populations, 45, 47–49
A Few Small Nips (Kahlo), 26
Agrupaciones femeninas, 46
Ahern, Maureen, x, 47
Alemán, President Miguel, 23–24
Alienation, 69, 72, 83
Anderson-Imbert, Enrique, 33
Andrés. *See* Ascencio, General Andrés
Androgyny, 26
Apocalyptic moment, 33
Arizmendi, Fernando: character in *Arráncame la vida,* 96–99
Arráncame la vida [trans. as *Mexican Bolero*] (Mastretta), xiv, 88, 90, 102, 140n.11; departure from the classic bildungsroman, 89, 95, 109–10, 112, 132n.44; feminine liberation in, 117–18n.12; levels of, 89, 92; a novel of transition, 90; use of popular songs in, 88, 90, 93–95, 97, 101–3, 110. *See also* Guzmán, Catalina, *and by individual characters*

Ascencio, General Andrés: character in *Arráncame la vida,* 95–104, 109; death parallels Mexico's history, 104–6, 141n.20
Ascencio, Catalina Guzmán de. *See* Guzmán, Catalina
Assimilation. *See* Acculturation, of indigenous populations
Ateneo de la Juventud, 9–10
Autobiographical discourse: of Castellanos, 51–60, 131n.32; in Kahlo's self-portraits, 12, 22, 120n.4

Bakhtin, Mikhail, 113
"Barca de Guaymas, La" [The launch from Guaymas], 94
Bataille, Georges, 4, 15
Beloff, Angelina, xii, xiv, 64–65, 67, 87, 137nn.30, 32; character of, 84–86; in exile, 78–79, 83–84; memoirs of, 135n.7; relationship with Poniatowska, xv; letters to Rivera, 73–83; compared to Toklas, 78, 138n.36
Berger, John, 28

Bildungsroman: departures from the classic, 89, 95, 109–10, 112, 132n.44; female-centered version of, xv, 140n.15

Blanco, José Joaquín, 38

Body, the female, xv–16, 46, 96; alienated, 69, 72, 83; Castellanos on, 42, 51, 124n.41, 130n.23; images of, related to Kahlo's illness and paralysis, 3–5, 8–9, 13–20, 22–27, 29, 76; physical and cultural or political as one, xv–36, 61, 83, 112; Poniatowska on physical impairment, 111–12

Bolero [ballad], 88, 93–94

Breton, André, 10, 25

Brimmer, Gaby, xiv, 51, 61, 67, 70–74; biographical film of, 68–69; character of, 86–87; libertarian leanings of, 80; physical impairment of, 64, 76, 79, 82, 111–12

Brimmer, Sari, 65, 82

Broken Column, The (Kahlo), 17

Bus, The (Kahlo), 35–36

Camión, El [The Bus] (Kahlo), 35–36

Cantinflas (Mario Moreno), 12

Capitalism: disjunction with indigenous culture, 11–12, 44; transition to, 24, 28, 34, 89, 106, 110, 118n.14, 134n.2

Cárdenas, Cuauhtémoc, 44

Cárdenas, President Lázaro, xiii, 6, 35, 44–47, 49

Cardenismo, 44–46

Carlos. See Vives, Carlos

Carpentier, Alejo, 11, 33

Castellanos, Rosario, xi, xiii–xiv, 19, 37, 42; on the body, 42, 51, 124n.41, 130n.23; essays of, 37–38; ethnographic form used by, 51–60; and indigenous cultures, 47–51; irony in work of, 48, 55, 129n.20; life of, 47, 131n.32; persona or mask of, 41; acts of self-violence of, 41, 44

Catalina. See Guzmán, Catalina

Chronicles, private, 38, 112. See also Epistolary form

Cinema. See Film

Class (social), 35, 64, 136n.26; bourgeoisie, 101, 109, 112

Cockcroft, James D., 89, 113

Coleridge, Samuel Taylor, 13–14, 20

Confessional writing, 70

Cosmic Race, The (Vasconcelos), 10, 30, 32

Cruz, Sor Juana Inés de la, 21, 121–22n.19, 125n.49

Cuatro habitantes de la ciudad de México, Los [Four Inhabitants of Mexico City] (Kahlo), 35–36

Day of the Dead celebrations, 5, 12

Dear Diego (Poniatowska), 61

Death, consciousness of, 4–5, 12

Deceased Dimas, The (Kahlo), 5, 36

De Man, Paul, 22

Desires, displaced, 97, 109

Diaries, 112. See also Epistolary form

Díaz Ordaz, Gustavo, 47
Díaz, Porfirio, 5
Didion, Joan, 38–39
Diego, Me and Señor Xólotl (Kahlo), 23
Diego and Frida (Kahlo), 26
Diego and I (Kahlo), 23
"Difícil acceso a la humanidad" [Difficult access to humanity] (Castellanos), 49
Double persona, 20–21, 28, 31, 33
Du Plessis, Rachel Blau, 66

Earth Itself, The (Kahlo), 31
Echeverría, President Luis, 39, 47, 62
Écriture féminine, 43
Emotions, and color, 125n.51
Epistolary form, 64–82
Eros and Civilization (Marcuse), 28
"Escritor como periodista, El" [The writer as journalist] (Castellanos), 50
Escuela Nacional Preparatoria, 9–10
Excélsior, 37, 39
Eye. *See* Gaze

Félix, María, 12
Feminism: *agrupaciones femeninas,* 46; feminine liberation, 65, 108–10, 117–18n.12; *feminismo integracionista,* 43; proto, xiii, 37. *See also* Gender relations; Women
Fernández, Emilio (*El Indio*), 12
Fiction: and the epistolary form, 82–87; and history, xv, 68
Film: emergence of, 11–12, 107–8;

women's point of view in, 119n.3. *See also by individual films*
First World, confronting traditional culture, 10–12, 28–36, 41–42, 44, 47–51, 99–101
Fito, character in *Arráncame la vida,* 99, 106
Flores, Angel, 11
Four Inhabitants of Mexico City (Kahlo), 35–36
Franco, Jean, x
Frida and the Abortion (Kahlo), 17

Gaby—A True Story, 68
García Ponce, Juan, 6, 22
Garcilaso de la Vega, 31
Garro, Elena, 113–14
Gaze, 23–24; male, 3
Gender relations, 4–5, 37, 67, 81, 97; historical context of, 92, 113; male authority or privilege, 3, 15, 75, 110, 125n.52. *See also* Feminism
Gómez Arias, Alejandro, 20
Gómez Carrillo, Enrique, 39–40
Government. *See* Mexico, politics and government of
Guzmán, Catalina: main character of *Arráncame la vida,* xv, 89–110; as personification of Mexican national history, 91–92, 103

Hernández, Luisa Josefina, 114
Heteroglossia, 113
"Historia de una mujer rebelde" [Story of a rebellious woman] (Castellanos), 43

History: and fictional forms, xv, 68; interacting with art and culture, 112; personification of, 91–92. *See also* Mexican nationalist consciousness; Mexican Revolution; Mexican society; Mexico, politics and government of
"Hombre del destino, El" [trans. as "A Man of Destiny"] (Castellanos), 44, 49

"Idioma en San Cristóbal Las Casas, El" [Language in San Cristóbal Las Casas] (Castellanos), 48
Illness, 131n.32, 137n.30; Brimmer's cerebral palsy, 64, 76, 79, 82, 111–12; in Kahlo's life and art, 3–4, 13–20, 22–27, 29, 76, 118–19n.1, 119n.2, 124n.45
Indian culture. *See* Indigenous cultures
Indigenous cultures: Castellanos' relation to, 47–51; *indigenismo,* 37, 49; influence of, on Kahlo, 10–11, 24–26, 35–36; confronted by the modern, 10–12, 28–36, 41–42, 44, 47–51, 99–101; of pre-Columbian past, 11–12
Indio, El (Emilio Fernández), 12
Individuality, cult of, 110
Individual voice, 110; as "pseudo-individualization," 142n.30
Instituto Indigenista [Indian Institute], 45, 47

Intellectuals, role of, in Mexican society, 62, 112
International Women's Year Tribunal, 64
"Involuntary Prologue" (Castellanos), 50
Irony, in Castellanos' work, 48, 55, 129n.20

Jameson, Fredric, 5, 11, 34
Josefita, character in *Arráncame la vida,* 108
Journalism: bridge with fiction, 62–63; literary, 38–40, 42–43; the "new," 128n.8; traditional genre of, 112
Juicios sumarios [Summary judgments] (Castellanos), 38

Kahlo, Cristina, 25
Kahlo, Frida, xi–xiii, 117n.11; body imagery of, 5, 8–9, 15, 17, 24; domestic imagery of, 7–9; double persona of, 20–21, 28, 31, 33; on emotions and color, 125n.51; Indian and mestizo influences on, 10–11, 24–26, 35–36; and magical realism, 11–12, 33–36; male persona of, 26; narrative point of view of, 3–4, 119n.3; images of nature in work of, 10, 14, 16, 23, 32; pain and illness reflected in art of, 3–4, 13–20, 22–27, 29, 76, 118–19n.1, 119n.2, 124n.45; relationship with Rivera, 16, 22–23, 26–28, 123nn.31, 37; search for self-identity, 26; self-

portraits of, 12–13, 22–24; and Surrealism, 10–11, 25–26, 32–33, 122n.23; work expresses conflicting elements of Mexican culture, 10–12, 28–36
Kingdom of This World, The (Carpentier), 11
Krauze, Ethel, 114
Kristeva, Julia, 41

Language in San Cristóbal Las Casas (Castellanos), 48
Larra, Mariano José de, 38–39, 41, 43
Latin America, women in, ix–xiii, 118n.13
Lavrin, Asunción, ix
"Learning About Things." *See* "Lecciones de cosas"
"Lecciones de cosas" [trans. as "Learning About Things"] (Castellanos), 128–29n.15
Letters. *See* Epistolary form
Levi Calderón, Sara, 114
Liberalism, 43. *See also Cardenismo*
Liberty, Statue of, 17
Lilia, character in *Arráncame la vida*, 94, 103–4
Lispector, Clarice, 140–41n.15
Literary journalism. *See* Journalism, literary
Loaeza, Guadalupe, 114
Love, fraternal, 10, 24
Love Embrace of the Universe, the Earth, The (Kahlo), 23, 26
Love story, 89, 139

Mac Orlan, Pierre, 34
Magical realism, 11–12, 33–36

Male gaze, 3
"Man of Destiny, A" (Castellanos), 44, 49
Marcuse, Herbert, 28
Marín, Lupe, 85
Marriage, 95–96, 123n.37
Marxismo dará salud a los enfermos, El (Kahlo), 24
Mar y sus pescaditos, El [The sea and its little fishes] (Castellanos), 38
Mask. *See* Persona
Mass media, 8, 44, 107, 111. *See also* Film; Journalism
Mastretta, Angeles, xiv–xv, 88, 110; cult images in narrative of, 94; feminist themes of, 117–18n.12; use of popular songs, 88, 90, 93–95, 97, 101–3, 110; images of the sea in work of, 103–4, 142n.24; authorial voice in character, 91; text departure from traditional bildungsroman, 89, 95, 109–10, 112, 132n.44. *See also Arráncame la vida;* Guzmán, Catalina
Meditación en el umbral [trans. as *Meditation on the Threshold*] (Castellanos), 41–42
Meditation on the Threshold. See Meditación en el umbral
Mendoza, María Luisa, 114
Mestizo population. *See* Indigenous cultures
Mexican Bolero. See Arráncame la vida
Mexican nationalist consciousness, xii, 3, 5–7, 12, 24–26, 30–31,

33; *cardenismo,* 44–46; "la mexicanidad," 9

Mexican Revolution, xii–xiii, xvi, 5, 27, 37, 40, 45

Mexican society, xi, xiv–xv, 34, 112; conflicting elements of, expressed in Castellanos' work, 41–42, 44, 47–51; conflicting elements of, expressed in Kahlo's work, 10–12, 28–36; conflicting elements of, expressed in Mastretta's work, 99–101; effects of capitalism on, 11–12, 44; embodiment of, 91–92, 103–6, 141n.20; intellectuals in, 62, 112; role and representation of women in, xi–xii, 7, 46, 97, 118n.14, 120–21n.14, 121n.15, 130n.23, 131n.32

Mexico, politics and government of, 6, 23, 112; Cockcroft on, 89, 113; crisis and transitions of, 106–7; disillusionment with, 100, 128–29n.15; effects of transition to capitalism on, 24, 28, 34, 89, 106, 110, 118n.14, 134n.2; the "revolution from within," 62. *See also* Mexican nationalist consciousness; Mexican Revolution; Mexican society

Mi constitución [My constitution] (Castellanos), 47–48

Mi libro de lectura [My reader] (Castellanos), 47–48

Modernism, literary, 84

Modernity, clash with indigenous culture, 11–12, 29, 44

Molina, Silvia, 114

Monsiváis, Carlos, 15, 38, 40

Mora, Gabriela, 88

Moreno, Mario (*Cantinflas*), 12

Moretti, Franco, 109

Mujer del puerto, La [Woman of the docks], 108

Mujer que sabe latín [A woman who knows Latin] (Castellanos), 38

Muray, Nickolas, 24–25

Music. *See* Popular songs

My Birth (Kahlo), 5, 17

My Dress Hangs There (Kahlo), 17–18

My Nurse and I (Kahlo), 31, 36

Narcissism, 16, 19–20, 28

Nationalism. *See* Mexican nationalist consciousness

National Palace murals (Rivera), 25

Native populations. *See* Indigenous cultures

Nature, images of, in Kahlo, 10, 14, 16, 23, 32

Novedades (Kahlo), 26

Novel, historical, 112, 117–18n.12. *See also Arráncame la vida;* Bildungsroman

Origen [Origin] (Kahlo), 41

Orozco, José Clemente, 6

Other, the, in Kahlo's art, 13–14, 22, 24, 26–27; self-identity in letters to, 71, 75

Pacheco, Cristina, 38, 114

Pain, images of, 3–4, 13–20, 22–27, 29, 124–25n.48

Palancares, Jesusa, character in

Hasta no verte Jesús mío (Poniatowska), 90

Patient, point of view of, 3

Paz, Octavio, 62

Persona: doubles, 20–21, 28, 31, 33; male, 26; as mask, 13, 41, 67

Petul Puppet Theater, 48

Photography, 34–35

Picasso, Pablo, 11

Plural (Paz), 62

Point of view: male and female, 3–4, 119n.3; third eye, in Kahlo's art, 23–24

Politics. *See* Mexico, politics and government of

Poniatowska, Elena, xiv, 51, 61–62, 82–87, 90; relationship with texts on Beloff, xv, 85–86; use of epistolary form, 64–82; intermediary role of, 65, 82–87. *See also* Beloff, Angelina; Brimmer, Gaby

Popular songs, as a structural element in *Arráncame la vida,* 88, 90, 93–95, 97, 101–3, 110

"Portrait of Diego" (Kahlo), 22, 26

Posada, José Guadalupe, 8, 20

Postrevolutionary Mexico. *See* Mexico, politics and government of

Power, political, 102. *See also* Mexico, politics and government of

PRI (Institutional Revolutionary Party), 93

"PRI, cocina, paz, ingenio, amor" [PRI, cooking, peace, ingenuity, and love] (Castellanos), 49

"Prólogo involuntario" [Involuntary prologue] (Castellanos), 50

Querido Diego, te abraza Quiela [trans. as *Dear Diego*] (Poniatowska), 61

Quiela. *See* Beloff, Angelina

Raza cósmica, La [The cosmic race] (Vasconcelos), 10, 30, 32

Reino de este mundo, El [trans. as *The Kingdom of This World*] (Carpentier), 11

"Relámpago" [Lightning bolt], 94

Remembrance of an Open Wound (Kahlo), 17

"Retrato de Diego" [Portrait of Diego] (Kahlo), 22, 26

Revolution of 1910. *See* Mexican Revolution

"Rime of the Ancient Mariner" (Coleridge), 13–14

Río, Dolores del, 12

Rivera, Diego, xi, 6, 10, 25, 30, 64–65; Beloff's letters to, 61, 70–76, 78–79, 84–86; describing Kahlo, 15–16; relationship with Kahlo, 16, 22–23, 26–28, 123nn.31, 37

Roh, Franz, 11, 33

Rosario Castellanos Reader, A (Ahern), x, 46, 130n.23

Ruta, Suzanne, 39, 47

Sabogal, José, 31

Scarry, Elaine, 18, 123n.31, 124n.45

Scherer, Julio, 39

Sea, imagery in Mastretta's work, 142n.24

Sea and Its Little Fishes, The (Castellanos), 38

Seale Vásquez, Mary, x

Self-Portrait as a Tehuana (Kahlo), 23

Self-Portrait on the Borderline (Kahlo), 36

Self-portraiture, 12–14, 22–24, 36

Self-Portrait with Monkey (Kahlo), 14

Sexuality, 4–5

Sierra, Justo, 9

Siqueiros, David Alfaro, 6, 25

"Social fantastic" theory, 34–35

Sontag, Susan, 17, 38

Stastny, Francisco, 30–31

Staváns, Ilán, 8, 20

Steele, Cynthia, 67, 84

"Story of a rebellious woman" (Castellanos), 43

Summary judgments (Castellanos), 38

Sun and Life (Kahlo), 23

Surrealism, 10–11, 25–26, 32–33, 122n.23

Technology, 16–17, 36

Teoría y práctica del indigenismo [Theory and Practice of *Indigenismo*] (Castellanos), 49

Texture and (literary) text, xv

Thinking About Death (Kahlo), 23

Third World: relation of art to culture in, 5, 16; representation and self-representation of women in, xi. *See also* Indigenous cultures; Latin America, women in; Mexico, politics and government

"Three Knots in the Net" (Castellanos), 46, 131n.32

Tientos y diferencias (Carpentier), 11

Tierra misma, La [The Earth Itself] (Kahlo), 31

Toklas, Alice B., 78, 138n.36

Toña (la Negra), 101–2

Tradition: clash with modernity, 11–12, 29, 44; as the female body, 6, 46. *See also* Indigenous cultures

Traditional genres, 111

Tree of Hope (Kahlo), 17, 36

Trespassing, xv

Two Fridas, The (Kahlo), 17, 31

Two Nudes in a Forest (Kahlo), 31

Unos cuantos piquetitos [*A Few Small Nips*] (Kahlo), 5

Uslar Pietri, Arturo, 11

Uso de la palabra, El [The use of the word] (Castellanos), 38, 47, 50

Utopia, the search for, 28–30, 41, 78, 80, 126n.60

Varo, Remedios, 25–26

Vasconcelos, José, 6, 10, 24, 28–32, 126n.60

Victim, point of view of, 3

Viva la vida (Kahlo), 17

Vives, Carlos, character in *Arráncame la vida,* 95, 99–104, 109

Voice: author's, merging with character's, 91; individual, 110

Wandering Jew, theme of the, 14

Weil, Simone, 41, 49–51

What the Water Gave Me (Kahlo), 18, 31

Widowhood, as "liberation," 108–10

Wolfe, Bertram, 65, 68, 86

Wolfe, Tom, 38–39

Woman Who Knows Latin, A (Castellanos), 38

Women, 28, 64, 101; cultural productions of, 112; history of, in Latin America, ix–x; current generation of, 104; relationships between, xv, 85–86; representation of, in Third World, ix–xiii, 118n.13; role and representation of, in Mexican society, xi–xii, 7, 46, 97, 118n.14, 120–21n.14, 121n.15, 130n.23, 131n.32. *See also* Body, the female; Feminism; Gender relations

"Writer as Journalist, The" (Castellanos), 50

Writing, Castellanos on, 42, 50

Young People's Atheneum, 9–10

Zamora, Martha, 36

ABOUT THE AUTHOR

Claudia Schaefer is Associate Professor of Spanish and Director of the Program in Comparative Literature at the University of Rochester. She received her Ph.D. from Washington University in St. Louis in 1979. Her recent publications include articles on literary journalism by women, the culture industry in Spain and Latin America, detective fiction, gender and representation in contemporary Mexico, and autobiographical narrative. She is the author of a book on literary representations of the Third World: *Juan Goytisolo: Del 'realismo crítico' a la utopía* (Madrid: José Porrua Turanzas, 1984). Her current research project is a study of erotic writings by women in Mexico and post-Franco Spain.